P9-DGB-907

Photographing New York City
Digital Field Guide

Photographing New York City

Digital Field Guide

Jeremy Pollack and Andy Williams

WILEY

Wiley Publishing, Inc.

Photographing New York City Digital Field Guide

Published by
Wiley Publishing, Inc.
10475 Crosspoint Boulevard
Indianapolis, IN 46256
www.wiley.com

Copyright © 2010 by Wiley Publishing, Inc., Indianapolis, Indiana

Published simultaneously in Canada

ISBN: 978-0-470-58685-3

Manufactured in the United States of America

10 9 8 7 6 5 4 3 2 1

No part of this publication may be reproduced, stored in a retrieval system or transmitted in any form or by any means, electronic, mechanical, photocopying, recording, scanning or otherwise, except as permitted under Sections 107 or 108 of the 1976 United States Copyright Act, without either the prior written permission of the Publisher, or authorization through payment of the appropriate per-copy fee to the Copyright Clearance Center, 222 Rosewood Drive, Danvers, MA 01923, (978) 750-8400, fax (978) 646-8600. Requests to the Publisher for permission should be addressed to the Permissions Department, John Wiley & Sons, Inc., 111 River Street, Hoboken, NJ 07030, 201-748-6011, fax 201-748-6008, or online at http://www.wiley.com/go/permissions.

LIMIT OF LIABILITY/DISCLAIMER OF WARRANTY: THE PUBLISHER AND THE AUTHOR MAKE NO REPRESENTATIONS OR WARRANTIES WITH RESPECT TO THE ACCURACY OR COMPLETENESS OF THE CONTENTS OF THIS WORK AND SPECIFICALLY DISCLAIM ALL WARRANTIES, INCLUDING WITHOUT LIMITATION WARRANTIES OF FITNESS FOR A PARTICULAR PURPOSE. NO WARRANTY MAY BE CREATED OR EXTENDED BY SALES OR PROMOTIONAL MATERIALS. THE ADVICE AND STRATEGIES CONTAINED HEREIN MAY NOT BE SUITABLE FOR EVERY SITUATION. THIS WORK IS SOLD WITH THE UNDERSTANDING THAT THE PUBLISHER IS NOT ENGAGED IN RENDERING LEGAL, ACCOUNTING, OR OTHER PROFESSIONAL SERVICES. IF PROFESSIONAL ASSISTANCE IS REQUIRED, THE SERVICES OF A COMPETENT PROFESSIONAL PERSON SHOULD BE SOUGHT. NEITHER THE PUBLISHER NOR THE AUTHOR SHALL BE LIABLE FOR DAMAGES ARISING HEREFROM. THE FACT THAT AN ORGANIZATION OR WEB SITE IS REFERRED TO IN THIS WORK AS A CITATION AND/OR A POTENTIAL SOURCE OF FURTHER INFORMATION DOES NOT MEAN THAT THE AUTHOR OR THE PUBLISHER ENDORSES THE INFORMATION THE ORGANIZATION OF WEB SITE MAY PROVIDE OR RECOMMENDATIONS IT MAY MAKE. FURTHER, READERS SHOULD BE AWARE THAT INTERNET WEB SITES LISTED IN THIS WORK MAY HAVE CHANGED OR DISAPPEARED BETWEEN WHEN THIS WORK WAS WRITTEN AND WHEN IT IS READ.

For general information on our other products and services or to obtain technical support, please contact our Customer Care Department within the U.S. at (877) 762-2974, outside the U.S. at (317) 572-3993 or fax (317) 572-4002.

Wiley also publishes its books in a variety of electronic formats. Some content that appears in print may not be available in electronic books.

Library of Congress Control Number: 2010925691

Trademarks: Wiley and the Wiley Publishing logo are trademarks or registered trademarks of John Wiley & Sons, Inc. and/or its affiliates. All other trademarks are the property of their respective owners. Wiley Publishing, Inc. is not associated with any product or vendor mentioned in this book.

WILEY

About the Authors

Jeremy Pollack is a Connecticut-based photographer with a wide range of interests. As a result of growing up in the woods, his first love has always been nature photography which he started shooting with his father's Canon FT QL. As his passion grew over the years, so did the breadth of his interests. Today he shoots commercial and fine art photography, selling prints at art shows and online. To connect to his blog, portfolios, fine art storefront, and other online presences, please visit www.jeremypollack.net.

Andy Williams (New York, NY) is a Photographer, COO, General Manager, and House Professional Photographer at SmugMug. Andy has been a photographer all his life, and shooting professionally for 20 years. When he is not doing portrait and event work, his artistic interests tend toward landscape and street photography. He teaches and holds several workshops a year. Andy lives in the New York City area and is a member of Photographic Arts, NY, the Professional Photographers of America, the National Association of Photoshop Professionals, the IR League, and Canon Professional Services. Andy can be found on Twitter, Facebook, and LinkedIn. His beautiful photos can be seen via his Web site at www.moonriver photography.com.

Credits

Senior Acquisitions Editor
Stephanie McComb

Project Editor
Chris Wolfgang

Technical Editor
Mike Hagen

Copy Editor
Beth Taylor

Editorial Director
Robyn Siesky

Editorial Manager
Cricket Krengel

Business Manager
Amy Knies

Senior Marketing Manager
Sandy Smith

Vice President and Executive Group Publisher
Richard Swadley

Vice President and Executive Publisher
Barry Pruett

Project Coordinator
Katie Crocker

Graphics and Production Specialists
Ana Carrillo
Andrea Hornberger
Jennifer Mayberry

Quality Control Technician
Lauren Mandelbaum

Proofreading and Indexing
Valerie Haynes Perry
Penny Stuart

Chance favors the prepared mind.

- Louis Pasteur

Acknowledgments

This book would not have been possible without so many wonderful people. Their belief and trust in me is humbling. A huge thank you to every one of you.

To Rick Sammon, who believed in me enough to recommend me for this project and has been incredibly supportive of my photographic journey.

To Michael Vertefeuille, who has supported me in both words and actions and made it possible to live and breathe this project.

To everyone at Wiley who made this book a reality.

And, of course, to my wonderful wife Crista Grasso, who has supported and pushed me every step of the way. I would not be here today without her.

—*Jeremy Pollack*

Contents

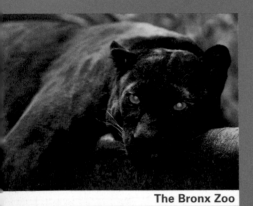

The Bronx Zoo

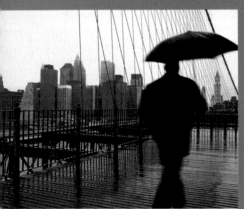

The Brooklyn Bridge

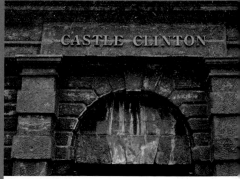

Castle Clinton

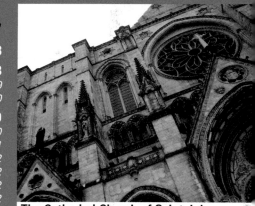

The Cathedral Church of Saint John
The Divine

Central Park

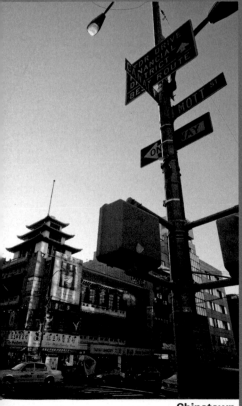

Chinatown

The Cloisters

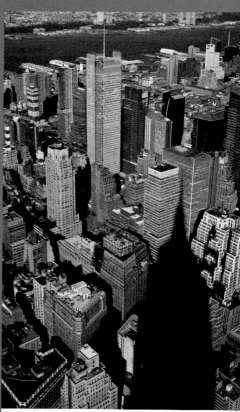
The Empire State Building

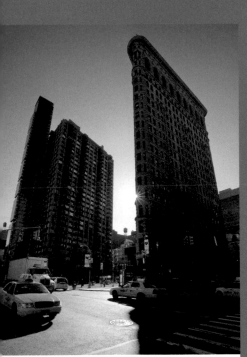

The Flatiron Building

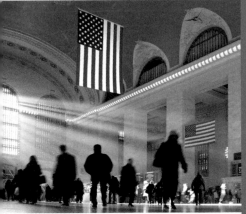

Grand Central Terminal

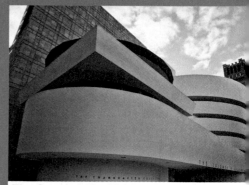

The Guggenheim Museum

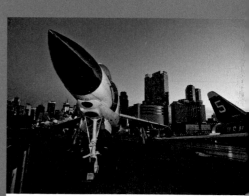

The USS Intrepid

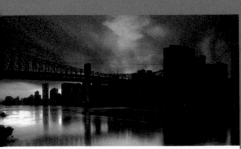

Manhattan From Roosevelt Island

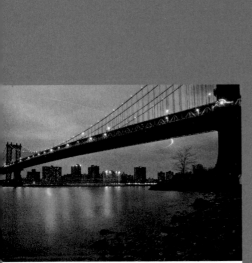

Manhattan and Williamsburg Bridges

The Metropolitan Museum of Art

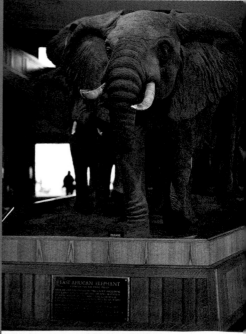

The Museum of Natural History

New York Botanical Garden

The New York Public Library

Rockefeller Center

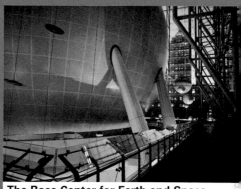

The Rose Center for Earth and Space

Saint Patrick's Cathedral

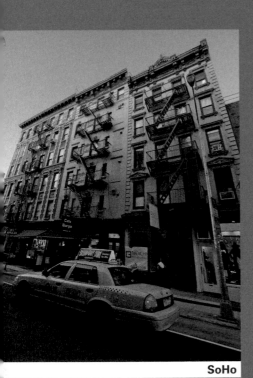

SoHo

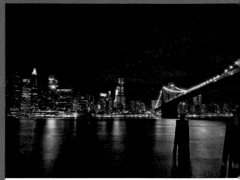

The Staten Island Ferry

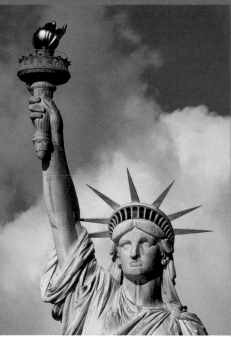

The Statue of Liberty

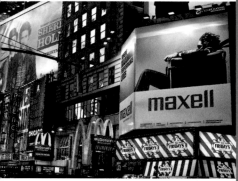

Times Square

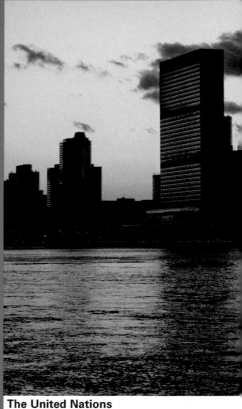

The United Nations

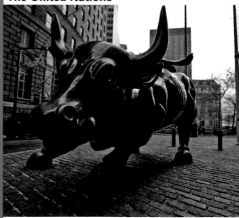

Wall Street

Introduction

This Digital Field Guide is designed to be a pocketable companion in your quest to create postcard-worthy photographs in New York City. Whether you are visiting for the first time or are a long-time resident, a beginner or seasoned shooter, this photo guide will offer tips and suggestions for 28 of the most photogenic spots in the city. Beyond simply telling you about a landmark, this book will guide you through learning and seeing examples of the best vantage points from which to take photographs at each location, what equipment to bring and why, suggested camera settings, and even how to plan for the seasons, weather, and photographing at night.

Who the Book Is For

This book is for anyone with a love of photography that will be shooting in New York City. While many of the discussions are around digital SLR cameras, point-and-shoot cameras can certainly be used for any of the shots in the book. A basic knowledge of your camera settings will be helpful, as will an understanding of the relationship of aperture, shutter speed, and ISO to create a proper exposure. However, these details are not central to the book. Instead, we focus on wonderful photographic opportunities in one of the greatest cities in the world, provide examples to inspire and follow, and explain how you can create beautiful images of your own.

One of the challenges in making great photographs of a location are the time and preparation it takes to scout, find the best angles, and learn the best times to visit. This book will help you in each of these areas. We have done the research and planning so you can enjoy your time making photographs.

A few other resources that might be helpful for your trip to New York City are:

- ▶ **Google Maps with Streetview.** New York City is thoroughly covered by Google Streetview. This gives you a photographic look at every street in the city! Take a virtual look around your destinations and get a feel for the street layouts before setting foot in town.

- ▶ **MTA Trip Planner.** Located at http://tripplanner.mta.info, this excellent resource will help you plot your way around the city using mass transit.

- ▶ **Destination Web sites.** While we have endeavored to include the most up-to-date and pertinent information possible in this book, things do change. Web sites for major destinations such as the Empire State Building or the Statue of Liberty will provide up-to-the-minute details and contact information.

How To Use This Book

This book is organized alphabetically by location, starting with the Bronx Zoo all the way to Wall Street. You can go directly to any chapter rather than reading from start-to-finish. Some discussions will be cross-referenced to an earlier chapter, and there are useful tips and tricks spread throughout the entire text, so reading it from cover-to-cover will be beneficial, too.

A lot of travel photography is spent learning where to go, when to go, and why to go. The goal of this book is to free you from those tasks, allowing you to focus on your photography and finding beautiful light.

Lenses and Crop Factor

Images for this book were shot with a mixture of full-frame and crop-sensor cameras. A crop-sensor camera will offer a different angle of view with the same lens as a full frame camera. Generally these cause a 1.5x/1.6x magnification with some of the newer models giving a 2.0x magnification.

The photo captions in this book list the lenses which were used to create the photograph. These measurements have been normalized for a full-frame camera. See the table below for a comparison of some of the common lenses used and their full-frame versus crop-sensor focal lengths.

Full-frame sensor	1.5x/1.6x crop sensor	2.0x crop sensor
16-35mm zoom	25-60mm zoom	32-70mm zoom
24-70mm zoom	38-112mm zoom	48-140mm zoom
24-105mm zoom	38-170mm zoom	48-210mm zoom
70-200mm zoom	112-320mm zoom	140-400mm zoom
50mm prime	80mm prime	100mm prime
85mm prime	128mm prime	170mm prime
300mm prime	480mm prime	600mm prime

A leopard eyes the camera in the JungleWorld exhibit. Taken at ISO 1000, f/4.5, 1/80 second with a 300mm lens.

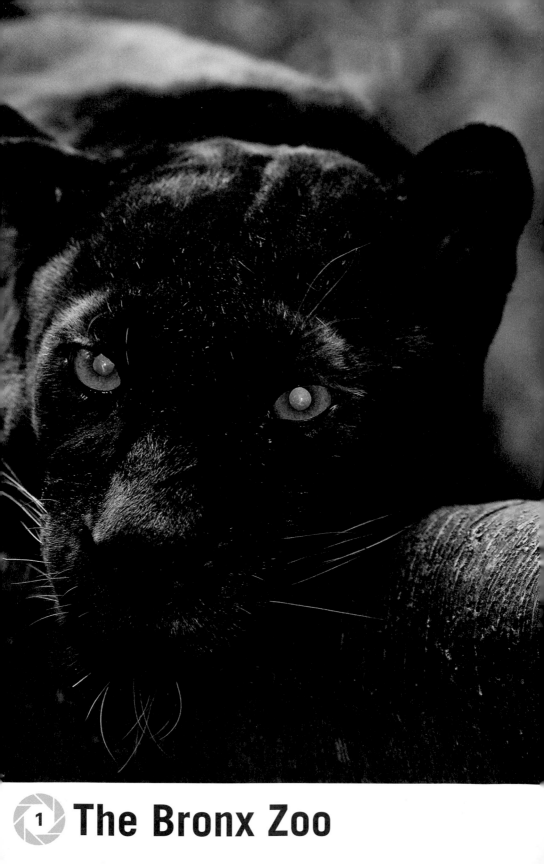

1 The Bronx Zoo

Why It's Worth a Photograph

The Bronx Zoo, just a short trip north of Manhattan, is a great place to take photos. Over 4,000 animals — including many endangered and threatened species — live on its 265 acres. The zoo has a focus on naturalistic habitats both indoors and out, so you can photograph animals including tigers, rare snow leopards, and bears in such a way that people viewing your photo won't be able to tell that it was taken at a zoo. Whether you just plan a day trip or combine it with a visit to the neighboring New York Botanical Garden, the Bronx Zoo is an enjoyable and exciting photographic opportunity.

Where Can I Get the Best Shot?

The Bronx Zoo has many photo opportunities. The best locations to visit first are the Zoo Center, Big Bears, Congo Gorilla Forest, JungleWorld, Tiger Mountain, and the Sea Bird Aviary.

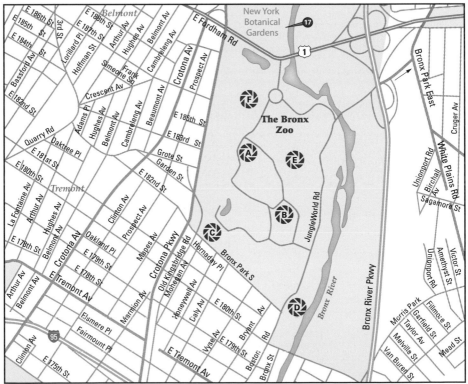

The best vantage points from which to photograph the Bronx Zoo: (A) Zoo Center, (B) Big Bears, (C) Congo Gorilla Forest, (D) JungleWorld, (E) Tiger Mountain, and (F) Sea Bird Aviary. Other photo ops: (17) New York Botanical Gardens.

Zoo Center

Originally known as the Elephant House when it opened in 1908, the Zoo Center is one of the original six Beaux-Arts style buildings designed for the zoo. This large, heavily ornamented building is the gateway to other original zoo buildings of Astor Court.

The Zoo Center hosts small exhibits and only a few animals, but the outside is a beautiful sight. It is flanked on the south by two large rhinoceros statues and often some roaming peacocks. A telephoto zoom lens lets you capture the entire building from a distance or isolate some of the intricate details (see Figure 1.1).

Big Bears

Polar and grizzly bears live next door to each other in the Big Bears exhibits. The grizzlies' enclosure includes swimming holes and a high ridge where the bears can play and patrol. The naturally aquatic polar bears spend a lot of time in their pool. Both bear exhibits offer excellent photo opportunities whether the bears are lounging, playing, or waving to the crowds.

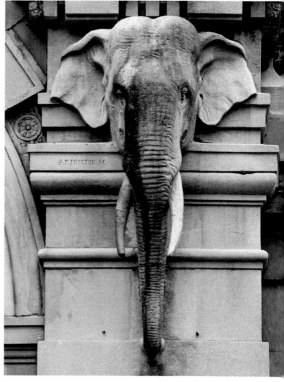

Although you can get closer to these animals than you ever might in nature, a telephoto zoom or super-telephoto lens is still going to be your best bet to get a close-up shot of these creatures (see Figure 1.2).

TIP Consider renting gear if you want to try new equipment, such as a super-telephoto lens. Whether you want to try something before buying or only have an occasional use for an expensive piece of gear, local or online rentals are a great option. Make sure to give yourself enough time to practice with the rental gear if you have never used it before.

1.1 A large stone elephant head adorns the Zoo Center (see A on the map). Taken on a wet, winter afternoon at ISO 1000, f/5.6, 1/80 second with a 70-200mm lens.

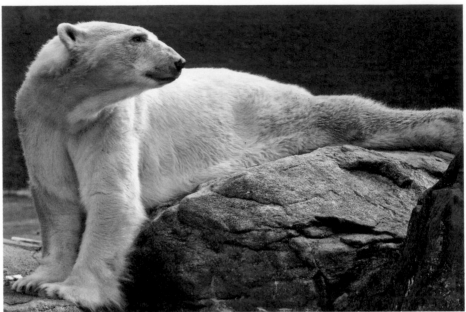

1.2 A polar bear relaxes by his swimming hole on a late winter afternoon. Taken at ISO 400, f/6.3, 1/400 second with a 300mm lens and 1.4x teleconverter.

Congo Gorilla Forest

This 6.5 acre rainforest is home to more than 20 western lowland gorillas. The outdoor exhibit takes you through a range of views, from the forest floor to treetop lookouts. During colder months you can still photograph the gorillas in their indoor habitat, but the warmer months bring them back out to the forest environment.

Bring your telephoto to super-telephoto lenses to capture the gorillas up close (see Figure 1.3). A standard zoom lens lets you create images of them amongst their families.

JungleWorld

The indoor JungleWorld exhibit re-creates an Asian jungle with over 800 animals on display. This warm and humid environment is home to an army of assorted apes, tapirs, and a variety of jungle insects.

A telephoto zoom lens is a great choice here, because you can get close-up images when fully zoomed in or include a few animals in the frame at the short telephoto end (see Figure 1.4).

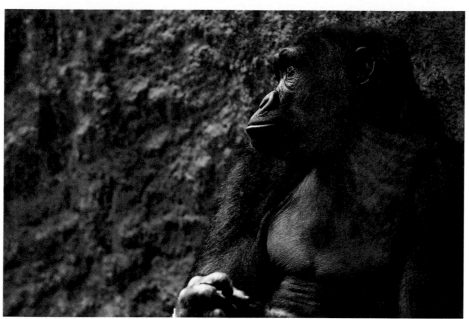

1.3 A gorilla in repose at the Congo Gorilla Forest (see C on the map). Taken at ISO 2000, f/4, 1/30 second with a 300mm lens.

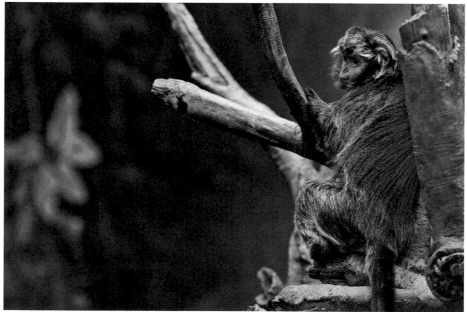

1.4 An ebony lemur hangs out inside JungleWorld (see D on the map). Taken at ISO 1600, f/4.5, 1/320 second with a 300mm lens.

Tiger Mountain

Tiger Mountain showcases not only the endangered Siberian tiger but also the zoo's enrichment program. The keepers use toys, training, and games three to four times a day to keep the tigers in shape and stimulated.

Although you can get relatively close, a telephoto zoom or super-telephoto lens is your best choice, so you can fill the frame with your subject (see Figure 1.5).

The feeding and enrichment programs are a great time to visit an exhibit. Arrive 15-20 minutes before the scheduled start time because the animals are often most active when they know feeding or play time is coming. Check the zoo's Web site for daily schedules and incorporate them into your plans.

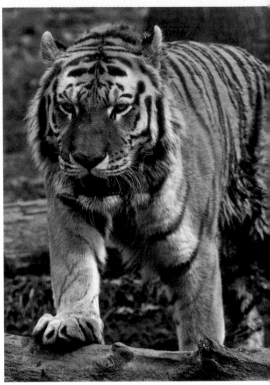

1.5 A tiger prowls at Tiger Mountain (see E on the map). Taken at ISO 400, f/7.1, 1/500 second with a 300mm lens.

Sea Bird Aviary

Next to the indoor Aquatic Bird House, the outdoor Sea Bird Aviary is home to Magellanic penguins and other birds native to the Patagonia region of South America. The penguins swim and walk across the lands and are very active at their daily feeding time. The whole area is enclosed in netting with many birds in flight.

This exhibit offers a spectacular opportunity to practice avian photography, a popular and challenging photographic discipline (see Figure 1.6).

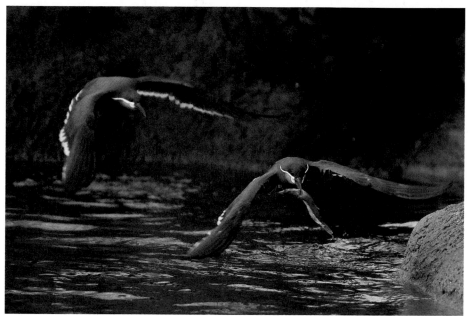

1.6 Inca terns in the Sea Bird Aviary on a blustery winter afternoon (see F on the map). Taken at ISO 640, f/2.8, 1/1250 second with a 70-200mm lens.

How Can I Get the Best Shot?

Just as the eyes are the window to a person's soul, the same is true for animals. An image with the eyes in perfect, sharp focus draws your viewer's attention every time. To create a more natural composition, shoot at the animal's eye level if at all possible. Also, because you generally can't comply here with the adage of *take two steps closer*, you want to consider a longer lens than you might initially expect. Your subject should fill the frame, and at most exhibits, you need a telephoto zoom lens to accomplish this.

When creating your composition, be extra vigilant for intruders in the edges of the frame. You want to create a shot that looks like it could have been taken on a safari, not in a zoo. Finally, the intangibles may be the biggest challenge. All the animals at the zoo have a mind of their own. Although you may have a photo you want to take, a gorilla may have another idea altogether! Lots of patience is required if you want the perfect shot (see Figure 1.7).

Equipment

A number of lenses are available to create great images at the zoo. Tripods and monopods are also allowed at most exhibits.

Lenses

There are many choices available when selecting a lens or lenses to bring to the zoo. While many options are outlined below, including some more expensive options, good photos are available at the zoo with any camera and lens combination.

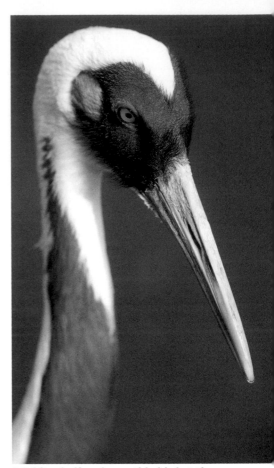

1.7 After half an hour, this bird at the Northern Ponds finally wandered close enough for a full-frame headshot. Taken at ISO 640, f/4.5, 1/2000 second with a 300mm lens.

- ► **A standard zoom lens in the 24-105mm range.** A standard zoom can be useful for shooting some of the indoor exhibits. These lenses often offer a close minimum focusing distance, which is great for animals just on the other side of a glass enclosure. Their small size and weight make them easy to keep in a bag when not in use.

- ► **A telephoto zoom in the 70-200mm range.** A standard telephoto zoom lens in the 70-200mm range is a great place to start your quest to get close to the animals. These lenses are often available with image stabilization, which means they can be handheld even at longer focal lengths that might otherwise require a tripod.

There are longer telephoto zoom lenses available from most manufacturers as well, up to 400mm at the longer end and 500mm if you go with a third-party brand. These end up getting a bit more difficult to handhold, requiring a tripod or monopod to create sharp pictures.

▶ **A telephoto or super-telephoto prime lens.** Beyond 200mm, consider a prime lens instead of a zoom. These tend to have larger apertures than equivalent zoom lenses, offering a faster shutter speed and better background blur, or *bokeh*. You can find reasonably priced lenses for the non-specialized professional available up to 400mm, although they are still not inexpensive. Consider planning ahead and renting a longer lens if you would like to try one at the zoo.

▶ **A 1.4x or 2x teleconverter.** In some cases, a 1.4x or 2x teleconverter can be a good alternative to a super-telephoto lens. Although you lose a bit of light and sharpness, many lenses, such as the 70-200mm zoom lens will still produce excellent images. As a general rule, use a teleconverter by the same manufacturer as the lens with which it is paired.

Filters

A polarizing filter can be very useful at the zoo. The most typical benefits of a polarizer are more saturated colors in the sky and foliage due to reduced reflections. At the zoo, you will also see the benefits of using a filter when you are shooting animals in the water. By cutting the reflections off the water's surface, you can photograph animals partially or fully underwater.

Extras

There are a number of extras that can be beneficial for a trip to the zoo. The first is a tripod or a monopod to help hold your camera steady, especially when using a longer lens. The monopod provides greater mobility, but the tripod offers the most stability. Some exhibits do not allow such an accessory, so be sure to have a way to carry it comfortably; a shoulder strap or belt hook works well. Even when you are shooting during the daytime, a flash can be a key component to a great shot. By using a fill flash, you can help fill in the shadows under an animal's eyes and create a catchlight. Both of these serve to draw your viewer's attention to your subject's gaze (see Figure 1.8). There are also flash accessories called *flash extenders* that magnify your flash for even far-off subjects.

For indoor images, you may want to bring a pocket gray card to help ensure proper white balance. Finally, a good way to carry this equipment is very important. A backpack, belt pack, or shoulder bag can all offer the extra space needed while being comfortable enough to carry all day. When choosing a bag, consider comfort but also ease of use and accessibility.

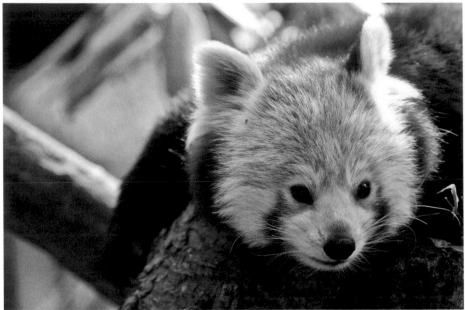

1.8 An accessory flash with an extender added some light to a red panda's face and created catchlights in his eyes. Taken at ISO 400, f/6.3, 1/200 second with a 300mm lens and 1.4x teleconverter.

Camera settings

There are two main setups for capturing images of animals at the zoo. The first is for fast-moving subjects, such as birds or sea lions. The second setup is for more sedentary animals, such as tigers or bears. In either scenario, a low f/stop creates a shallow depth of field, reducing distractions in the background of your frame.

Fast-moving subjects

The movement of these animals means that you need to ensure a constantly adjusted focus and a sufficiently high shutter speed to freeze their movements. Don't get discouraged when you have some shots that don't come out. Many of your images may not be sharp or even in focus. But when you get *that shot* of a bird in flight or a sea lion leaping from the pool, the effort will be worth it (see Figure 1.9).

▶ **Exposure mode.** Because your subject is moving quickly, you will need to ensure a sufficiently high shutter speed to freeze the motion. Shutter Priority mode allows you to set your shutter speed, and the camera's internal meter sets an appropriate aperture and ISO. Start at 1/500 second, shoot a few

images, and review them to check for sharpness. Keep increasing the shutter speed until you find that you are able to freeze the action.

▶ **Focusing mode.** Use your camera's continuous focusing mode when tracking moving subjects. This mode not only tracks your subject by constantly adjusting the focus but actually predicts where the focus should be in the brief moment it takes to depress the shutter button and release the shutter.

▶ **Image stabilization.** Make sure that your lens offers Mode 2 image stabilization, which disables the feature in the direction you are panning. Otherwise, disable image stabilization completely. Your very high shutter speeds mostly obviate the need for this feature in this scenario.

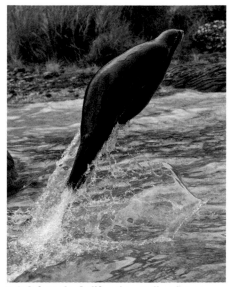

1.9 A female California sea lion leaps from the water during an afternoon enrichment session on a rainy winter afternoon. Taken at ISO 800, f/4.5, 1/1600 second with a 70-200mm lens.

▶ **File format.** Although RAW format files give you the most latitude in the digital darkroom, they are larger and cause your camera's buffer and memory card to fill up faster. If you find that your camera is unable to keep up with your shooting, consider utilizing high-quality JPEG format instead.

▶ **Drive mode.** Trying to predict when to take a single shot of a fast-moving subject is difficult. Use your camera's continuous burst mode instead to shoot a number of photos before, during, and after the decisive moment.

▶ **White balance.** Utilize your camera's white balance presets as appropriate. These presets are very reliable outdoors. Indoors, in mixed lighting, use a pocket gray card to dial in the proper white balance.

▶ **ISO.** Always try to use the lowest ISO possible that still allows a sufficient shutter speed and aperture combination. Doing this minimizes the potential for digital noise in your images. ISO 200 to 400 on most days should be sufficient, although 800 or even higher might be required if you are using an exceptionally high shutter speed.

Slow-moving subjects

For the slower moving subjects, you can focus more on the animals' expressions and composition in the frame while utilizing a much simpler set of settings. You still need to be quick when you see the image you want. Being prepared when it arrives is important (see Figure 1.10).

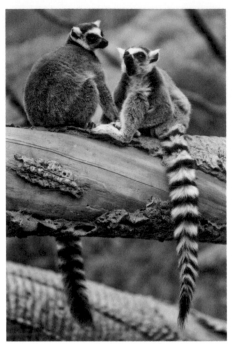

1.10 Two ring-tailed lemurs hang out in the Madagascar exhibit. Taken at ISO 1000, f/2.8, 1/80 second with a 70-200mm lens.

▶ **Exposure mode.** Although you will still use your camera's internal meter, for a slower-moving subject use Aperture Priority mode. This mode allows you to directly control the aperture, setting the depth of field as you like for a particular composition. The internal meter sets an appropriate shutter speed and ISO.

▶ **Drive mode.** You may still want to use your camera's burst mode even for more stationary subjects. Many of the animals may still make quick motions with their eyes or head, and having the ability to capture three to five images increases your chances of capturing the perfect shot.

▶ **White balance.** Use your camera's presets for white balance outdoors. Indoors, if the presets are not accurate in a mixed-light environment, use your pocket gray card. Shooting in RAW mode allows you the most latitude with the color settings in the digital darkroom.

▶ **ISO.** Keep your ISO as low as possible to minimize the digital noise. Outdoors, use 100-200 on a clear day and 400 if it is overcast. Indoors, many of the exhibits are fairly well lit, so you can start at 400 but don't hesitate to move to 800 or even 1600. A sharp picture with digital noise is better than a blurry picture without.

Ideal time to shoot

The zoo offers year-round photographic opportunities. Different animals are viewable and active at various times of the year. Check the Bronx Zoo's Web site for more details about what exhibits are open when you are visiting. Weekdays and the colder months are generally less crowded than weekends and the summertime. If

you plan on bringing a lot of equipment, you will have much more room to work and walk during off-peak times.

Many animals are very sensitive to weather conditions and may not be out in heavy wind, rain, or temperature extremes. The zoo's Web site has some of this information published, but you may need to call to get specific information for the day. However, plenty of indoor exhibits are open in all weather. Ensure that both you and your equipment are appropriately protected from the elements. Visit on a cold or rainy day and you may find you have the run of the zoo (see Figure 1.11).

Low-light and night options

There are numerous low-light and even nighttime indoor exhibits around the zoo. At some exhibits, you are not allowed to use your tripod, so you need to ensure your camera remains stable. Increase your ISO to 800 or 1600 and set your aperture to its largest setting. Look for something to help balance your camera against, such as a support beam or railing.

You can also put the front of your camera directly against the glass of the exhibit if that is an option, which not only serves to help stabilize the camera but to reduce any glare on the glass. Shoot in two- to three-shot bursts. The second image is often the sharpest because you aren't actively depressing the shutter.

Getting creative

Capturing the perfect composition relies on preparation and patience. After viewing an animal's habitat, try to visualize an image that you want to create. Look in the scene for the background and light that you want to create the image, and set up your camera to take that shot, including prefocusing. To prefocus, point the camera where the animal will be, press down the shutter halfway to focus on that spot, and then disable autofocus. The hard part now is to wait for and be ready when your subject comes into your frame.

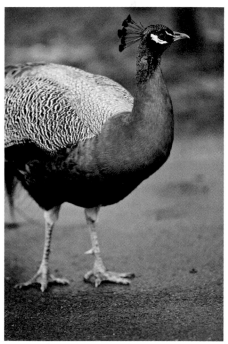

1.11 A friendly peacock approaches the camera at a nearly-empty Bronx Zoo on a rainy winter afternoon. Taken at ISO 1000, f/3.5, 1/125 second with a 70-200mm lens.

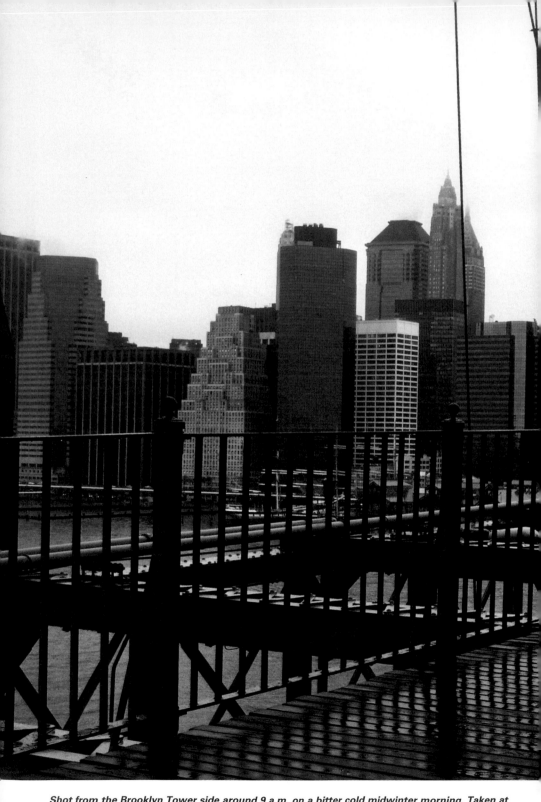

Shot from the Brooklyn Tower side around 9 a.m. on a bitter cold midwinter morning. Taken at ISO 100, 1/8 second, f/8, with a 28-200 lens at 40mm.

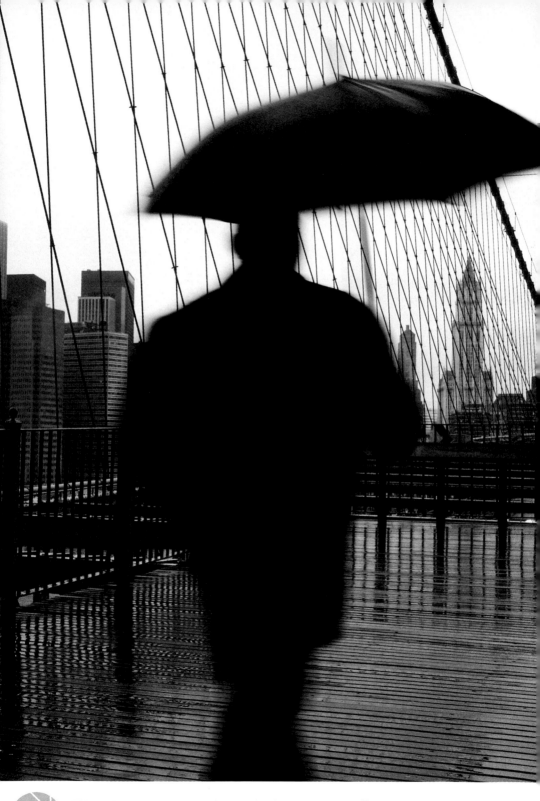

◉ The Brooklyn Bridge

Why It's Worth a Photograph

If you watch a television show or see a movie set in New York, chances are you'll see a scene that includes the Brooklyn Bridge. Built in 1883, the bridge is a visually appealing structure. From far away, directly underneath, or even on the bridge, you instantly know where you are: New York City. The Brooklyn Bridge presents many artistic choices for great photographs, so whether you're taking pictures to remember your trip to New York by, creating fine art images, or even producing commercial work, your images are sure to be eye-catching.

Where Can I Get the Best Shot?

The bridge runs from the southeastern shore of Manhattan to the east to Brooklyn. With its orientation and multitude of places to shoot from, no matter what time of day you're out, you can get great shots.

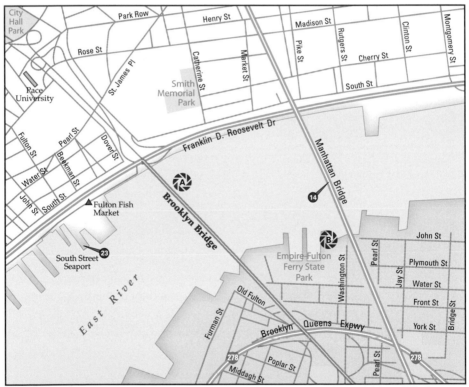

The best vantage points from which to photograph the Brooklyn Bridge: (A) the pedestrian walkway and (B) the Brooklyn Bridge Park. Other photo ops: (14) Manhattan Bridge and (23) South Street Seaport.

The pedestrian walkway

The pedestrian walkway (see Figure 2.1) by the Manhattan-side tower is a great place from which to shoot. With views of the East River, Brooklyn, South Street Seaport and the New York Harbor, you have a diverse range of backdrops for people photos or scenic shots. The bridge itself makes an excellent subject, and the flag-bedecked tower is a great shot to add to your collection.

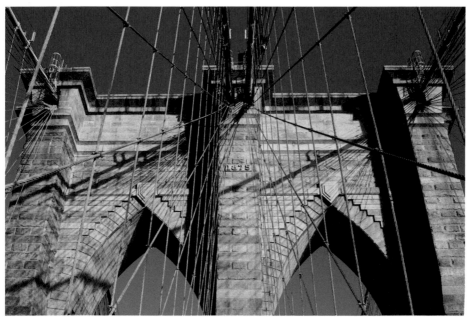

2.1 Detail of the Manhattan Tower of the Brooklyn Bridge shot early on a March morning (see A on the map). Taken at ISO 100, f/8, 1/400 second, with a 28mm lens.

The Brooklyn Bridge Park

Brooklyn Bridge Park (see Figure 2.2) offers a great shot just underneath the bridge on the East River. If it's a nice day and you've got the energy, walk across the bridge and exit down the pedestrian stairs on the Brooklyn side, and then, as you are facing Manhattan, walk toward the river and to the right of the bridge to get to the park. If you're pressed for time or tired, hop in a cab. Walk along the path toward the water; there's a railing just over some rocks that lead down toward the water, a perfect place to capture an impressive shot.

As of Jan 1, 2010, the western half of the park, Empire-Fulton Ferry, is closed for construction. However, the eastern half of the park, the Main Street Lot, offers equally stunning views of the Brooklyn Bridge. See BrooklynBridgePark.org for maps and more details.

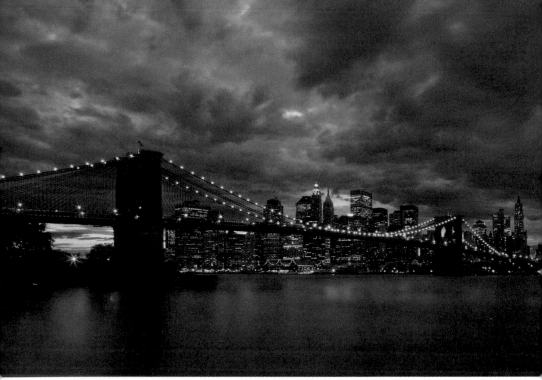

2.2 The Brooklyn Bridge from Brooklyn Bridge Park shot around 30 minutes past sunset on a late spring evening (see B on the map). Taken at ISO 100, f/22, 6 seconds with a 24mm lens.

How Can I Get the Best Shot?

The Brooklyn Bridge is a great environment because it offers wonderful, recognizable architectural photos, stupendous skylines of Brooklyn and Manhattan and an endless array of people traversing the structure. Being prepared with the right equipment and settings goes a long way towards being able to create the shot you may see in your mind's eye.

Visualizing the images you wish to create allows you to select appropriate equipment and choose where to shoot from to create that shot. However, don't hesitate to go out with a blank slate and see what you can create.

Equipment

Ensuring you have an appropriate selection of equipment, and not too much equipment, is important when planning a trip to the Brooklyn Bridge. You can easily end up walking a few miles going back, forth, and around the bridge so you want to have everything you need with you for this trip.

Lenses

The lenses that give the most utility when shooting the bridge are:

▶ **A standard zoom lens in the 24-105mm range.** This type of lens will offer you a great deal of flexibility when creating your images. You can go wide and capture the whole scene or use the long end of the lens to fill the frame with a more distant subject.

▶ **A telephoto zoom lens in the 70-200mm range.** This lens starts out at a short telephoto distance and gets longer from there. Excellent for picking out details, it also compresses the distances between foreground and background objects, making them appear closer together.

▶ **An ultrawide-angle lens in the 16-35mm range.** A truly wide-angle lens is very important to capture shots of the entire bridge unless you get quite far away.

Filters

There are two filters that are invaluable when photographing the Brooklyn Bridge: a circular polarizer and a 3- or 6-stop neutral density filter. Using the polarizer during the middle of the day, with the high, bright sun, can help minimize the reflections in the water and also give you a really rich, deep blue sky. Use the ND filters to have longer exposures during the day or even at twilight or dawn. Longer exposures over the water will create a creamy smooth water surface.

Extras

A bendable tripod, such as a Gorillapod, is a great thing to have with you. You also need a sturdy tripod, cable release, and lens hood for longer exposure shots.

Camera settings

How you set up your camera largely depends on what you are shooting. For general action on the bridge itself, use a relatively fast shutter speed, 1/250 second or faster. For scenic cityscapes, the depth of field is critical. Shoot in Aperture Priority (A or Av) mode on your dSLR so that you can control the depth of field.

Exposure

Today's cameras are really good at making great exposures, but it never hurts to be just a little smarter than your camera.

One thing that can cause problems is that the light from overhead during the day can be overpowering, which tells a camera to expose in a way that produces too-dark shadow areas. Or, depending on where you take the meter reading from, you may have good detail in the shadows and some blown-out highlights. Use exposure creatively, shooting long exposures to smooth the water, for example.

If you have to shoot during the harsher midday light, don't forget to watch out for blown highlights and white areas. Applying a little negative exposure compensation of around 1/3 stop helps alleviate these problems. But review your image and your histogram before moving on to that.

If you want elements in your shot to appear as sharp as possible, from foreground to the far, distant buildings, use a small aperture, such as f/11 or f/14. This technique is commonly called *stopping down* and results in the deepest depth of field.

During the brightest daylight hours, you can usually get away with these smaller apertures because your corresponding shutter speed will still be fast enough to handhold. As the light dwindles near sunset, shutter speeds typically get longer (see Figure 2.3) and a tripod becomes necessary.

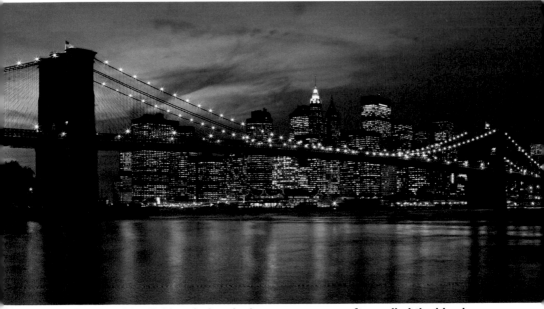

2.3 The Brooklyn Bridge during the hour past sunset, often called the blue hour, shot on a late fall evening. Taken at ISO 100, f/11, 10 seconds with a 24mm lens.

For best results, use the tried-and-true method of not using a shutter speed slower than 1/focal length. For example, if you are shooting at 200mm, don't go slower than 1/200 second; if shooting at 30mm, you can go to 1/30 second.

ISO

Don't be shy about raising your ISO on your camera as the light wanes. You can get some cool shots of people and the city as the light goes down. ISO 800 to ISO 1600 will allow you to handhold your camera and get sharp shots. Still, it's a good idea to do this only as much as you absolutely need to, because quality diminishes as ISO goes up, especially in most point-and-shoot cameras.

Today's newer dSLRs have superb quality at ISO 1600, 3200, and for some models, even higher. But raise the ISO just enough to shoot at hand-holdable shutter speeds to minimize digital noise.

Ideal time to shoot

Sunset and the blue hour (that gorgeous light that comes just after sunset) are fantastic from the Brooklyn side. Any time of the year, you can get some really spectacular images, if the weather cooperates. If you can't get there for sunset, don't sweat it. You can go to the Brooklyn Bridge any time of day and shoot.

In cold weather, look for ice in the East River that makes for great photographs — catch it early in the morning if the weather is cold enough. If you get really lucky, you can capture frost webs on the cables of the bridge. For the sunset shot from the Brooklyn side, remember that clouds and changing weather are your best friends, so don't be shy about making the effort for that shot if the weather is going to be questionable. Rain can make for dramatic light; it causes people to wear colorful rain gear, and of course, produces reflections (see Figure 2.4)! Carry an umbrella and have a few zipper bags or even a plastic trash bag to cover up your gear in case of heavy rain.

Low-light and night options

If the sky is right when shooting from Brooklyn Bridge Park, you'll have a wall-hanger. Don't forget; stay 30 or 60 minutes post-sunset to shoot in twilight. Shoot in Manual mode, f/11 or f/14, and continue to adjust your shutter speed as the light fades.

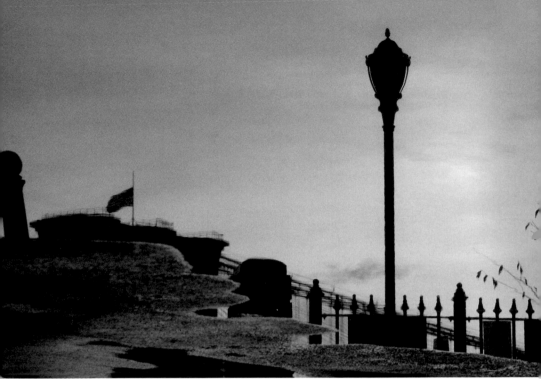

2.4 Reflection of the Brooklyn Bridge from Brooklyn Bridge Park shot on a rainy fall afternoon. Taken at ISO 100, f/1.7, 1/800 second at 100mm with a 24-105mm lens.

If you can shoot at smaller apertures like f/14, f/16, or f/22, you can get the star effect on the lights of the bridge. It's not unusual to have 6- or 8- or 10-second exposures. Here's where a neutral density filter has importance. Even if there's still tons of light coming from the setting sun, you can still obtain a long exposure of 10 seconds or more (see Figure 2.5). The long exposure helps to smooth the water, making for a really dramatic shot.

Getting Creative

Using an ultrawide-angle lens can create interesting effects when shooting large pieces of architecture. Try getting as close to the base of the bridge as possible and shoot different angles with a wide-angle or fisheye lens. This perspective will greatly exaggerate the feeling of size of the structure, especially if you shoot up or at an angle on the bridge.

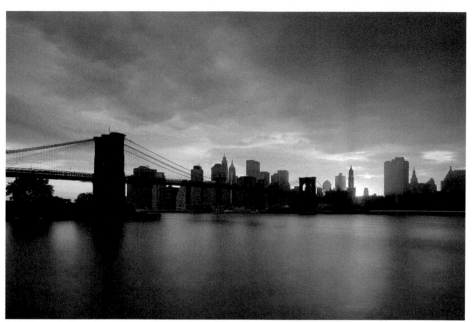

2.5 Sunset, Brooklyn Bridge from Brooklyn Bridge Park shot just at sunset on a June evening. Taken at ISO 100, f/22, 10 seconds, using a 6-stop neutral density filter on a 24mm lens.

The front of Castle Clinton during a winter snowstorm. Taken at ISO 400, f/4.5, 1/80 second with a 40-170mm lens.

3 Castle Clinton

Why It's Worth a Photograph

Castle Clinton is a cornerstone of Manhattan's Battery Park located on the southern tip of the island. Built between 1808 and 1811, this circular fort was originally intended to defend New York City from British forces. Throughout its history, it has been a theater, immigration station, and public aquarium. Today, it is a national monument and serves as the ticketing station and Manhattan embarkation point for the Statue of Liberty ferries. Beyond the interesting structure of the fort, the waterfront and surrounding Battery Park offer excellent vantage points for the harbor, Staten Island Ferry, and Statue of Liberty at sunset. Adjacent to the structure is a myriad of monuments and memorials along with beautiful gardens and trees to incorporate into your imagery. This historic location is rich with opportunities to create beautiful photographs.

Where Can I Get the Best Shot?

There are three locations where you can get the best shots: the exterior of the fort, the interior of the fort, and on the waterfront.

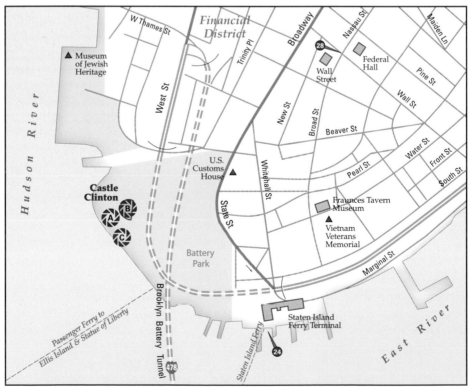

The best vantage points from which to photograph at Castle Clinton: (A) exterior, (B) interior, and (C) on the waterfront. Other photo ops: (24) Staten Island Ferry Terminal and (28) Wall Street.

The exterior

The outside of Castle Clinton provides opportunities to take photographs of the fort itself and include aspects of the park. In the spring, the blooming trees offer a wonderful foreground contrast to the sandstone construction of the fort. Much of the year the sun sets over the building, giving you the chance to include the beautiful sunset in your images.

Most of these shots can be accomplished with a standard zoom lens on your camera. This lets you move around and travel light while trying a range of compositions around the fort (see Figure 3.1).

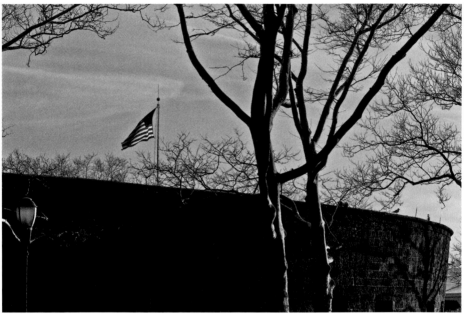

3.1 Castle Clinton's southwest side is shadowed by trees on a cold winter afternoon (see A on the map). Taken at ISO 100, f/16, 1/100 second, -1 EV with a 70-200mm lens.

The interior

Inside, opportunities abound to create detailed images of this historic building. Canons look out upon the harbor through 200-year-old windows. A recently unearthed section of wall sits in the middle of the fort's interior next to the Statue of Liberty cruise ticketing office.

Focus on exploring the historic minutiae to minimize the inclusion of tourists or the modern components of the interior in your photos. A macro lens lets you get close and fill the frame, and a standard zoom lens offers you the most freedom while moving around this small area (see Figure 3.2).

3.2 An antique canon watches over a southeasterly window on a blustery winter day (see B on the map). Taken at ISO 800, f/4.5, 1/100 second, -1 2/3 EV with a 16-35mm lens.

On the waterfront

Because Castle Clinton is situated on the waterfront of New York Harbor, exquisite views are available, from the Staten Island Ferry to the Statue of Liberty to Governors Island. As the park faces southwest, the sun sets straight out over the Statue of Liberty in the winter and Ellis Island in the spring and fall.

A wide-angle lens lets you capture an encompassing view of the harbor or include foreground components, such as the fort itself. A telephoto lens gives you the ability to isolate distant subjects such as ships coming through the harbor (see Figure 3.3).

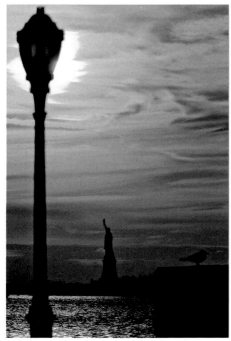

3.3 The sun sets over the upper bay, creating silhouettes on a winter afternoon (see C on the map). Taken at ISO 100, f/11, 1/3200 second, -2 EV with a 70-200mm lens + 1.4x multiplier.

How Can I Get the Best Shot?

Being located in a public park means you have more freedom than some other locations to bring gear if you want to try a range of shots. However, if you are visiting on your way to the Statue of Liberty, you will have to pass through multiple security checkpoints and cannot bring bags inside the statue proper.

The sunset is a wonderful time of day to visit, first offering the great light of the golden hour and the sun setting over the water. Although shooting into the sun can be challenging, doing so can also be quite rewarding when done carefully. You can shoot HDR imagery to increase the dynamic range available, or embrace it and create beautiful silhouettes (see Figure 3.4).

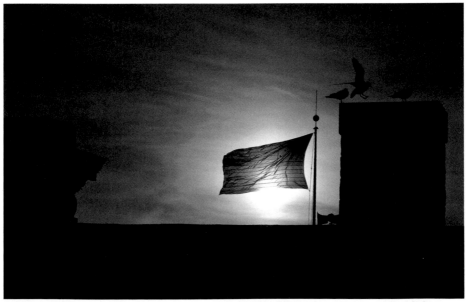

3.4 The setting sun silhouettes the flag over Castle Clinton's entrance while birds come down to roost. Taken at ISO 100, f/16, 1/4000 second, -2 EV with a 70-200mm lens.

Equipment

There are many lens options depending on what kinds of photographs you are looking to create. Remember that you still have to carry your gear to and from the site, however. Choose one or two lenses for a single trip so that you can focus on creating a few great images.

Lenses

▶ **A standard zoom in the 24-105mm range.** This powerful multipurpose lens may be all that you need to create your images. It allows wide-angle shots as well as medium telephoto perspectives. Often, these lenses offer some basic macro capability, giving you the ability to isolate details inside the fort.

▶ **A telephoto zoom in the 70-200mm range.** This longer lens is great for pulling in details from a distance and compressing the features in the frame (see Figure 3.5). As the focal length increases, the narrow perspective causes far-off objects to appear closer to the foreground subjects.

3.5 The New York Korean War Veteran's Memorial in front of the setting sun and the Statue of Liberty on a chilly winter evening. Taken at ISO 100, f/16, 1/400 second, -4 EV with a 70-200mm lens.

▶ **A macro lens.** A macro lens with the capability to obtain 1:1 magnification is useful to explore the details of the castle. The sandstone has a wonderful look on its own, or to combine with other images in the digital darkroom to give them a textured feel.

Filters

A polarizing filter can help deepen a blue sky or cut through the haze of a humid day. It also reduces glares from a reflective monument or the harbor water. A neutral density filter, or its counterpart the graduated neutral density filter, is great for shooting from the waterfront on a tripod. You can slow down your shutter speeds enough to smooth out the water to a glasslike finish or impart a sense of motion to the ships moving across the waters.

Extras

A tripod is a good tool if you want to shoot images from the waterfront, especially when utilizing the neutral density filters. You can carry it in and around the park but if you are then departing to the Statue of Liberty, you may have trouble getting into the statue itself or fitting it in the storage lockers on Liberty Island. If you want to really reach out into the harbor to take photos, a teleconverter can give you that extra zoom with your existing lenses.

Camera settings

Shooting at sunset and twilight can present a challenge to your camera's internal light meter, so you may need to use exposure compensation or shoot bracketed shots to ensure that you are getting the correct exposure. If you are shooting far-off images and intend to crop later, center the area that you intend to crop as much as possible in the frame. The center of your lens provides the sharpest images and the most latitude when cropping in the digital darkroom.

Exposure

Most exposures should be straightforward using your camera's internal metering. When including the setting sun in your images, be aware of the huge dynamic range in the image and compensate for the meter being fooled by the brightness of the sun. As the sunset fades into the blue hour and twilight, use your tripod to keep the camera steady for the longer exposures.

Aperture Priority mode gives you the most control over your depth of field while utilizing the camera's meter to get your exposure. Using the exposure compensation dial lets you adjust for shooting into the sun. If you want to create a silhouette with the sun and keep more details in the sky, decrease your exposure compensation by two stops.

White balance

Using your camera's Auto white balance or presets for Cloudy or Sunny will get you very close to the correct setting in camera. Shoot in RAW mode and tweak the settings in the digital darkroom for the exact look you want.

ISO

Use the lowest available ISO for the shot that you are creating. ISO 100-200 will generally work outdoors, while 400 or higher might be needed on a cloudy day or inside in the shade (see Figure 3.6).

3.6 The 200-year-old sandstone windows offer photogenic textures and shapes. Taken at ISO 800, f/5.6, 1/15 second with a 16-35mm lens.

Ideal time to shoot

The park's beautiful flowers and trees are at their peak in the springtime. The sunset is visible from the waterfront from late summer to early spring, finally moving a bit far to the north around the summer solstice.

Open year-round and in all weather, Castle Clinton can be photographed in many different types of weather. The building is only partially covered, so be aware that it does not provide much cover in the rain or snow. Be sure to check the weather forecast before visiting so that you can choose to reschedule or prepare appropriately for any inclement weather.

Low-light and night options

Bring your tripod and keep shooting as the sun sets and twilight descends into night. Watch the park's lighting showcase the fort and the monuments. You can also turn your camera around and take images of the lit-up buildings of Wall Street.

Getting creative

Try combining multiple elements in the frame to give your images a sense of depth and presence. Instead of just a straight-on shot of the building, include the surrounding trees and flowers. Or use the Statue of Liberty as a powerful background element instead of the main subject. When shooting with the sunset, try creating an HDR image in the digital darkroom to increase the dynamic range of the scene.

Façade of the Cathedral Church of Saint John the Divine on an overcast February afternoon. Taken at ISO 64, f/2, 1/30 second with a 28mm lens.

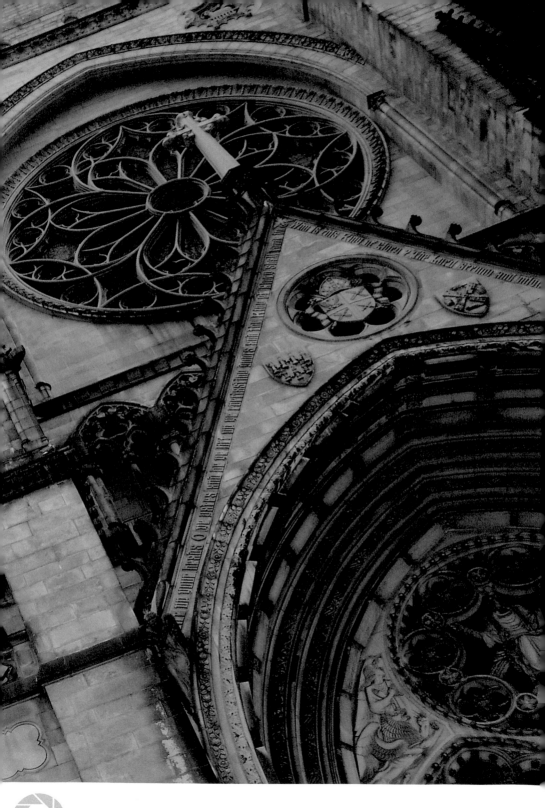

The Cathedral Church of Saint John The Divine

Why It's Worth a Photograph

There are two great reasons to shoot this cathedral: It is incredibly beautiful, and it is very photographer friendly.

Standing in front of the Cathedral Church of Saint John the Divine, you can't help but feel transported to one of the great cities of Europe. Covering more than half a city block, it is one of the largest Gothic cathedrals in the world. This church gives you the opportunity to make creative architectural shots on a grand and close-up scale.

Where Can I Get the Best Shot?

The cathedral is a bit off the beaten track. You won't really see this magnificent building unless you actually plan for it. It's just a 15-minute subway ride from midtown (take the 1 or 9 train to 110th Street). Once there, you have a chance to shoot this magnificent building from the front, and also inside.

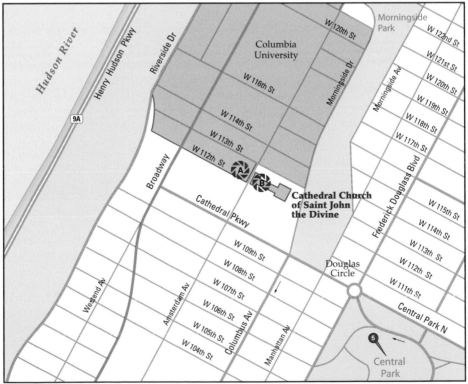

The best vantage points from which to photograph the Cathedral Church of Saint John the Divine: (A) 112th and Amsterdam Ave and (B) interior of the cathedral. Other photo ops: (5) Central Park.

TIP Be sure to plan your visit around the church's scheduled services. Guided tours are also available, where you can explore some of the areas not generally accessible to the public. I recommend the Vertical Tour. See the church's Web site at www.stjohndivine.org for more information.

112th and Amsterdam Avenue

The cathedral, sitting on the corner of 112th Street and Amsterdam Avenue, is stunningly large. Getting the whole thing in one shot is difficult. For a single shot, the best location is going to be directly across from the cathedral, on the other side of Amsterdam Avenue. This vantage point gives the best view of the front of the cathedral (see Figure 4.1).

Even still, you may not be able to get the whole thing into a single shot without an ultrawide-angle lens. This is where creativity comes into play. Using a wide-angle lens, create an interesting composition exploring just a piece of the vast façade. With a creative crop, you can convey the details and size of the structure. While you are here on the steps of the Cathedral Church of Saint John the Divine, take the time to explore the amazing details (see Figure 4.2).

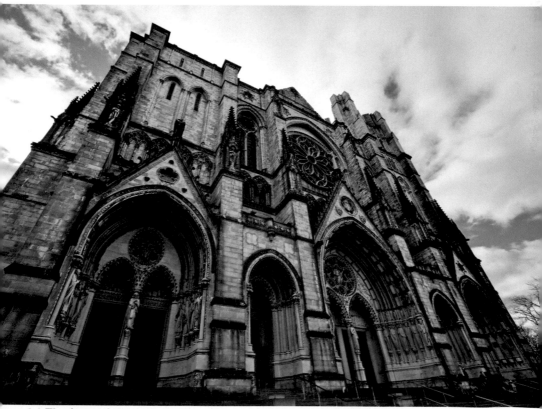

4.1 The front of the cathedral (see A on the map). Taken at ISO 200, f/9, 1/50 second.

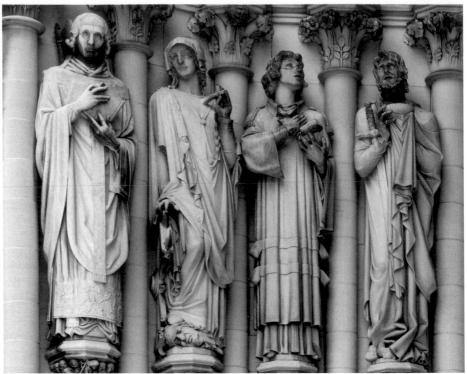

4.2 Statuary carvings, front steps of the cathedral on an early spring afternoon. Taken at ISO 64, f/5.6, 1/40 second with 35mm lens.

Interior of the cathedral

The first stop inside the cathedral will be the security checkpoint. There are beautiful details to be photographed everywhere you look inside the church (see Figure 4.3). Tripods are usually allowed, but be mindful of the crowds around you when setting up for your shots.

How Can I Get the Best Shot?

When photographing the church, start from farther out and move in close, creating images all the way. Coming closer and closer will force you to try different compositions and explore the details in different ways. Don't worry about having people in your images; the worshippers in the pews provide a sense of place and scale.

Equipment

There are a variety of options available to bring to the cathedral, but it is one of those subjects where you don't want your equipment to get in your way of the experience

and location. Consider bringing a single lens and possibly a tripod, and then plan to come back again with a different lens should you wish to create more images.

4.3 Rear of the chancel (see B on the map) at midafternoon. Taken at ISO 64, f/8, 2 seconds with a tripod and a 28-135 lens at 28mm.

Lenses

▶ **A standard zoom lens in the 24-105mm range.** A multipurpose zoom lens allows you to create images with a variety of focal lengths without being forced to carry and change multiple lenses. These lenses usually offer a basic macro functionality so you can get close to the interesting details scattered about the church. Image stabilization is also available on many models of standard zoom lenses, which is beneficial in low-light environments such as the inside of the church.

▶ **An ultrawide-angle zoom lens in the 16-35mm range.** Shooting large subjects in a confined area, either indoors or out, an ultrawide-angle lens can help you capture the entire subject in the frame.

▶ **A fast prime lens.** With so little light, having a prime lens with a very low f/stop in the f/1.2 to f/1.8 range is useful. These lenses, often available around the 35mm, 50mm, and 85mm focal lengths, allow you to shoot indoors with no flash and explore the natural light that filters throughout this regal building.

Filters

Outside, a neutral density filter can help cut reflections off of windows and deepen the blue of the sky. The darkened sky serves to increase the contrast between building and background and can help the church really stand out. Inside, you want to remove all filters, even a UV or Haze filter. When shooting in low-light environments such as the inside of this cathedral the chance for distortion or reflection caused by any additional filters is much higher than outside in the midday sun.

Extras

The cathedral is usually very dark, so a tripod is essential; you'll be using longer exposures than can be handheld. With such beautiful detail in this building, making sharp images is a must.

Camera settings

Remember that a sharp, noisy picture is better than a blurry, clean picture. Making certain you have the correct exposure and ISO will go a long way in ensuring you have the sharpest image possible.

Exposure

Shoot in Aperture Priority mode to have direct control over your depth of field. This is especially important when trying to get close-up images of a subject with a distracting background. In this case, use a very large aperture of f/3.5 or larger if your lens supports it. This will isolate your subject by throwing the background out of focus. For the wider shot of the whole sanctuary, chancel, or stained glass windows, set a smaller aperture of f/8 to f/11 to keep as much in focus as possible.

ISO

It's going to be very dark, no matter the weather outside. If shooting handheld, you need to set your ISO to 1600, or 3200 if your camera supports it. Remember that your camera's image quality will improve with lower ISO settings. If shooting from a tripod, reduce your ISO as low as possible to ensure the cleanest digital file.

Ideal time to shoot

Late-morning to midafternoon allows as much light as possible to enter the cathedral's regular and stained glass windows (see Figure 4.4). The cathedral is open year-round with hours posted on their Web site.

The weather outside will do little to impact your ability to shoot the inside of this grand building. A rainy day may help you to obtain shots with less people if you wish to focus on the architecture.

4.4 Late light through the windows. Taken at ISO 1600, f/1.4, 1/40 second.

Low-light and night options

The cathedral opens near sunrise and closes near sunset much of the year. Take advantage of this timing to capture the beautiful light of these times of day. After sunrise, the sun rises behind the building, backlighting it and creating some interesting silhouettes. The glowing light of the setting sun will provide incredible colors and shadows across the intricate face of the building.

Getting creative

Consider context and story when you create your images. Regardless of your own religious beliefs or lack thereof, knowing the context of why the cathedral was created and what draws people there today can help you to create images with impact and power.

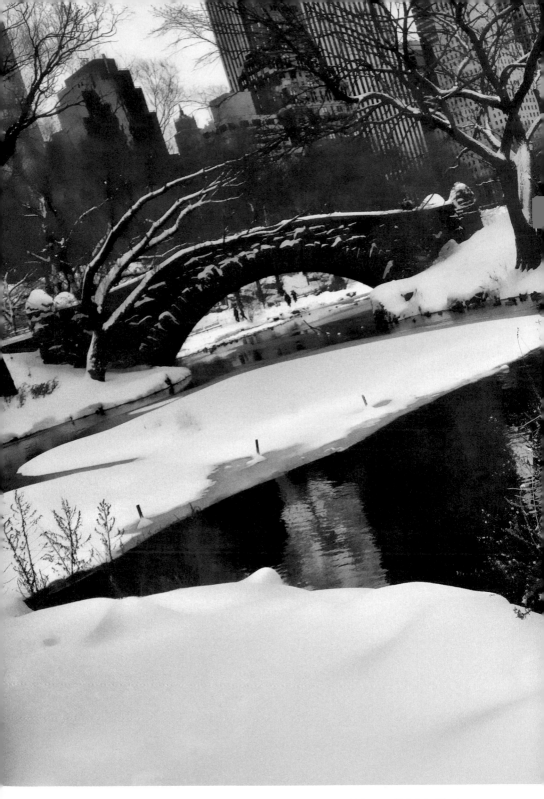

Gapstow Bridge over the Pond on a snowy winter morning. Taken at ISO 200, f/7.1, 1/250 second with a 24-105mm lens.

5 **Central Park**

Why It's Worth a Photograph

Central Park is an oasis of nature in the middle of Manhattan. The park occupies over one square mile from 59th Street all the way to 110th Street. Over 25 million people visit the park every year to walk the many miles of paths, ice skate at Wollman Rink, hike in natural woods, and unwind in the many gardens. Central Park is an escape from the constant hustle of the city as well as a great place to explore with your camera.

The frequent juxtaposition of nature and city can help you create compelling images, and the well-manicured flowers and trees offer nature photographs. Images of some of the landmarks in Central Park are iconic and instantly recognizable. However, the park's size ensures that there are innumerable hidden corners to point your camera at as well. Whether for a relaxing afternoon of exploration or an early morning trip to beat the crowds to an often crowded destination spot, Central Park is a wonderful place to make photos.

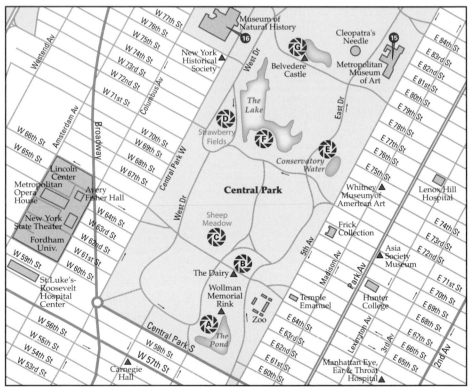

The best vantage points from which to photograph Central Park: (A) the Pond, (B) the Dairy Visitor Center, (C) Sheep Meadow, (D) Strawberry Fields, (E) Conservatory Water, (F) at the Lake, and (G) Belvedere. Other photo ops: (15) Metropolitan Museum of Art and (16) American Museum of Natural History.

Where Can I Get the Best Shot?

You can find a multitude of fantastic photo opportunities in Central Park. The best places to capture a great shot are at the Pond, from the Dairy Visitor Center, at Sheep Meadow, at the Conservatory Water, in Strawberry Fields, at Belvedere Castle, and at the Lake.

The Pond

Located in the far southeastern corner of the park near the Wollman Rink, the Pond and its signature Gapstow Bridge greet many of the park's visitors (see Figure 5.1).

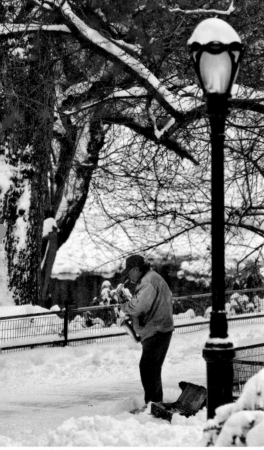

5.1 A saxophonist plays at the foot of Gapstow Bridge in the early morning after a big snowfall in late fall (see A on the map). Taken at ISO 200, f/3.5, 1/1000 second with a 70-200mm lens.

The bridge is an icon, so any image with it will be recognizable to anyone who has visited the park. The proximity of the city and eye-catching buildings, such as the chateau-style Plaza Hotel offer an interesting juxtaposition for your images. A standard zoom lens offers you the greatest flexibility when creating images of and around this beautiful corner of Central Park.

Dairy Visitor Center

A short walk north from the Pond and Wollman Rink, the Dairy Visitor Center is a good place to begin a serious exploration of Central Park. Inside, you find a shop with maps and guides and a large three-dimensional relief map of the entire park. Outside, the Dairy building and the surrounding areas are great photo ops (see Figure 5.2).

Utilizing a standard zoom lens with wide-angle and telephoto options gives you the greatest range of choices when exploring the images in this section of the park.

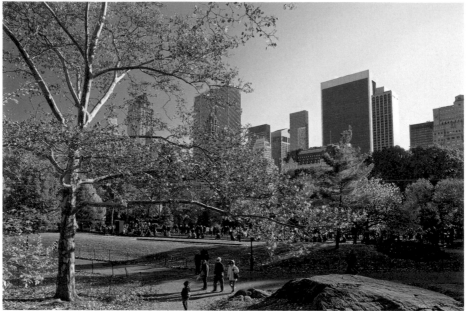

© Patrick Batchelder

5.2 A view of the midtown Manhattan skyline seen from Central Park near the Dairy and Wollman Skating Rink on an autumn afternoon (see B on the map). Taken at ISO 100, f/5.6, 1/30 second with a 25-60mm lens.

Sheep Meadow

Sheep Meadow was originally designed as a military parade ground and actually housed sheep from 1864 until 1934. It is second in size only to the Great Lawn as the largest open space in the park. As many as 30,000 visitors a day flock to this greensward with spectacular midtown views.

A multifunctional standard zoom lens offers you the ability to capture wide, sweeping scenes of the often crowded grass against a backdrop of distinctive New York City buildings. Alternatively, the telephoto end of the zoom lets you isolate individual subjects (see Figure 5.3).

Strawberry Fields

Strawberry Fields is a memorial to the musician John Lennon. A peaceful and quiet park, the memorial was dedicated in 1985 directly across from the Dakota Apartments. The only direct tribute to Lennon is the mosaic near the west side entrance with the single word *IMAGINE* in the center.

However, the 2.5 acre landscape is a tranquil and beautiful place in which to be inspired. If you are creating an image of the mural, get low to create a feeling of depth instead of shooting it straight down or from a standing position (see Figure 5.4).

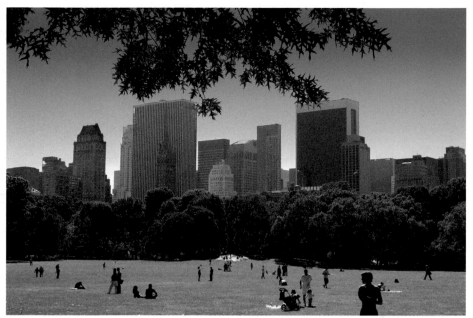

© Bruce Sawle

5.3 Sheep Meadow plays host to families, sunbathers, and more on a clear fall morning (see C on the map). Taken at ISO 100, f/16, 1/60 second with a 24-105mm lens.

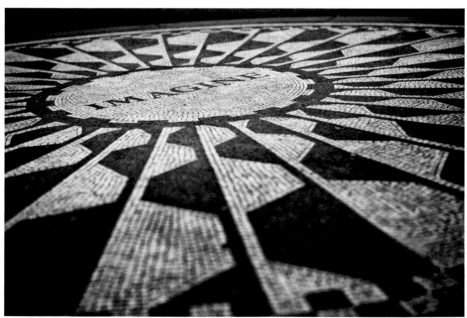

5.4 The IMAGINE mosaic at Strawberry Fields (see D on the map). Taken at ISO 320, f/2.8, 1/800 second with a 24-70mm lens.

Conservatory Water

Often called the Model Boat Pond, this water feature sits in a beautifully land-scaped section of the park. Pilgrim Hill on the south is covered with a wide variety of beautiful trees that flower in the spring and turn fantastic shades of red, yellow, and orange in the fall. The flotillas of model boats that crisscross the pond from spring until fall make a fantastic photo opportunity (see Figure 5.5).

The Lake

The second largest body of water in Central Park, the Lake's 18 acres and the sur-rounding Ramble are a great place for exploration. The shore of the Lake twists and turns, creating many small coves with rocky outcrops and overhanging trees. The narrowest point is spanned by the Bow Bridge with a great view of the Central Park West skyline (see Figure 5.6). The Ramble is a natural woodland walk on the

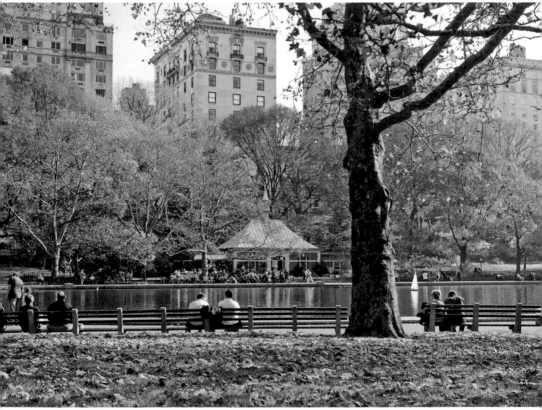

© Patrick Batchelder

5.5 Central Park on an autumn afternoon with the boathouse at the Conservatory Water (see E on the map). Taken at ISO 100, f/5.6, 1/40 second with a 25-60mm lens.

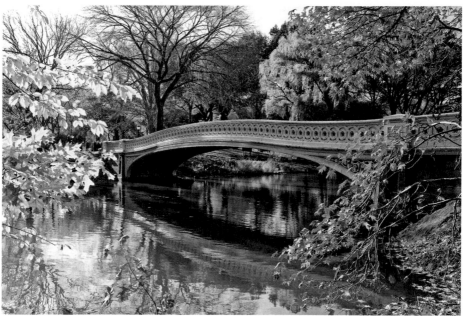

© Patrick Batchelder

5.6 The Bow Bridge spans the narrowest point of the Lake (see F on the map). Shot on an autumn morning at ISO 100, f/5, 1/40 second with a 25-60mm lens.

north side of the Lake. A standard zoom lens offers many choices in creating compositions. A longer telephoto lens is another option if you want to participate in the epicenter of Central Park bird watching and photography.

Belvedere Castle

Built upon Vista Rock, Belvedere Castle overlooks the Ramble to the south and the Great Lawn to the north. As one of the most popular locations for bird watching in the park, it offers sweeping views of the park and surrounding city from atop its walls. The castle is also an interesting subject to shoot; it is set atop the second-highest natural point in the park (see Figure 5.7).

A telephoto lens allows you to bring out details or practice bird photography from the castle's outlooks. A standard zoom lens is a good choice as well, offering wide-angle shots of the castle and its environment or a short telephoto view of the castle.

How Can I Get the Best Shot?

Although Central Park has a large and varied landscape, you can create many compelling images with a simple standard zoom lens. Having more options can be nice

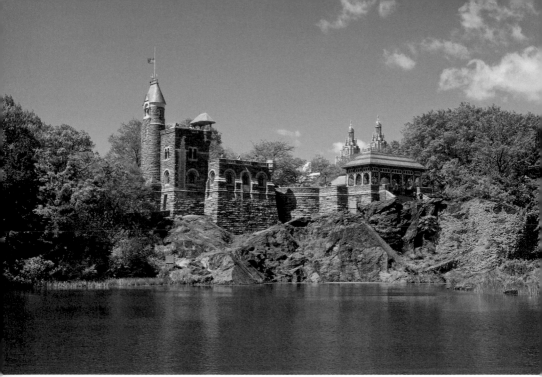

© Patrick Batchelder

5.7 Belvedere Castle on Vista Rock beside Turtle Pond on a spring morning (see G on the map). Taken at ISO 100, f/7.1, 1/60 second with a 25-60mm lens.

at times, but taking too many lenses can be cumbersome. Arriving very early in the morning for the golden hour around sunrise is your best bet for a quiet and peaceful atmosphere, although if you look hard enough you can usually find an empty enclave deeper in the park any time of day.

Equipment

You are freer to bring a wider variety of lenses and equipment to Central Park than many other places in the city due to its open spaces. A general lack of crowds means that you will not hinder yourself (and others) if you carry a backpack, tripod, or other gear with you.

Lenses

▶ **A standard zoom lens in the 24-105mm range.** This flexible lens offers you the greatest variety of opportunities of any single lens. The wide-angle end allows a perspective that exaggerates very close objects while including a large portion of the scene in a single shot. The telephoto end allows you to

isolate features and compress the apparent distances between objects. They often also have a close minimum focusing distance, allowing basic macro photography of the varied flora in the park.

▶ **An ultrawide-angle zoom lens in the 16-35mm range.** Such a lens allows you to capture extremely wide shots. Landscape photographers often prefer such a wide view because it allows the viewer to see such a large portion of the scene.

▶ **A telephoto zoom in the 70-200mm range.** A favorite lens for portraits and sports, a telephoto zoom lens can also be a great choice for landscapes. The telephoto aspects of this lens allow you to isolate a smaller subject or details of a large subject with a perspective that appears to compress the distances between foreground and background.

▶ **A macro lens.** If you want to truly get close to flora and fauna in the park, you can use a dedicated macro lens. Generally available in 50mm, 100mm, and 180mm focal lengths, they usually offer a 1:1 magnification ratio and allow you to get large, full-frame shots of insects, flowers, and other very small subjects.

Filters

When photographing outdoors, a polarizing filter is often a great tool to have available. By reducing the reflections on the sky and foliage, a polarizing filter deepens their colors. It also reduces reflections on water and glass. Combined with a tripod, a neutral density filter allows you to create longer exposure than might otherwise be possible. Longer exposures can help smooth out the surface of a rippling lake or create motion blur of a moving subject.

Extras

If you plan on bringing lots of equipment, a reliable photo backpack can make your trek much more enjoyable. A tripod can be a great asset when composing a landscape shot or using a longer telephoto lens to photograph the wide range of wildlife in the park.

Camera settings

Central Park's natural setting offers a respite from the busy city life and correspondingly offers an opportunity to focus on a slower-paced style of photography. Using your camera's light meter to choose your settings in Aperture Priority mode will yield reliable exposures and allow you to focus on your composition and finding the perfect light.

Exposure

Central Park's open spaces mean that the beautiful light of the golden hours can envelop the scene before you. Search for this compelling light just after sunrise and before sunset to create stunning photos anywhere in the park. Bringing a tripod means you can also capture the twilight hours with a longer exposure.

 The golden hours are the hour after sunrise and the hour before sunset. These offer some of the most beautiful light of the day.

Aperture Priority mode allows you to select an aperture appropriate to your intent and utilize the camera's internal meter to set the shutter speed and ISO. If you are shooting in snow or against a bright sky, you may need to utilize some positive exposure compensation.

White balance

Use your camera's preset white balance of Cloudy, Sunny, or Shade as appropriate. These presets are very close to accurate and ensure consistency across all of your frames. Shoot in RAW mode to give yourself the most latitude in the digital darkroom.

ISO

The lowest possible ISO setting ensures the least amount of digital noise. Generally use ISO 100-200 on a clear day and ISO 400 when it is overcast. At night, you may need to go to ISO 800 or 1600 to ensure a sufficient shutter speed for a sharp photo unless you are utilizing a tripod.

Ideal time to shoot

The park is beautiful all year. In the spring, flowers bloom and blossoms weigh heavily from tree branches. Come summer, the verdant expanses bring people and nature out day and night. Fall's drop in temperatures brings with it the color explosions of the trees and forests. Winter's barrenness offers rarely seen compositions with the skeletal trees. The beauty of a hushed morning after a fresh snowfall is a truly special experience.

Ensure that you and your equipment are properly protected from the elements when venturing into the park. Check the local weather forecasts to minimize the potential to be surprised by a change in conditions. However, don't let rain or other inclement weather stop you from your explorations. A rainy day can offer many interesting images not seen in sunny weather (see Figure 5.8).

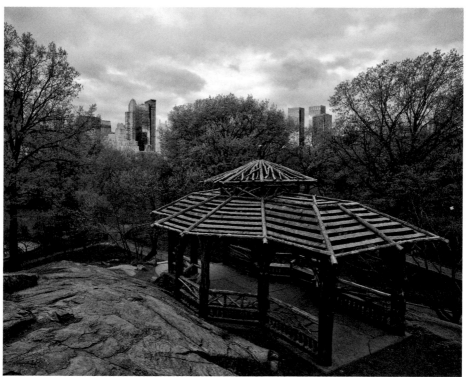

5.8 Central Park after a spring rainfall. Taken at ISO 320, f/5.6, 1/200 second with a 16-35mm lens.

Low-light and night options

After dark, the park continues to provide myriad photo opportunities. Many street-lights line the paths, offering pockets of light bright enough to shoot handheld without a flash. Using a tripod for a longer exposure lets you blur motion, allowing people to disappear or cars to turn into streaks of light.

Getting creative

One of the more recognizable scenes in Central Park is the carriage horses. These subjects offer an excellent opportunity to practice panning. Using a longer shutter speed and moving the camera along with the moving subject in order to blur the background imparts a sense of motion. Set your camera to Shutter Priority mode and start around 1/3 second.

The carriages follow the same path again and again, so find a composition you like and get yourself situated and prepared. Prefocus where you know the carriage is going to be and then disable autofocus. As a carriage comes by, pan along with it

as it moves past, depressing the shutter as you reach your desired composition. Now check the results on your LCD and try again until you get the shot you want (see Figure 5.9).

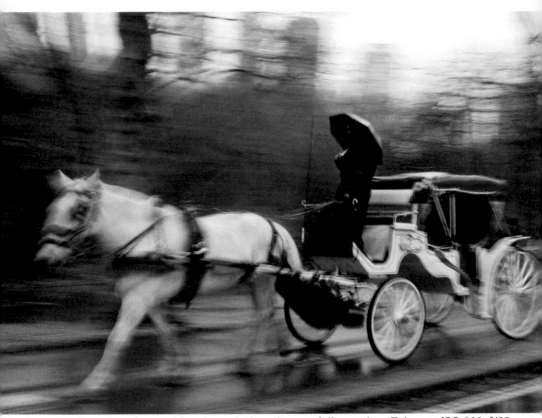

5.9 A carriage horse rides through the rain on a fall morning. Taken at ISO 200, f/22, 1/3 second with a 24-70mm lens.

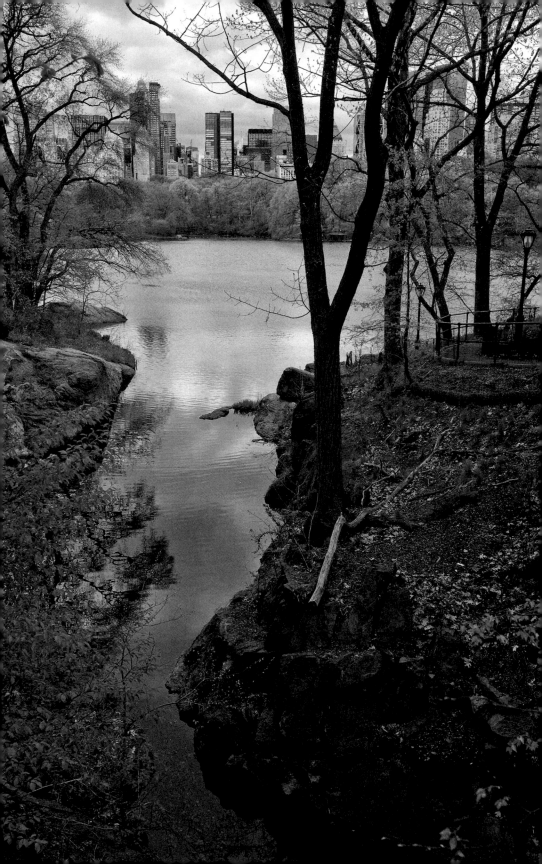

6 Chinatown

The Golden Bowl from the northeast corner of Mott Street and Canal Street. Taken on a clear fall afternoon at ISO 400, f/11, 1/250 second with a 16-35mm lens.

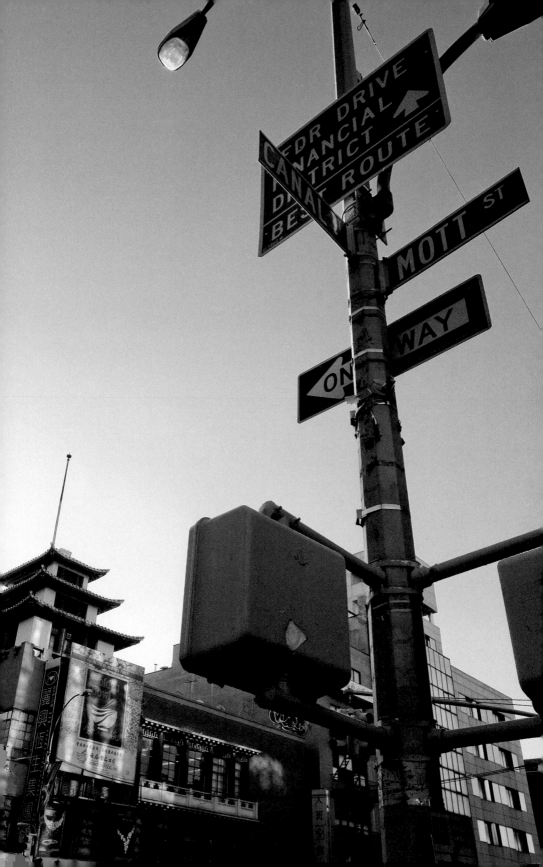

Why It's Worth a Photograph

Manhattan's Chinatown, the largest in the U.S., is a tightly packed area of two square miles that was settled in the 1880s. Traditionally bounded by Canal, Bowery, Worth, and Baxter streets, a 1990s growth spurt has increased the district's size.

The area is a vibrant, bustling, and perpetually crowded feast for your camera. The northern edge along Canal Street is a busy two-way road with a wide range of shops that sell watches, jewelry, purses, and all manner of colorful clothing interspersed with a range of Asian cuisine. Venturing south from this hub of tourist consumerism brings you into areas with more restaurants and grocery stores selling food, fruits, and vegetables in a wide variety of shapes and colors. The colors, signs, and energy of the neighborhood make it a wonderful place to create images.

Where Can I Get the Best Shot?

The best places to get photographs in Chinatown are from Mott Street and Canal Street.

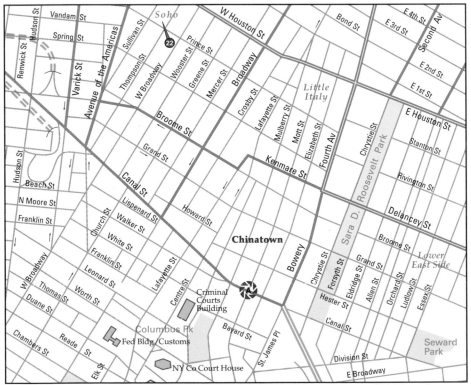

The best vantage points from which to photograph Chinatown are: (A) Mott Street and Canal Street. Other photo ops: (22) Soho.

Mott Street and Canal Street

The corner of Mott Street and Canal Street is a great place to start your Chinatown journey. Take the train to the Canal Street station and walk down Canal Street to ease into the hustle and bustle of the neighborhood (see Figure 6.1). Not being in a hurry is best, because the streets tend to be very busy at all times. Weekends are even more crowded and can make moving a single block a five-minute affair.

However, because you are here to create photographs, relax and go with the flow of the crowds that surround you (see Figure 6.2).

After exploring this fascinating intersection, head out wherever your desire takes you. There are photographic treasures around every corner (see Figure 6.3). When you are tired, you can even get an inexpensive foot or back massage on almost any block. Because you are constantly moving and in large crowds, travelling light is important. Select a single lens, usually a general purpose standard zoom, for the day.

> **TIP** Although not traditionally part of Chinatown, take a walk north into the area that is an amalgam of a receding Little Italy and an expanding Chinatown.

6.1 A dragon-bedecked Chinatown NYC information kiosk on a chilly fall afternoon (see A on the map). Taken at ISO 400, f/10, 1/250 second with a 16-35mm lens.

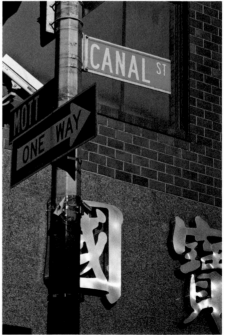

6.2 A bank sits behind the street sign on the corner of Mott Street and Canal Street. Taken on a clear winter afternoon at ISO 400, f/10, 1/640 second with a 24-70mm lens.

How Can I Get the Best Shot?

Canal Street is a fairly large, open area with a lot of light down onto the street. As you explore other side streets, you will find them much dimmer, sometimes mostly lit by artificial lights.

Be careful when creating your compositions to ensure that your photo has a subject. The throngs of people and signs everywhere make it difficult to create a clean composition (which might not express the feeling of Chinatown anyway). However, your images should still have a clear subject, whether that be a person on the street, a distinctive building, or even the interesting shapes and colors of an outdoor grocery.

6.3 Dried fish, squid, and octopus sit in bins outside a marketplace near Mott Street and Canal Street on a fall afternoon (see A on the map). Taken at ISO 200, f/3.5, 1/160 of a second with a 16-35mm lens.

Beyond a clear subject, look to create images that give the feeling of the Chinatown district and incorporate those features that resonate with anyone who has ever visited the area (see Figure 6.4).

Equipment

You have a few options when choosing lenses, but I recommend selecting a single lens for a single trip. Come back another time with a different lens to try new perspectives; Chinatown is never the same twice!

Lenses

▶ **A standard zoom in the 24-105mm range.** A zoom lens with a large range gives you the most freedom to explore different views. These lenses usually have some basic macro functionality, allowing you to isolate details even up close. The zoom from wide-angle to medium telephoto offers you the freedom to find a great spot and try a variety of compositions. Chinatown is one spot in which it can be difficult to *zoom with your feet*, and the flexibility of a large zoom range can offset this.

- ▶ **An ultrawide-angle zoom in the 16-35mm range.** Even a standard wide-angle lens can't always capture the breadth of activity found on a single street corner. Use the ultrawide-angle zoom to bring more people, colors, and shapes into a single frame.

- ▶ **A fast prime lens.** Using a fast prime lens is a good idea when shooting at night, when less light is available. Also, it allows you to capture images with an acceptable shutter speed and no flash. Also, when you use a prime lens, you are forced to slow down and move yourself to create the composition you desire.

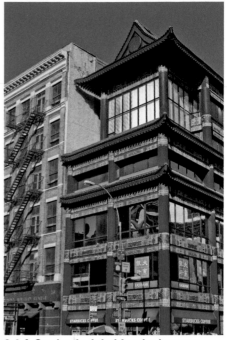

6.4 A Starbucks inhabits the bottom floor of this stereotypical-styled building on the corner of Centre Street and Canal Street. Taken on a chilly winter morning at ISO 200, f/5, 1/1000 second with a 24-70mm lens.

Filters

If you are visiting Chinatown during the daytime, a polarizing filter can be useful. This filter deepens the blue of the sky and increases the saturation in your images. Using this filter can also cut reflection when shooting store windows or other shiny objects.

Extras

Although you should always keep your lens hood on, doing so is even more important here. While moving through tight crowds, you are likely to bump into others. An unprotected lens might get an accidental fingerprint or scratch. A flash can be useful if you intend to shoot daylight portraits. Using a daylight fill flash helps to fill in shadows under your subject's eyes and can create a catchlight where one didn't exist.

Camera settings

While the side streets can be much darker than the main thoroughfares, your camera's meter will be able to handle most situations it encounters on the streets of Chinatown. Utilizing the meter and autofocus allows you to focus on your surroundings and be ready when the next opportunity to make an image surfaces. You can be sure it won't take long.

Exposure

When shooting during the daytime, you may find that you can't contain the sky and a storefront or other shadowed area within the dynamic range of your camera. You can either let the sky go overexposed or recompose to include only the darker area of the frame.

Aperture Priority mode gives you control over your depth of field. When shooting a well-lit street scene, you generally want to keep your f/stop in the f/8-f/11 range to ensure that the image is crisp.

ISO

ISO should be fairly straightforward in Chinatown. Set your camera to ISO 100 to ISO 400 during the daytime, increasing to ISO 800 or ISO 1600 at night as needed to keep an acceptable shutter speed of 1/focal length or faster.

White balance

In this ever-changing light, select an outdoor white balance of Sunny or Cloudy. Doing so keeps your image warm in the sunlight, although artificial light pools may appear overly yellow in some images. If you shoot to keep the artificial light closer to white, any areas of daylight will appear overly cool and blue.

Ideal time to shoot

There are few times of year that won't offer crowds, colors, and a lot of energy. The warmer spring and summer months will see an increase in street vendors and their vibrant wares. The Chinese New Year parades in late January or early February offer an exceptional opportunity to capture a traditional celebration.

Snow and rain can damage improperly protected equipment. A clear warm day is certainly a more comfortable time to visit Chinatown. However, don't discount the opportunities available when the streets are quiet on a drizzly day. Bright umbrellas, slickers, and boots are great attention-grabbing touches to an image created on an otherwise flat day.

Low-light and night options

After sunset, Chinatown continues to thrive and offers a fair amount of light to shoot. Explore the same streets by night and find new compositions with new lights and colors.

Getting creative

Don't just look around, look up, too. Many shots can be made in three dimensions. Be sure to put something in the foreground to help create a sense of depth. And most of all, have fun (see Figure 6.5).

6.5 Stuffed Pikachu dolls hang from the awning of a storefront as the Chinese flag flies from the top of a building on Bayard Street on a clear fall afternoon. Shot at ISO 500, f/11, 1/100 second with a 16-35mm lens.

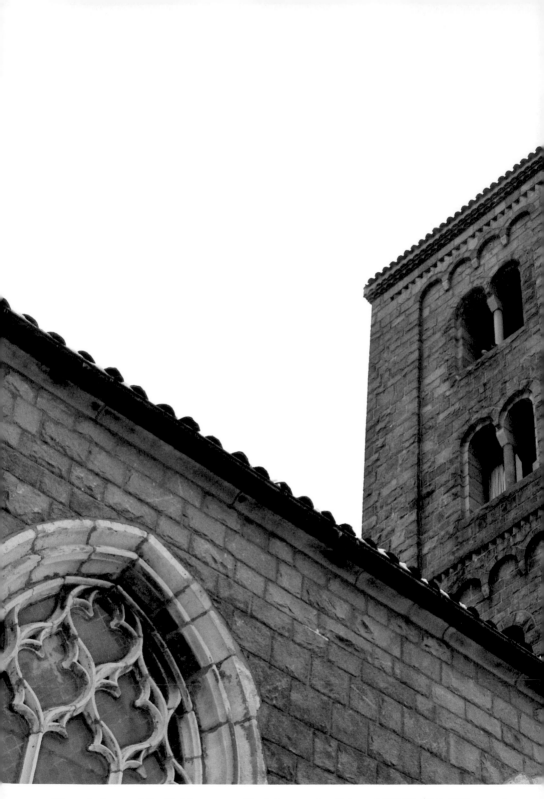

The main tower of the Cloisters on a cold winter morning. Taken at ISO 64, f/5.6, 1/80 second with a 28mm lens.

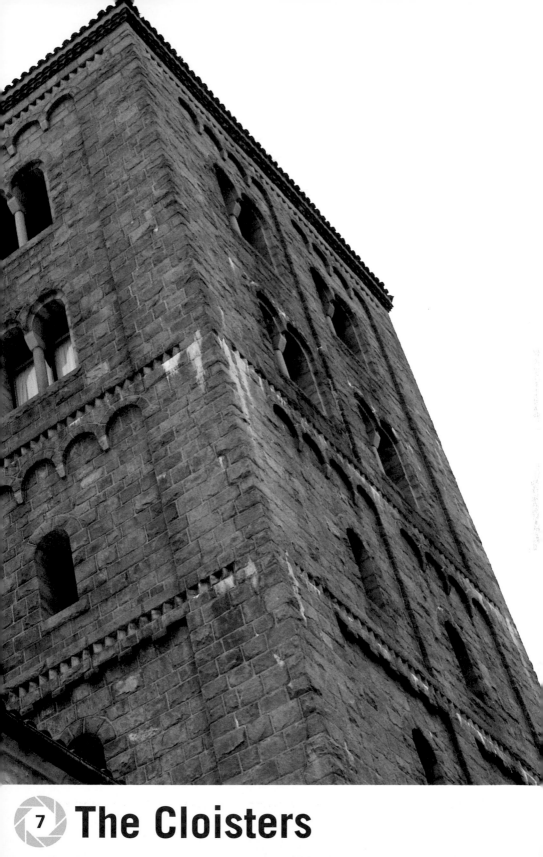

⦿7 The Cloisters

Why It's Worth a Photograph

From the northern tip of Manhattan Island, you can instantly transport yourself to medieval Europe at the Cloisters. Completed in 1938 from an endowment grant by John D. Rockefeller, Jr, the Cloisters is a branch of the Metropolitan Museum of Art dedicated solely to European medieval art. The building itself is an amalgam of five medieval French cloisters and other French monasteries. Beautiful grounds, gardens, vaulted passageways, and a world-renowned collection of 6,000 works of art, from tapestries to sculptures, paintings to arms and armaments, all await you and your camera.

Where Can I Get the Best Shot?

They say the best things require a little effort — get to the Cloisters by Subway (A) to 190th street and then take a short 10-minute walk. Or, take a taxi from wherever you are in New York City. The Cloisters are at the northern end of Manhattan Island.

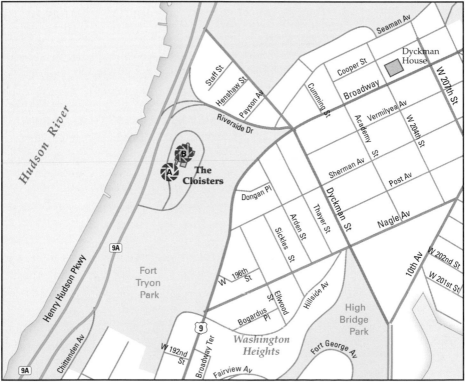

The best vantage points from which to photograph the Cloisters: (A) outside from the south and (B) inside in the museum galleries.

Outside from the south

From the main lawn area just south of the building complex, there are many views of this beautiful place. The building is so large, that shooting it in manageable chunks is a good way of getting great shots. Consider using natural features such as tree limbs as framing elements (Figure 7.1). A standard zoom lens will offer the most flexibility when creating multiple compositions of this attractive building and grounds.

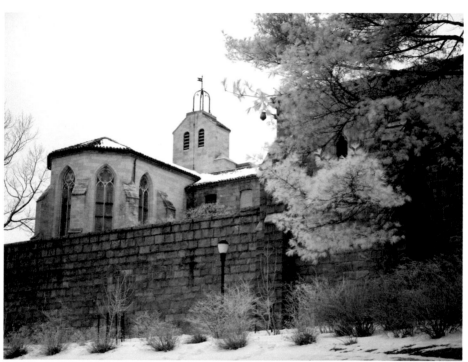

7.1 View of the Cloisters from the south, shot on a winter afternoon. (see A on the map). Taken at ISO 64, f/2.2, 1/30 second, with a 28-135mm lens at 35mm.

Inside, Museum Galleries

The galleries inside the cloisters feature a rotating collection of over six thousand objects. The enclosed quadrangles feature living gardens planted to the standards of medieval Europe. Inside, art from the 7th through 15th centuries is displayed and available to be photographed.

While flash photography is not allowed, many portions of the museum are lit well enough from the ambient and artificial light to create breathtaking images (see Figure 7.2). A wide range of tapestries, stained glass, and paintings are on display (see Figure 7.3). A fast prime lens may provide the most opportunities when creating images in some of the darker parts of the museum.

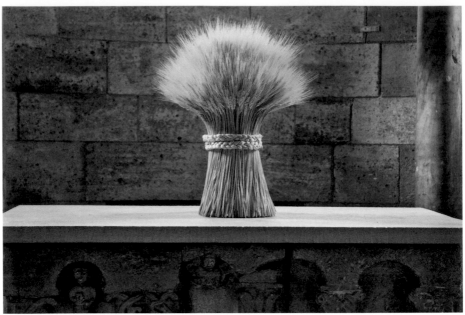

7.2 Sheaf of wheat on a carved stone table (see B on the map). Shot with morning light. Taken at ISO 1600, f/4, 1/25 second, with a 24-105mm lens at 50mm.

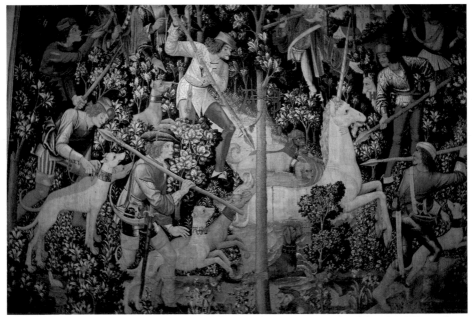

7.3 Tapestry wall hanging. Taken at ISO 1600, f/4, 1/3 second, with a 24-105mm lens at 28mm.

How Can I Get the Best Shot?

Both inside and out, the Cloisters is rife with great photographic opportunities all year-round. Create documentary photographs of the richly historical art or create your own artistic interpretations of the lights, shapes, and colors you find on the grounds. You will be shooting primarily with available light, so a lens with a large aperture will be an important piece of equipment to have on your trip.

Equipment

While you can bring a range of lenses to shoot the outside of this stunning architecture, inside the darker light means you will want to have a lens with a larger aperture available. When creating your architectural shots outside, consider bringing a tripod. Like the main branch of the museum on Fifth Avenue, you can even bring a tripod inside on certain days.

Lenses

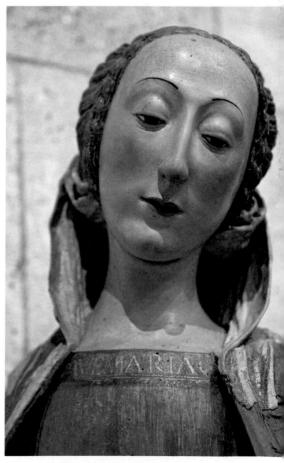

▶ **A standard zoom lens in the 24-105mm range.** A zoom lens with a large range of focal lengths gives you a great deal of flexibility when shooting both inside and out (see Figure 7.4). With some basic macro capability and possibly an image stabilization feature, this type of lens may be all that you need to create all your photographs.

▶ **A fast prime lens.** Often available in focal lengths around 50mm and 85mm, these lenses have very large apertures of f/1.2 to f/1.8 and can be quite reasonably priced. With an additional 2 to 4 stops more light, a fast prime lens can allow you to capture a sharp photograph sans flash where many zoom lenses would fail.

7.4 Statue close-up. Taken at ISO 1600, f/4, 1/25 second. a 24-105mm lens at 100mm.

Filters

Outside the Cloisters, you may consider using a polarizing filter to deepen the blue of the sky or increase the saturation of the colors of flowers and foliage in direct sunlight. Inside, remove all filters including UV or Haze filters, to minimize any reflection or diffraction caused by additional glass between your sensor and subject.

Extras

A tripod can help when creating landscape and architectural images outside the Cloisters. On Wednesday through Friday, you can use tripods inside the museum as well. You may consider bringing a pocket gray card in order to set a custom white balance for difficult lighting conditions inside.

Camera settings

The Cloisters can really push the limits of your camera, but that doesn't mean you can't capture some great images. Ensuring that you have a sufficiently fast shutter speed will go a long way towards creating a sharp image, even if a higher ISO setting results in some digital noise. Other parts of the Cloisters are well lit by natural light, including the historic gardens, giving you a lot more latitude with your camera's settings.

Exposure

Using Aperture Priority mode gives you the most control over the creative use of depth of field. Directly setting the aperture, your camera's meter will then calculate and set the appropriate shutter speed. With many of the scenes being a flat gray color, your camera's meter will be quite accurate. Shooting outside against a bright sky could fool the meter, however, and require 1/3 to 1 stop of exposure compensation.

White balance

Outdoors, you will want to use Sunny or Cloudy white balance presets as appropriate. Indoors, the mixed light from sunlight filtering and artificial light can be a challenge. Use your pocket gray card to set a custom white balance, and shoot in RAW mode to have the greatest latitude in the digital darkroom.

ISO

As a general rule of thumb, use the lowest ISO that will still allow you to capture a sharp image. Outdoors, this will range from ISO 100-400 depending on the

weather. Inside, however, the light varies from bright light near windows to very dark corners. You may need to go to ISO 800 or 1600 in these darker areas in order to ensure a sufficiently fast shutter speed for a crisp shot.

Ideal time to shoot

Because much of the shooting is indoors, shooting at late-morning to late-afternoon gives the most possible available light in the parts of the Cloisters with windows.

The Cloisters is a venue that is really great to be at in inclement weather. Inside, you stay warm and dry and have tons to shoot. Outside, any dramatic weather conditions (such as storm clouds, for example) accentuate the castle-like appearance of the Cloisters.

Getting Creative

As you explore the Cloisters, look for lines, patterns, framing, and repeating elements to create abstract images out of the scenes around you (see Figure 7.5). There are innumerable fascinating details that can be isolated or combined with other features to create an artistic statement.

7.5 Repeating elements in room-dividing stonework. Taken at ISO 400, f/4, 1/25 second with a 35mm lens.

8 The Empire State Building

The shadow of the Empire State Building looms over the nearby buildings as seen from the 102nd floor observation deck on a fall morning. Taken at ISO 400, f/10, 1/200 second with a 24-70mm lens.

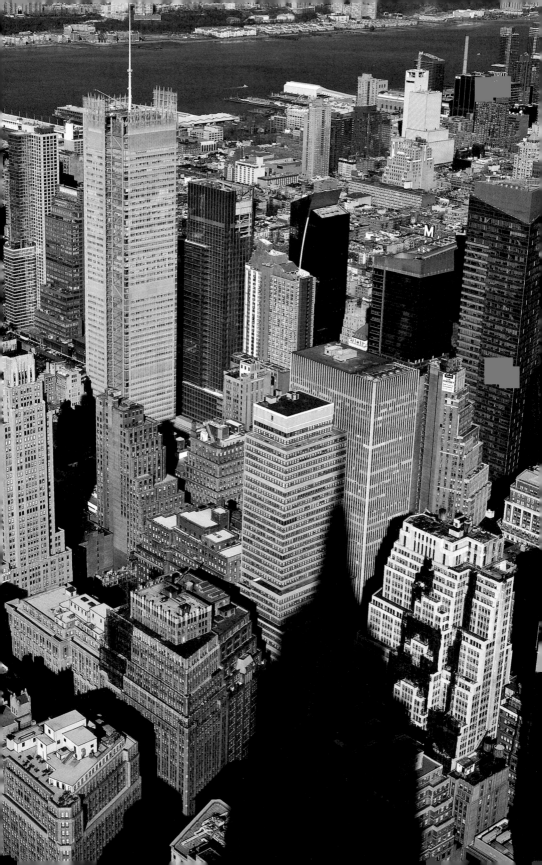

Why It's Worth a Photograph

The Empire State Building, located at Fifth Avenue and West 34th Street, is the tallest skyscraper in New York City and one of its most iconic. Offering the highest observation decks in town, this stunning Art Deco building has amazing views of the city from its open-air 86th floor. Construction was completed during the Great Depression in 1931 for a cost of under $41 million with the 102nd floor originally envisioned as an airship terminal. Today, over 110 million people have passed through the beautiful lobby and visited the top of the building, and the building has been featured in over 90 movies. A photo tour of New York City must include the landmark Empire State Building.

Where Can I Get the Best Shot?

The best locations from which to photograph the Empire State Building are from 34th Street and Fifth Avenue, in the building's lobby, and from the observation decks.

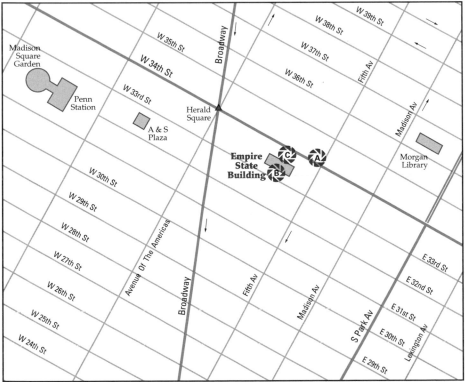

The best vantage points from which to photograph the Empire State Building: (A) 34th Street and Fifth Avenue, (B) in the lobby, and (C) the observation decks.

34th Street and Fifth Avenue

Before your trip to the observation decks, this intersection offers a good place to capture some street-level images of this massive structure. Using a wide-or ultra-wide-angle lens, you can explore the building as it rises into the sky. You have to choose your shots carefully if you want to avoid other buildings, so don't hesitate to shoot off-axis (see Figure 8.1).

Sometimes a crooked shot can be a great shot, giving your image a sense of motion and play with the building diagonal in the frame. Showing the building with its neighbors can offer a great photograph as well, giving context to your shot.

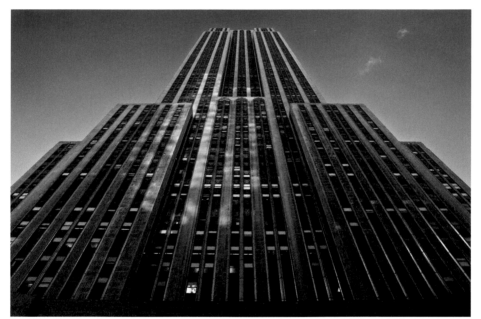

8.1 The Empire State Building as seen from 34th Street near Fifth Avenue on a clear fall morning (see A on the map). Shot at ISO 200, f/10, 1/30 second with a 24-70mm lens.

In the lobby

The three-story lobby offers your first taste of the beautiful Art Deco decor you will experience on your visit. The centerpiece is an aluminum relief of the building immediately in front of you when you come in the door.

A zoom lens from the back of the lobby or wide-angle lens from below can capture the beauty of this artwork (see Figure 8.2). The lobby is often quite crowded with tourists, so you may need to be patient if you want to take a clean photograph.

The observation decks

High above most of the city, the 86th and 102nd floor observation decks are well worth the trip. After you get to the top, you may stay there as long as you want. The 86th floor has an enclosed central core with an outdoor section that wraps the entire building and offers views in all directions up to 80 miles. To access the 102nd floor, you need to purchase an additional ticket that may be purchased along with your original ticket or on the 86th floor with a credit card.

This upper floor is fully enclosed in polarized glass but is usually much quieter than the often-crowded lower floor. A myriad of lenses offer a lot of choices here, and though there are security checks, you can get through with large backpacks if you want to bring a selection of gear. Be aware that on many days a longer zoom lens will have difficulty getting clear photographs through atmospheric haze. You can use a polarizer to help cut down on this haze outside on the 86th floor, but all the polarized glass on both observation decks will cause deleterious effects if you shoot through them with this filter in place. (see Figure 8.3).

How Can I Get the Best Shot?

Although tripods are expressly not allowed, backpacks can be brought through security, so you can bring a few lenses if you want to try some different shots. Sunsets can be quite spectacular from the top of the building

8.2 The aluminum relief in the lobby of the Empire State Building (see B on the map). Taken at ISO 400, f/4.5, 1/50 second with a 70-200mm lens.

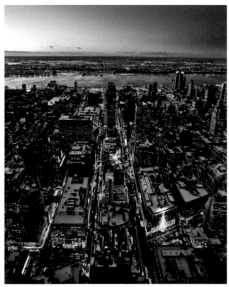

8.3 34th and 35th streets run west to the Hudson River 30 minutes after sunset (see C on the map). Taken at ISO 800, f/2.8, 1/40 second with a 16-35mm lens.

if you are willing to brave the afternoon lines. Otherwise, go early to catch the first elevators going up at 8 a.m. and avoid the sometimes hours-long queues.

Equipment

Wide-angle and ultrawide-angle lenses enable you to capture the building and lobby while on the ground floors, and large swaths of the city from the upper floors. A standard or telephoto zoom gives you the option to isolate smaller sections, such as Wall Street to the south (see Figure 8.4).

Lenses

▶ **A wide-angle or ultrawide-angle zoom lens.** These lenses can help you create impressive and overwhelming images while looking up at the building. The massive structure appears even larger from this perspective. These lenses can also show a large piece of the city at once while allowing slower shutter speeds than a large telephoto zoom lens when handholding the camera.

▶ **A standard or telephoto zoom lens.** A standard zoom in the 24-105mm range or a telephoto zoom in the 70-200mm range can let you view smaller sections of the city at a time without being forced to crop in the digital darkroom. At 200mm, for example, you can fill up the frame with a view of the southern quarter of Manhattan Island or most of Central Park.

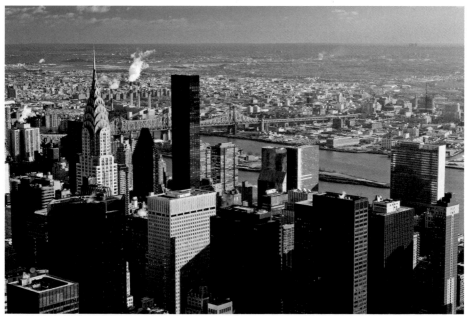

8.4 The Chrysler Building and the United Nations Headquarters frame the edges of the view looking northeast over the East River as it splits around Roosevelt Island on a brisk fall morning. Taken at ISO 200, f/9, 1/80 second with a 24-70mm lens.

▶ **A larger telephoto zoom or prime lens.** Using a lens over 200mm, you can begin to isolate individual buildings or areas that are a bit farther out. Be aware that on many days you will have a great deal of haze between you and your subject, making it difficult to create a quality image of faraway landmarks, such as the Statue of Liberty.

 Call (212) 736-3100/(877) 692-8439 for wait times and visibility information from an operator.

Filters

During the daytime, a polarizing filter can deepen the blue of the sky and reduce reflections from the city below. This filter can also be effective in reducing effects of haze. A UV, Haze or Skylight filter can also help cut through haze, although the effect will not be as dramatic.

Extras

Tripod and monopods are not allowed on the observation decks or in the lobby. However, the instantly recognizable crosshatch of the fence installed around the 86th floor observatory makes a wonderful camera rest.

Make sure that your camera strap is secured before putting your camera through the fence (see Figure 8.5). If your lens has a hood, be sure to securely fasten it on the end of your lens to offer more protection from the multitude of protrusions on and around the fence.

Camera settings

Using a larger f/stop of f/8 to f/11 puts most lenses at their sharpest and offers a large depth of field for most of your images. At sunset or at night, you may need to reduce to a larger f/stop and increase your ISO to ensure a high enough shutter speed to capture a sharp image.

Exposure

When shooting in fading light or in the lobby, watch your shutter speeds to ensure that you have sharp images. Keep them at 1/focal length or higher to be certain you are not getting camera shake on your shots.

Aperture Priority mode gives you control of your depth of field while using your camera's generally reliable built-in meter. You might need to dial in +2/3 to +1 exposure

8.5 Looking southwest through the fence surrounding the outside of the 86th floor open-air observation deck at the winter solstice. Shot at ISO 800, f/4, 1/4000 second with a 16-35mm lens.

compensation if shooting into the sunset. The lobby can present a challenge due to the dark paneling and extremely bright spotlights. Bracket your exposures or check your shots on your LCD to ensure a proper exposure.

White balance

When shooting from the observation deck or the street, use a Cloudy or Sunny white balance as appropriate. In the lobby, use a Fluorescent white balance to get your white balance close in this mixed-light environment, and shoot in RAW mode to get the most latitude in the digital darkroom.

ISO

Using the lowest ISO for the lighting conditions yields the cleanest shots. Outdoors this will generally be 100-400 during the day although you may need to increase to 800 or 1600 during twilight and into the night.

Ideal time to shoot

It's hard to beat a beautiful sunset and the subsequent twilight from the observation decks. The sun's light fades over the city, and you can watch the shadows creep down the streets and over the East River. Then watch the city light up below you while still enjoying the final throes of the setting sun. Be sure to check the queue length or spring for the Express Ticket; you don't want to miss the setting sun while standing in line for the elevators. If you do not want to deal with the lines, get there early and be in line for the first elevators to go up at 8 a.m.

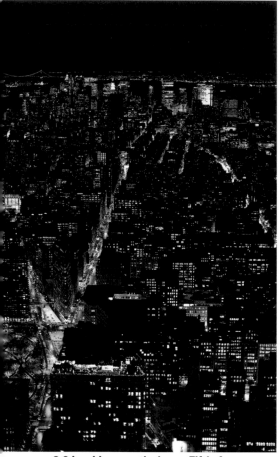

8.6 Looking south down Fifth Avenue toward Wall Street on a cold early winter evening. Taken at ISO 1600, f/1.4, 1/50 second with a 50mm lens.

The outdoor observation deck on the 86th floor is cold and windy. If you are comfortable on the street, you will be cold 1,050 feet higher. A windbreaker or outer shell is strongly recommended, because the winds tend to be quite strong.

Also be aware that your camera batteries may drain more quickly in the cold. You can stay in the enclosed area of the 86th and 102nd floor observation decks, but you will be shooting your images through glass and the fence around the outside of the building.

Low-light and night options

Civil twilight into the evening is a beautiful time to create images of Manhattan from the observation decks (see Figure 8.6).

You may need to brace your camera on the fence, or try kneeling on the concrete and resting your camera on the wall to get out of the wind and ensure your camera is stable with slower shutter speeds.

Getting creative

Instead of shooting stock photos of the Manhattan skyline, include some foreground elements in your shots, such as the iconic binoculars that line the 86th floor (see Figure 8.7). You can also try playing with angles instead of shooting straight horizons.

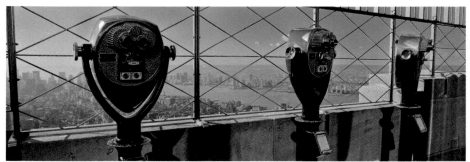

8.7 A panoramic crop of the binoculars on the Empire State Building observation deck on a fall morning. Taken at ISO 400, f/9, 1/640 second with a 24-70mm lens.

The Flatiron Building

9

The Flatiron Building on a clear fall morning at the intersection of 23rd Street and Fifth Avenue. Taken at ISO 200, f/11, 1/125 second with a 16-35mm lens.

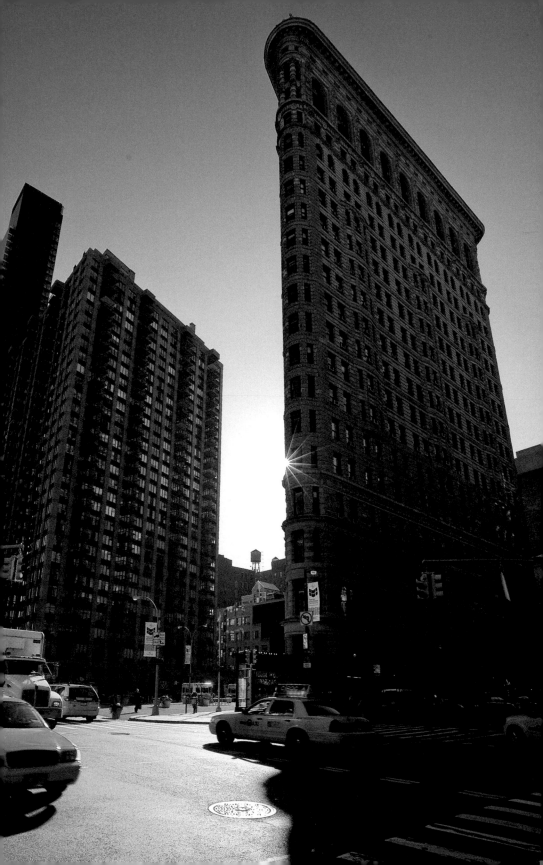

Why It's Worth a Photograph

The Flatiron Building is located at 175 Fifth Avenue at the intersection with Broadway. Originally named the Fuller Building when it was built in 1902, it is considered to be one of the world's first skyscrapers and is on the U.S. National Register of Historic Places. One of the most photographed and recognizable landmarks in New York City, the triangular building's signature shape features a rounded tip on the northern side of the building. A beautiful frieze wraps the top floors, and other distinctive decorations abound across the building. This highly recognizable building offers turn-of-the-century architectural flourishes, an open shooting area, and the opportunity to have some fun creating architectural images.

Where Can I Get the Best Shot?

The best locations to photograph the Flatiron Building are at 23rd Street and Fifth Avenue, from the sides, and from Madison Square Park.

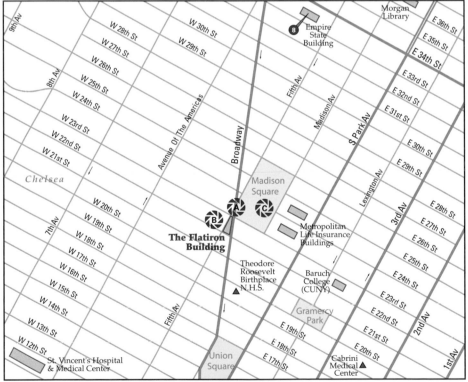

The best vantage points from which to photograph the Flatiron Building: (A) 23rd Street and Fifth Avenue, (B) the sides, and (C) Madison Square Park. Other photo ops: (8) Empire State Building.

23rd Street and Fifth Avenue

There are a number of places to shoot the building at and around the intersection of 23rd and Fifth. Immediately beneath the building, a wide to ultrawide-angle lens allows you to capture the building as it soars into the sky with a minimum of other distractions. The perspective from a wide-angle lens can help accentuate the odd shape of the structure.

From a bit farther back, there are signs or the Fifth Avenue Building clock on the west side that can add a foreground element to your shot. Using a telephoto lens from a bit farther back allows you to isolate portions of the building or individual decorations (see Figures 9.1 and 9.2).

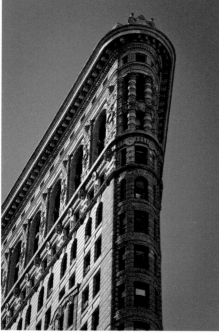

9.1 The peak of the Flatiron Building from 23rd Street and Fifth Avenue on a clear winter day (see A on the map). Taken at ISO 200, f/5.6, 1/200 second with a 38-112mm equivalent lens.

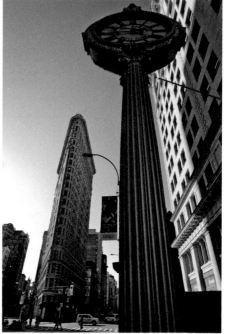

9.2 The Flatiron Building with the Fifth Avenue Building clock in the foreground on a clear winter morning. Taken at ISO 200, f/11, 1/160 second with a 16-35mm lens.

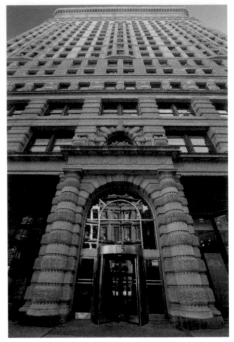

9.3 The western side of the Flatiron Building on a clear fall morning (see B on the map). Shot at ISO 400, f/10, 1/40 second with a 16-35mm lens.

The sides

The sides of the Flatiron Building also offer some great photo opportunities. The two east-west sides are mostly the same, and you should choose the side that has the most interesting light for the time of day you are shooting. The morning sun bathes the eastern side of the building much of the year.

This light can be great to shoot in until the sun is bright enough to cause unavoidable highlights off of the windows. The opposite side from the sun offers a nice flat light and even exposures to really explore the architectural ornamentation (see Figure 9.3).

Madison Square Park

Lying along 23rd Street and Fifth Avenue, this park offers an opportunity to add some natural elements to your image.

In the spring when the trees are in bloom this location can be especially striking (see Figure 9.4). Using a longer focal length causes these natural foreground elements to appear closer to the building.

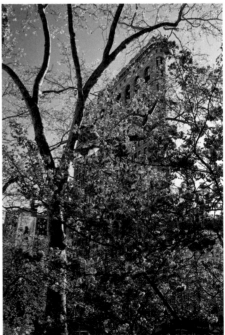

9.4 The Flatiron Building on a clear spring afternoon from Madison Square Park. Shot at ISO 100, f/8, 1/30 second with a 24-105mm lens.

How Can I Get the Best Shot?

The photographic opportunities around the Flatiron Building are varied, and as such you can use a wide variety of equipment. A standard zoom lens will offer you a number of options if you want to travel light, while an ultrawide-angle lens and a larger telephoto zoom lens will let you capture a broad scene or really isolate details on the building. On a clear or partly cloudy day you will get the best separation between the sky and the building. Incorporating elements such as street signs or taxis can give a sense of place and feel of New York City to your images. Because you are shooting on an active and busy intersection, be aware of people and traffic in your images and around you while shooting.

Equipment

Shooting on the street allows you the freedom to bring a variety of lenses or other equipment if you want to explore creating a range of different types of photographs.

Lenses

▶ **A standard zoom lens in the 24-105mm range.** This lens gives you a variety of options in capturing the building. You can shoot wide at the 24mm end and incorporate the whole building or zoom in to the medium telephoto end of 105mm and explore the designs across the top of the building.

▶ **An ultrawide-angle zoom lens in the 16-35mm range.** The ultrawide-angle lens allows you to get very close to the building and still capture its entire height or width. It creates distortion especially in the corners which can be used to exaggerate the extreme angles on the building. It also allows you to incorporate street elements such as vehicles or the Fifth Avenue Building clock while still capturing the entire building.

▶ **A telephoto zoom in the 70-200mm range.** A longer zoom in the 70-200mm range allows you to really isolate elements such as the designs around the peak of the building. It also compresses distances and reduces distortion, causing the building to appear straighter. It is an excellent choice to use from Madison Square Park.

Filters

A polarizing filter will deepen the blue of the sky when you are shooting perpendicular to the angle of the sun. This can increase the contrast and separation of the building against the blue sky.

Extras

A tripod would be a necessity if you want to shoot a panorama or longer exposures to blur the motion of people or vehicles.

 See Getting Creative in chapter 22 for more information on a lens for architecture.

Camera Settings

To create images with foreground and background elements or wide-angle shots you will want to use a smaller aperture of f/8 to f/11 to achieve a large working depth of field. Be aware of highlights from reflections on the building's windows.

Exposure

Outdoor exposures are usually quite reliable with today's cameras. Be aware of the building being too bright compared to the rest of your scene, which can cause the street or other foreground elements to be black or silhouettes. Expose for the highlights in the scene and edit in the digital darkroom.

Unlike traditional film photography, where areas of extreme overexposure can still record detail, in digital photography overexposed highlights are simply gone. Because of this, you always want to expose for the highlights in the scene and ensure that they are not clipped. Enable the histogram on the review display of your camera and ensure that it gets very close to, but does not touch the right-hand side of the graph. You must be shooting in RAW mode and process the image in your RAW processing software in order to get a benefit from this methodology.

Aperture Priority mode allows you to use the camera's excellent built-in meter and gives you direct control over the depth of field.

White balance

Automatic white balance generally works quite well outside. A challenge you may face with color with this building is when shooting in sunlight but including both sides of the building, the shadowed side will be much bluer due to the shade. Be aware of this when creating your composition. It is possible to adjust in the digital darkroom, but it is much less laborious to not include those elements in the first place.

ISO

A low ISO is best for your outdoor shots giving you the cleanest digital negative. Use ISO 100-200 on a clear day and up to 400 on a cloudy day or at dusk and dawn.

Ideal time to shoot

Early-morning and late-afternoon light is always the most beautiful. Any time of year works for most images. Spring is a very good time to create an image from Madison Square Park with the flowering trees in the foreground framing the Flatiron Building rising into the sky.

When shooting outside, rain is always a challenge. Be aware of the forecast and have a backup plan should the weather turn.

Low-light and night options

At dusk or into the evening a tripod can provide some interesting light where you have longer exposures and a mix of natural and ambient light.

Getting creative

The layout of the streets gives you a good opportunity to create a portrait of a travelling companion with the Flatiron Building in the background. Move a bit north of the building into the open square, get as low as you can and zoom in to compress the distance between your subject and the building.

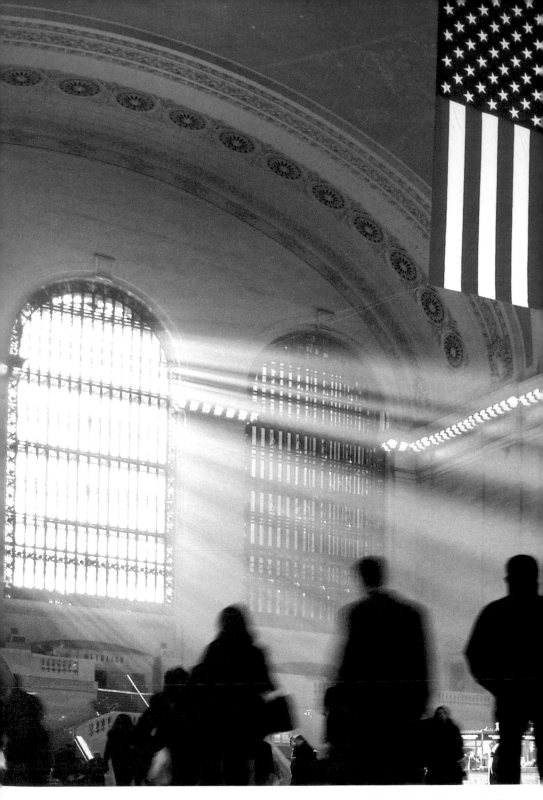

Grand Central Terminal shot on a late winter morning. Taken at ISO 64, f/2.2, 1/6 second with a 28mm lens.

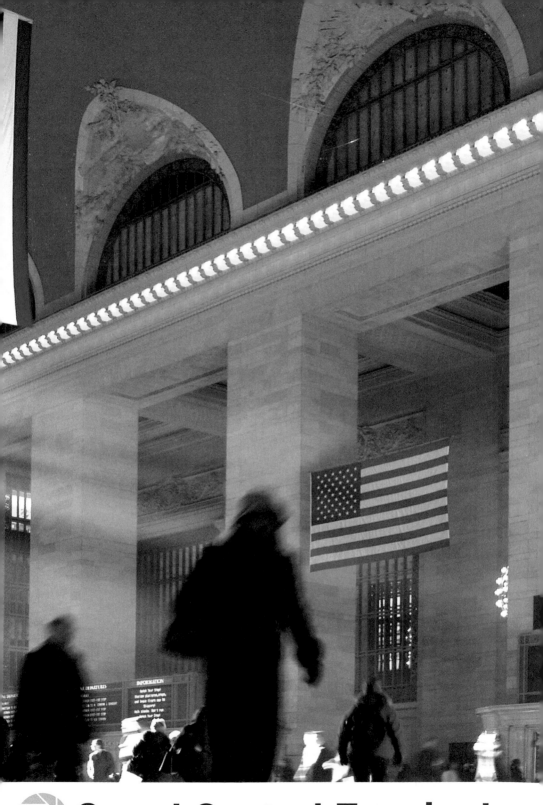

10 Grand Central Terminal

Why It's Worth a Photograph

"Meet me at the clock at Grand Central!" These are words that New Yorkers and visitors alike use and instantly understand. Grand Central Terminal has a rich history. The earliest train depot on this site opened in 1871. The current terminal was unveiled in 1913 and has been open ever since. The elaborately painted ceiling and the concourse clock are just a couple of the instantly recognizable symbols to incorporate into your images here.

Where Can I Get the Best Shot?

New York City's Grand Central Terminal offers many shooting opportunities to capture beautiful architecture and the hustle and bustle of the city.

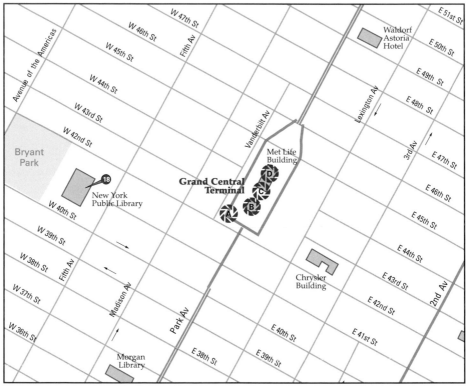

The best vantage points from which to photograph Grand Central Terminal: (A) 42nd St. and Vanderbilt Ave, (B) the Main Concourse, (C) the balconies, and (D) the tracks. Other photo ops: (18) New York Public Library.

42nd Street and Vanderbilt Avenue

Grand Central Terminal is huge — shooting it in smaller bits is definitely advisable. One of the best locations to do this is from the front of the terminal on 42nd Street (see Figure 10.1). You can really get a feel for the size and details.

Grand Central Terminal is an imposing building. While you can attempt to capture the entire thing with an ultrawide-angle lens, exploring smaller pieces and shooting specific details will create much more compelling images. One of the best locations to do this is from the front of the terminal on 42nd Street (see Figure 10.1). The statues and clock atop the broad facade make an excellent detail shot with a telephoto zoom lens while a standard zoom lens will allow you to capture the building amongst the surrounding city, traffic, and pedestrians.

The Main Concourse

Visit during morning or afternoon rush hour to fully experience Grand Central Terminal. During these hours the station is filled with people and the chaos can create some great photo opportunities. Budget your time to allow you to stay awhile because you never know what you'll find. While you are here in the Upper Level main concourse, spend some time on the architectural details.

10.1 The façade of the Grand Central Terminal (see A on the map). Taken at ISO 100, f/2.5, 1/100 second with a 35mm lens.

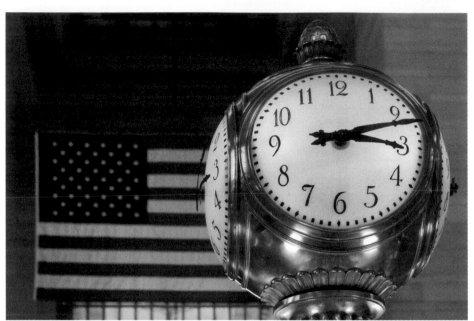

10.2 The clock at midafternoon (see B on the map). Taken at ISO 800, f/3.5 at 1/80 second with a 50mm lens.

The entire ceiling is a work of art, depicting the heavens and signs of the zodiac. The attention to detail everywhere is simply amazing. Be sure to capture some views with the famous concourse clock (see Figure 10.2).

The balconies

Two flights up from the main concourse, on both the east and west sides of the terminal are balconies (see Figure 10.3). These raised platforms overlook the concourse floor. With this great vantage point, you can create sweeping views of the busy floors full of commuters on their way to and from work.

The tracks

Head down into the tracks for more cool shots of the trains or people. It will be much darker here than above, so consider bringing a fast prime lens to enable a fast shutter speed in the minimal lighting. The masses of anonymous people can make for great street-type photography. Every few minutes, whole new groups of people will come through (see Figure 10.4).

There are also wonderful textures on walls. If you have ever wanted to explore textural overlays on your images in the digital darkroom, this is one of the best places in the city to capture them.

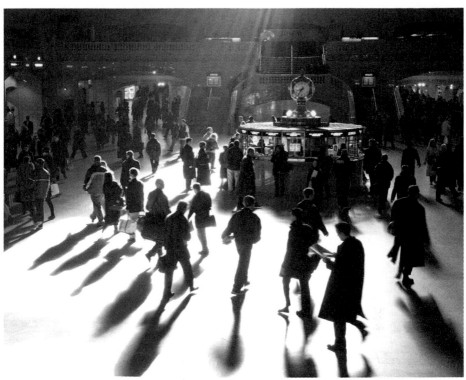

10.3 Commuters in Grand Central Terminal photographed on an early morning in late February (see C on the map). Taken at ISO 200, f/2.2, 1/30 second with a 28-200mm lens.

10.4 Commuters heading to work along the tracks at Grand Central Terminal (see D on the map). Taken at ISO 400, f/1.8, 1/40 second with a 50mm lens.

How Can I Get the Best Shot?

At Grand Central Terminal, you can create architectural as well as street photography. You don't need much in the way of specialty items; in fact, less is often more in street photography. Having good light is what helps get the best shot and, on a bright sunny day, there will be fantastic light entering through the massive eastern windows. A tripod can be helpful for architectural or slow-shutter speed shots, but a pass is required to use one.

Equipment

Generally speaking, wide-angle lenses are the best options here when capturing architecture or street-style photographs. A 50mm prime lens with a large aperture is also a great option especially when descending to the darker tracks. There are often heavy, chaotic crowds so consider this when choosing how much equipment to bring. Multiple trips with different lenses and gear may be a better choice than trying to bring it all in one visit.

Lenses

▶ **A standard zoom lens in the 24-105mm range.** Offering a great deal of flexibility is the strong suit of a standard zoom lens. You can create wide-angle shots and isolate interesting details with a single lens.

▶ **An ultrawide-angle zoom lens in the 16-35mm range.** If you want to create very wide scenes or photograph large pieces of architecture, an ultra-wide zoom lens is the best choice. Shooting level you can still capture a lot of the architecture even if it is above you, which keeps the lines and perspective all parallel. If you instead tip this lens up, the lines will converge to varying degrees and can create a sense of awe at being in a vast, overwhelming space.

▶ **A prime lens with a large aperture of f/1.2 to f/1.8.** A prime lens with a large aperture offers the benefit of 2 to 4 stops more light than an equivalent zoom lens. It also tends to be physically smaller and so less imposing. When shooting street photographs, this can be a great benefit, allowing you to blend in to the background and not attract the attention of your subjects.

Filters

Outside, a polarizing filter can be useful to deepen the blue of the sky while reducing reflections on windows. The increased contrast that this filter can create will help your photos of the terminal pop out from the background.

Extras

While a tripod can be a great tool to have available inside Grand Central Terminal, you must get a permit in order to use one. To obtain a permit, contact the Metro-

North Corporate & Public Affairs Department at (212) 340-4825. A pocket gray card is also a useful tool to have available to facilitate setting a custom white balance. Outdoors and in the concourse this may not be necessary, but underground the lighting can be very erratic. Shoot in RAW mode to ensure the most flexibility in the digital darkroom.

Camera settings

When shooting street-style photography, it is important to be prepared at a moment's notice. You want to be unobtrusive and ready to capture a scene without needing to fiddle with your camera settings (see Figure 10.5).

Depending on your goal, you can use an automatic mode or set the camera on manual and adjust your exposure for the scene in front of you before waiting for the moment to arrive.

Exposure

Being prepared means having your camera ready to shoot. This can mean using Aperture Priority mode, so you can set your aperture directly and allow your camera's meter to select an appropriate shutter speed for the scene.

You can also use Manual mode and have your aperture, shutter speed, and ISO set for your desired composition. You can even prefocus so your camera can instantly capture the frame when you are ready to create your image. You may need to use a larger f-stop of f/1.2 to f/4 in order to capture images with sufficiently high shutter speed indoors and especially down on the tracks.

10.5 A kiss at the clock in late afternoon. Taken at ISO 1600, f/2.8 at 1/30 second with a 50mm lens.

White balance

Utilize your white balance presets of Sunny or Cloudy outside. Indoors, you will want to use Incandescent or Fluorescent to get close, or use a pocket gray card to create a custom white balance. Either way, shoot in RAW mode to give the most latitude in the digital darkroom.

ISO

Set your ISO as low as possible to create an image with the least amount of digital noise. However, a sharp picture with some noise is generally preferable to a blurry picture with no noise so do not hesitate to raise your ISO to 800 or 1600 indoors.

Ideal time to shoot

The best time to visit Grand Central Terminal is in the early morning, capturing both the sunlight streaming in the massive, easterly windows and the throngs of commuters flowing through the building. Toward the end of February, the light spills in from the gigantic east windows with gorgeous sunbeams to include in your composition.

Grand Central Terminal is open year-round and is great to shoot in any weather conditions. Clear skies and bright sun in the mornings yield the most light through the few windows in Grand Central Terminal.

Getting creative

One of the great techniques to try at Grand Central Terminal is capturing a feeling of movement. Get a slow enough shutter speed, and you'll see a tiny bit of movement in the scene by blurring portions of the people in the scene.

Use Manual mode or Shutter Priority mode to set a shutter speed of 1/30 second to start and go slower from there, sometimes as low as 1/10 or 1/5 second (see Figure 10.6). The station is a never-ending sea of people who are constantly moving, making it a perfect place to try this technique.

10.6 Hurrying feet at Grand Central Terminal. Taken at ISO 400, f/8, 1/30 second using a 50mm lens.

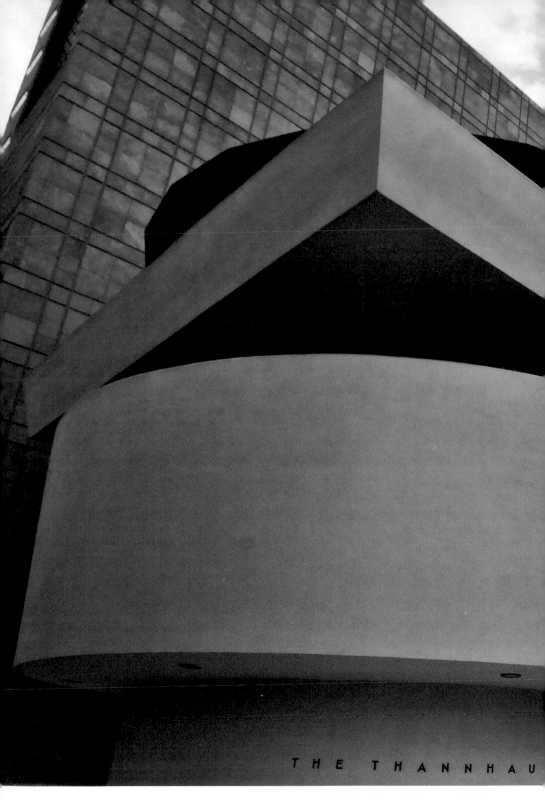

THE THANNHAU

The Guggenheim Museum on a fall afternoon. Taken at ISO 200, f/6.3, 1/400 second with a 16-35mm lens.

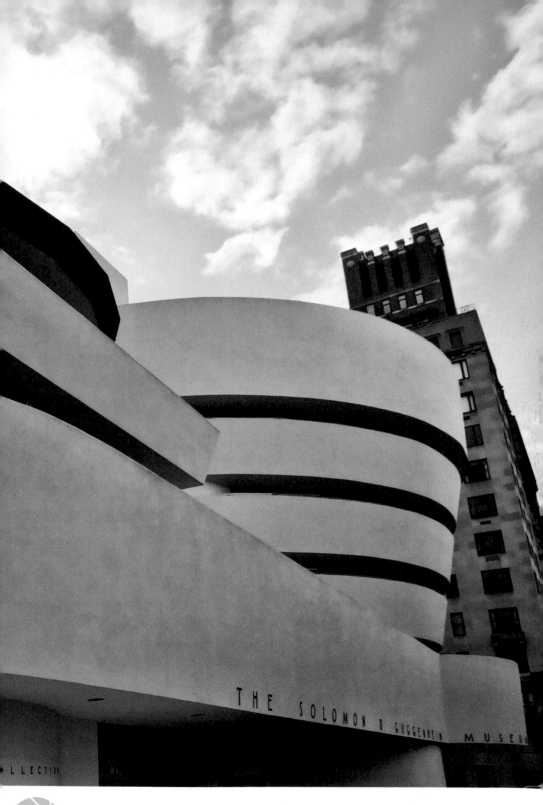

11 The Guggenheim Museum

Why It's Worth a Photograph

Located on Fifth Avenue at 89th Street, the Solomon R. Guggenheim Museum is Frank Lloyd Wright's only New York City building and his last major work. Although divisive when originally opened, the building is now viewed as one of Wright's most impressive achievements in a portfolio of masterpieces. The building features a distinctive round exterior and a helical spiral ramp that rises above the large rotunda lit by a massive skylight. The Guggenheim Museum offers you an opportunity to capture beautiful imagery while being inspired by a vision of unique architecture.

Where Can I Get the Best Shot?

The best locations from which to photograph the Guggenheim Museum are on Fifth Avenue and 89th Street and the rotunda.

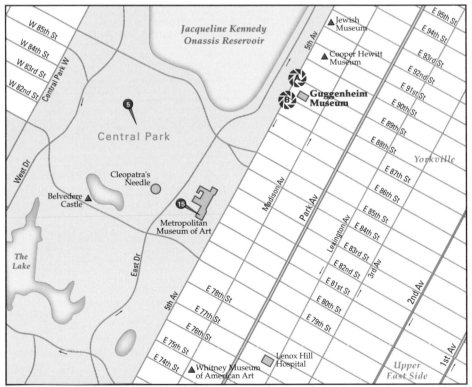

The best vantage points from which to photograph the Guggenheim Museum: (A) Fifth Avenue and 89th Street, (B) the rotunda. Other photo ops: (5) Central Park and (15) Metropolitan Museum of Art.

11.1 A portion of the facade of the Guggenheim Museum on a cold winter morning (see A on the map). Taken at ISO 200, f/7.1, 1/160 second with a 24-105mm lens.

Fifth Avenue and 89th Street

The Central Park facing facade of the building is an exploration in shapes and lines. The building has few corners. A standard zoom lens from the street corner allows you to create images that contain small pieces of the building yet still invoke a feeling of the whole (see Figure 11.1). A wide-angle lens from the same spot presents the building in its surroundings yet is close enough to avoid too much distraction from signs and streetlights.

Finally, use an ultrawide-angle lens from immediately in front of the building to view its distinctive features against the sky (see Figure 11.2).

11.2 Looking up at the Guggenheim Museum from the sidewalk below. Shot at ISO 200, f/9, 1/160 second, +1/3 EV with a 16-35mm lens.

The rotunda

The building's rotunda is at the center of the gently spiraling ramp that takes you from the ground to its apex six levels up. You can enter the building and view the rotunda without purchasing a ticket. However, you must wait in line for a ticket if you want to ascend into the museum proper or access any of its facilities.

At the top of this open area is a large skylight that lights up the space beautifully, although little of this light makes it into the display spaces, which are lit with artificial lights.

Besides shooting straight up into the open space with a wide or ultrawide-angle lens, try moving to the periphery and shoot out from underneath the upper levels (see Figure 11.3).

When shooting up, be sure that you are either centered under the skylight or well off-center. If you are slightly off-center, your composition will feel unbalanced.

After you have your ticket, be sure to check out the triangular staircase behind the elevators (see Figure 11.4). You can also explore the details with a standard telephoto lens.

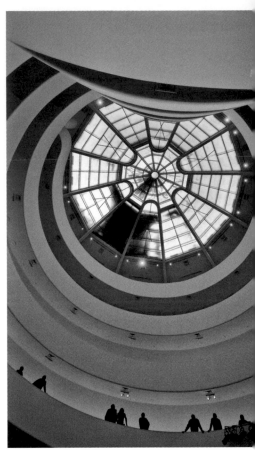

11.3 Looking up at the skylight and the spiral ramp in the rotunda (see B on the map). Taken at ISO 640, f/5, 1/25 second, +1 EV with a 16-35mm lens.

You are not allowed to take photographs above the rotunda level of the museum, but don't let this stop you from exploring the rest of the building. Even if you cannot create images with your camera, the architecture and the rotating art collections are incredible. Try viewing the rotunda from the fourth level opposite the abutment and allowing your eyes to explore the scene. It is an awesome sight.

11.4 Looking directly up the triangular staircase at the Guggenheim. Shot at ISO 1600, f/4, 1/20 second, +2/3 EV with a 16-35mm lens.

How Can I Get the Best Shot?

When exploring the building's shapes and lines outside, pay careful attention to keeping unwanted objects out of the edges of your frame. A crosswalk light or parked car in the corner of your shot won't carry the same magic as the same composition without those distractions.

Take advantage of the beautiful afternoon light as the sun sets over Central Park. A blue sky with a few clouds for contrast against the building is optimal. When inside the museum, be aware of the rotunda skylight fooling your light meter.

 The Guggenheim is open Friday through Wednesday, closed Thursday. It is one of the few major museums in the area to be open on Monday.

Equipment

Although you cannot bring large backpacks into the display areas, there is a coat and bag check if you are willing to check your equipment. Otherwise, don't bring so much gear that you can't ascend to the top of the museum because you will miss some inspiring views.

Lenses

▸ **A standard zoom in the 24-105mm range.** This lens offers you the ability to travel light. From shooting wide to a short telephoto, this lens covers the major range of options you will want for this museum. You can pick out architectural details when zoomed in or capture the whole building or rotunda in a single frame from the right locations.

▸ **An ultrawide-angle zoom in the 16-35mm range.** This lens lets you capture the entire building, both inside and out, from perspectives not available elsewhere. By allowing you to get close, you can increase your chance of having a cleaner image with less clutter in the frame.

▸ **A wide-angle fisheye lens.** As the entire building is made of curves, a fisheye lens is a natural fit to explore and accentuate those lines.

Filters

When shooting outside against the sky, a polarizing filter can help increase the contrast of the beige building against the sky. Deepening and darkening the blue of the sky, the curved exterior really pops when you use this filter on a clear day.

Extras

If you do not plan on visiting the museum's interior, a tripod would offer two advantages. The tripod would offer the ability to shoot the building at night when the long exposures would preclude shooting by hand and improve your ability to create HDR images. Tripods are not allowed inside the building at all, even in the rotunda. A pocket gray card can help you sort out the mix of lights inside the building by allowing you to create a custom white balance.

Camera settings

The light beige of the inside and out of the Guggenheim Museum can easily fool your camera's built-in meter as it tries to expose for a neutral gray. Check your histogram and image review after your first few shots to determine how much exposure compensation is needed. The skylight in the rotunda is also likely to cause your camera to underexpose. With all of these challenges, bracketing your exposures and shooting in RAW is a good idea in order to have the most latitude in the digital darkroom.

Exposure

Exposure compensation is key to getting a good exposure out of the camera. If you do not increase your compensation by 1/2 to one full stop, you will end up with an underexposed image any time the light-colored building dominates the frame.

Watch that you don't blow out the highlights, though, especially when including the rotunda skylight or clouds in your frame.

Increasing or decreasing your exposure allows you to use your camera's built-in meter and then tweak that reading based on the scene. An all-white or very light scene causes your camera to underexpose, so increase the exposure compensation by 1/2 to 1 stop.

Shooting in Aperture Priority mode allows you to control your depth of field with the turn of a dial.

White balance

Outside, the white balance is fairly straightforward. Use Cloudy or Sunny presets as applicable. Inside, you are working with a mix of natural and artificial light. Bring a pocket gray card to get your settings close with a custom white balance, but if you are shooting a wide-angle scene you will have a mix of colors no matter what.

ISO

The lighting indoors can be dim and may require increasing your ISO to 800 or 1600, especially if you are there in the evening. Outside, you want to keep your ISO as low as possible to ensure the cleanest digital file. At sunrise or sunset, you can increase the ISO as needed to ensure that you get an image.

Ideal time to shoot

The museum opens at 10 a.m. and is quiet in the morning during the week. If you want shots of the rotunda without too many people, this time of day is your best bet. The same suggestion applies to shooting wide-angle shots outside. Otherwise, sunset into twilight is a great time to shoot the building's exterior, because it is awash from sunlight filtering through the trees on the eastern edge of Central Park.

Rain and snow can always be difficult to shoot in, especially if you do not have the right clothing or protection for your gear. During the winter, the rotunda's skylight is often partially covered in snow, which could add a unique and singular element to a shot taken a million times.

Low-light and night options

The light indoors is sometimes a bit challenging, more so after sunset when the skylight is no longer adding sunlight to the artificial lights inside. Sometimes, the museum has shows with spotlights or laser light exhibits. Use spot metering mode when shooting these high-contrast lighting situations. Outdoors, the

museum sometimes has colored lights across the facade at night, which can add a new touch of color to your images.

Getting creative

Try an upward-facing portrait of a traveling companion or yourself from the rotunda. Place your camera on the floor with a self-timer and sit, kneel, or stand over it. Set your camera to a small aperture of f/8-f/16 and prefocus on your feet and then disable autofocus to ensure that you are in sharp focus after the camera is on the ground. You will have an iconic image of the Guggenheim rotunda that includes you or a traveling companion.

When outside, the building has been looked at in every way possible, so try looking away instead and see if you can still see it. Reflections on car windows, in puddles, or in a street vendor's mirror can provide a new look at the building (see Figure 11.5).

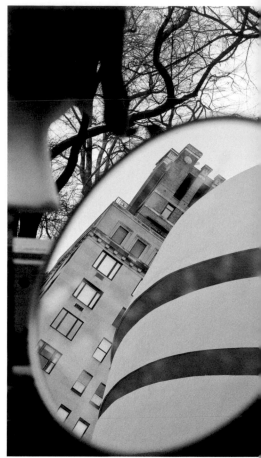

11.5 The Guggenheim Museum reflected in a street vendor's mirror framed by trees overhanging Central Park. Taken at ISO 200, f/8, 1/200 second with a 24-105mm lens.

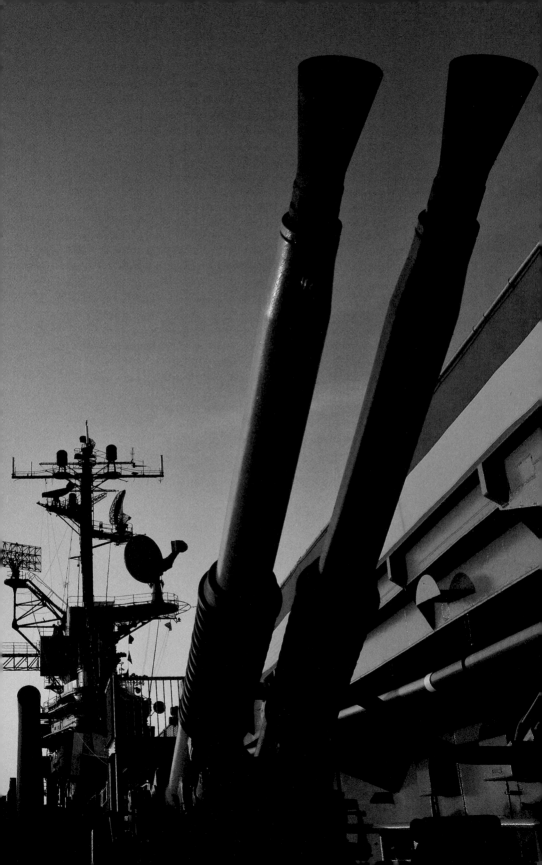

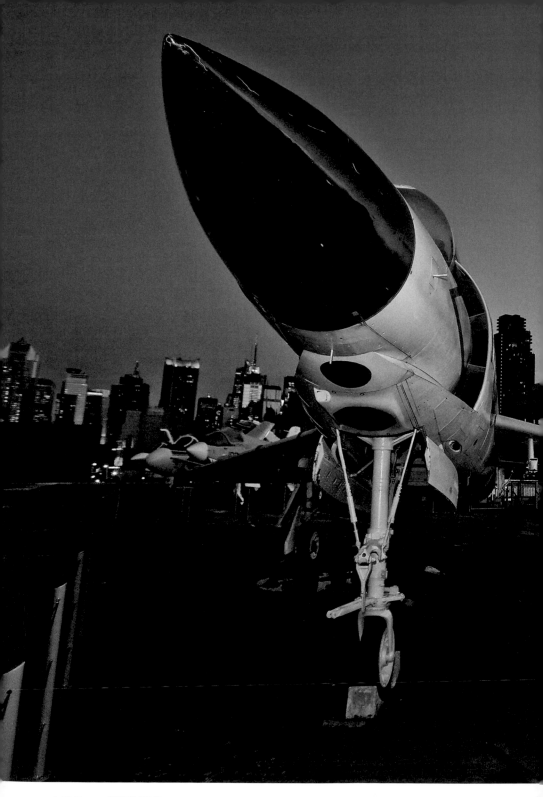

A McDonnell F3H-2N Demon sits on the deck of the USS Intrepid during a fall sunset. Taken at ISO 800, f/5, 1/30 second with a 16-35mm lens.

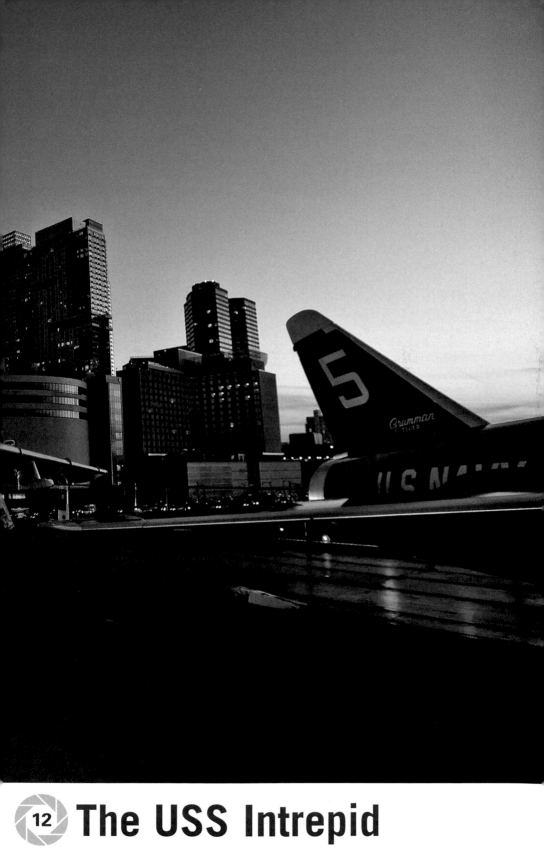

🄌 The USS Intrepid

Why It's Worth a Photograph

The USS Intrepid sits at the heart of the Intrepid Sea, Air & Space Museum at Pier 86 on Manhattan's West Side. The aircraft carrier houses one of the best Cold War aircraft collections in the country, and the museum grounds provide opportunities to capture excellent images of one of the last four Essex-class aircraft carriers in existence.

This impressive ship, launched on April 26, 1943, offers a unique opportunity to get up close to a World War II and Vietnam War aircraft carrier. The Intrepid's rich history includes being the first U.S. carrier to use steam catapults; it was also the recovery ship for the Mercury and Gemini space missions.

The 872-foot-long flight deck and spacious hangers are home to 30 aircraft, while the 2006 interior renovation opened new areas of the museum ship to the public, including the machine shop and the anchor chain room.

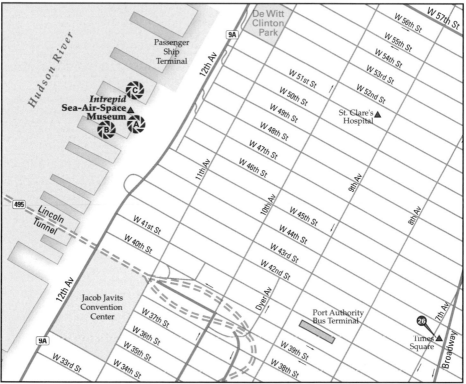

The best vantage points from which to photograph the USS Intrepid: (A) 12th Avenue in front of the bow, (B) the flight deck, and (C) the USS Growler. Other photo ops: (26) Times Square.

Where Can I Get the Best Shot?

The best locations from which to photograph the USS Intrepid are from the 12th Avenue sidewalk and the flight deck. The USS Growler submarine also offers a great photographic opportunity.

12th Avenue in front of the bow

The sidewalk along 12th Avenue offers a good vantage point for a photograph of the USS Intrepid before you even enter the museum. The ship's name is prominently displayed across the bow and the 902-foot overall length of the ship shot off center creates an incredible sense of depth (see Figure 12.1).

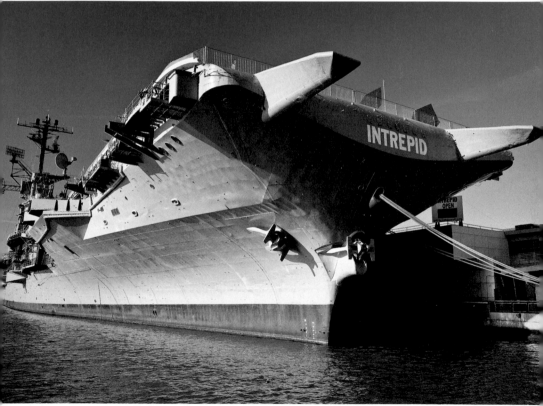

12.1 A view of the USS Intrepid's bow taken on a clear fall afternoon from the sidewalk off of 12th Avenue (see A on the map). Taken at ISO 200, f/7.1, 1/160 second, -1/3 EV with a 24-70mm lens.

The flight deck

The Intrepid's flight deck offers a multitude of photographic opportunities from sweeping wide-angle shots of the whole deck to individual portraits of a range of Cold War jet planes and helicopters (see Figure 12.2).

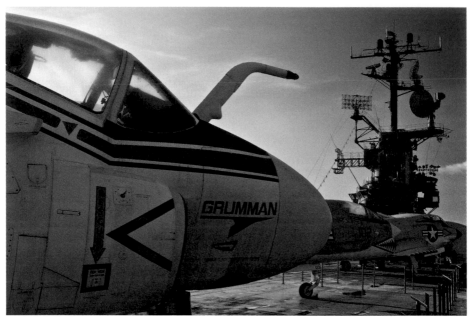

12.2 A fall afternoon view from the flight deck showing a line of aircraft and the superstructure (see B on the map). Taken at ISO 200, f/11, 1/60 second with a 24-70mm lens.

Images of the aircraft and the superstructure are both impressive and can be combined for an image with even more punch. A wide-angle lens adds drama to the aircraft or it can accentuate the vastness of the deck. A normal or medium telephoto lens allows you to isolate individual aircraft or specific details, which can be beneficial on a crowded day.

The USS Growler

The exit of the USS Growler submarine exhibit offers an excellent opportunity to isolate the stern of the boat (see Figure 12.3). You can capture a clean image of the stern from the gangway across the submarine to the pier. This angle features the USS Growler's name and is mostly free from the myriad distractions you find with most other angles of this museum display, such as floats, distracting colors, and the Manhattan skyline.

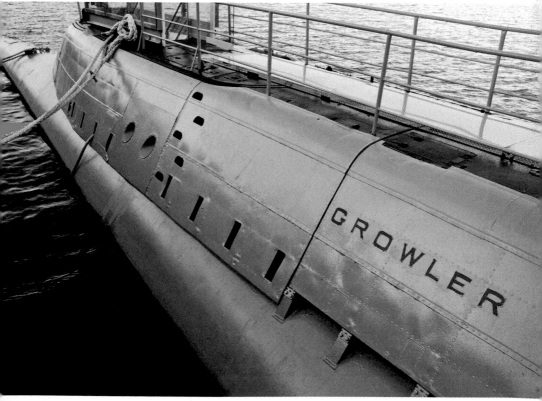

NOTE The USS Growler tour states no backpacks or bags are allowed due to the confines of the boat. Secure storage is not provided for your camera bag so you may need to have someone hold it if you want to go inside.

How Can I Get the Best Shot?

Don't bring too much gear if you plan on venturing inside any of the ships. The tight corridors and spaces of the USS Intrepid make carrying a camera bag full of lenses quite a challenge. Other portions of the museum, such as the USS Growler, do not allow bags at all. A clear blue sky offers excellent contrast to the gray steel present nearly everywhere on the ship and elsewhere in the museum.

You will want to be careful of direct reflections from the sun on the polished steel, especially when photographing the aircraft. This can cause underexposure of your image or blown-out highlights. Look for interesting shots from inside the ship looking out onto the carrier's flight deck or including the Manhattan skyline (see Figure 12.4).

12.3 The stern of the USS Growler submarine at the Intrepid Sea, Air & Space Museum on a fall afternoon (see C on the map). Taken at ISO 200, f/7.1, 1/100 second, +2/3 EV with a 24-70mm lens.

12.4 A view of the captain's bridge of the USS Intrepid looking out on the Manhattan skyline on a fall afternoon (see C on the map). Taken at ISO 400, f/8, 1/40 second with a 24-70mm lens.

Equipment

A wide-angle to short telephoto zoom lens offers a variety of options all around the museum while not forcing you to carry a lot of equipment in the tight quarters and steep stairwells of the ship.

Lenses

A standard zoom lens in the 24-100mm range allows you to capture wide shots of the ships and aircraft. It also allows you to isolate specific aircraft or features of the ship. It also generally offers small minimum focusing distances so you can isolate small details such as an instrument on the captain's bridge or the myriad signs, allowing you to record the details of interesting exhibits.

Filters

A polarizing filter will help to reduce the reflections on the water and undersides of the ship, increasing the contrast and drama of images that include these elements. It also darkens and saturates the blue of the sky, providing more contrast and separation between the ship and the sky.

Extras

While not necessary for most of these images, a flash can be useful if shooting environmental portraits with aircraft against a bright sky. You should avoid using a flash inside of the ship, opting instead for a high ISO and larger aperture. This will allow you to capture the interesting colors and lighting present throughout the body of the ship. A pocket gray card might be useful as well for these ambient light photos inside the ship. The gray card will help you set a custom white balance for a specific scene.

Camera settings

For most of the museum, especially outdoors, you want the large depth of field offered by a smaller aperture of f/8-f/11. Be conscious of specular highlights caused by the reflection of the sun outside. Indoors, be aware of slow shutter speeds when shooting with available light and use the largest aperture available on your lens.

Exposure

Outdoor exposures are straightforward using your camera's automatic metering. You will want to watch out for a bright sky or a shadowy section of an image fooling your meter and adjust your exposure compensation accordingly. Indoors you will have to be careful to keep up your shutter speeds while handholding. Aperture Priority mode allows you the most control over the depth of field.

White balance

Outside, an Auto white balance will work very well. Inside, the dramatically varying light levels and colors will be a challenge. Use a pocket gray card and shoot in RAW mode to ensure the most flexibility in the digital darkroom.

ISO

A low ISO will be best for all the outdoor shots; 100-200 on a clear day, up to 400 on a cloudy day. Inside you will have to go to 800 or 1600 in order to handhold the camera without a flash.

Ideal time to shoot

The museum is open all year and is much less crowded on weekdays and in the winter. You have a better chance to capture wide-angle shots without tourists in your images during those times. Otherwise, be aware of the forecast because most of the interesting photo opportunities are outside.

Rain is always a challenge when shooting outdoors. Watch for rain and snow and try for a clear blue sky for the most contrast between the ship, aircraft, and sky.

Low-light and night options

The museum closes at 5 p.m. ten months out of the year. If you are there from late November to late January, there are wonderful sunset images available. This really adds to the feeling of being out to sea as the sun sets over the horizon near the Statue of Liberty.

Inside the ship, the crew sections are behind plexiglass. Turn off your flash and put the lens right up against the plexiglass to stabilize the camera at slow shutter speeds and cut out reflections off the shiny surface.

Getting creative

One of my favorite techniques is to get low. Get right down on the flight deck with your camera at the wide end of your zoom and shoot a dramatic portrait of one of the fighter aircraft.

13 Manhattan From Roosevelt Island

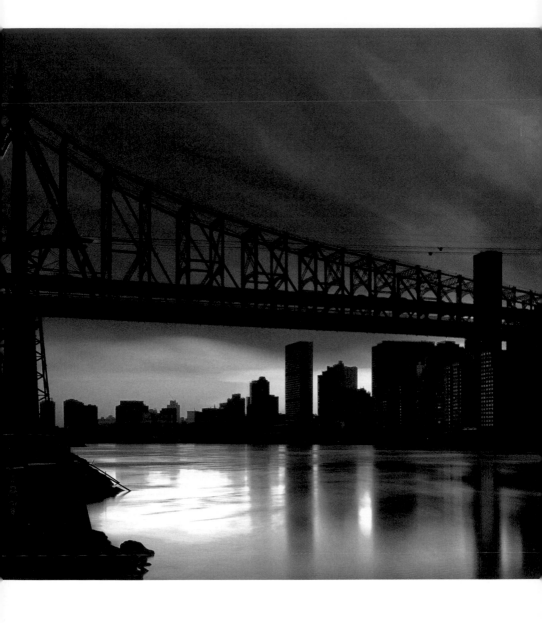

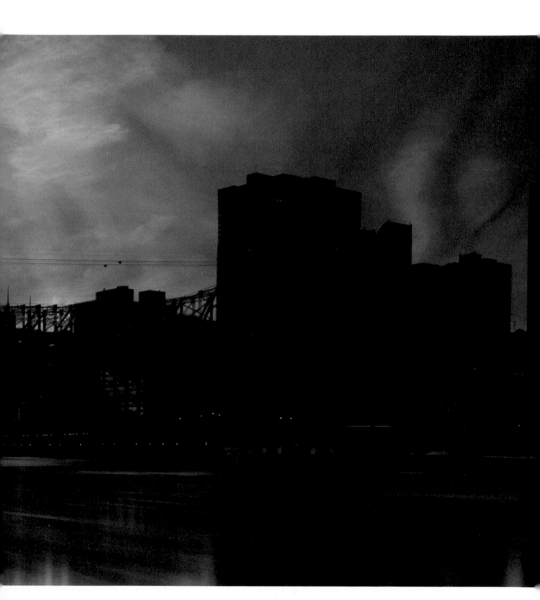

Manhattan from the southern end of the Roosevelt Island Western Promenade just before sunset on a cold winter afternoon. Taken at ISO 100, f/5.0, 25 seconds with a 24-70mm lens with a 10-stop neutral density filter.

Why It's Worth a Photograph

Located in the middle of the East River, two-mile long Roosevelt Island offers unique views of Manhattan. The island offers numerous opportunities to make panoramic images of the city and provides views of well-known buildings from a new angle. The iconic Roosevelt Island Tramway offers direct access from Manhattan as well as beautiful views from up to 250 feet over midtown and the East River on the north side of the Queensboro Bridge. You won't want to miss watching the city light up as twilight descends into night over Manhattan.

Where Can I Get the Best Shot?

The best locations to take photos of Manhattan from Roosevelt Island are along the Western Promenade, from Southpoint Park and from the tram.

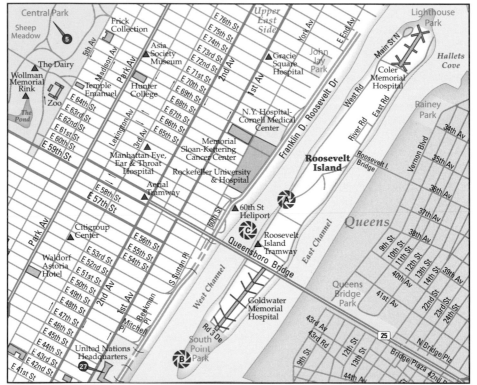

The best vantage points from which to photograph Manhattan from Roosevelt Island: (A) along the Western Promenade, (B) Southpoint Park, and (C) the Roosevelt Island Tramway. Other photo ops: (5) Central Park and (27) United Nations Headquarters.

Along the Western Promenade

The Western Promenade runs from just north of the subway up to Lighthouse Park on the northern tip of the island. Looking south from its southern terminus offers a great view of the city that includes the United Nations Headquarters and Trump World Tower all framed around the Queensboro Bridge.

Long exposures looking out over the East River smooth the water to a glass-like finish. From this location, the sun sets over the city behind the United Nations Headquarters on 42nd Street in the winter to just north of the bridge at the summer solstice. Using a wide-angle to normal zoom lens enables you to capture large swaths of the city, and a telephoto lens makes it possible to isolate smaller sections (see Figure 13.1).

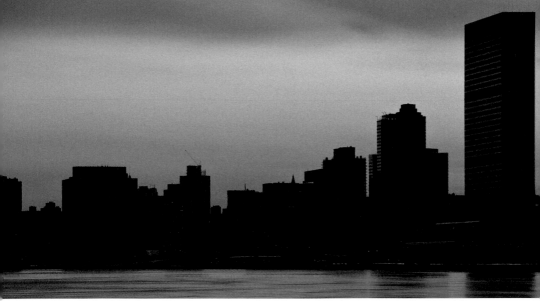

13.1 The United Nations Headquarters and midtown Manhattan over the East River on a blustery winter afternoon just minutes before sunset (see A on the map). Taken at ISO 100, f/5, 15 seconds with a 70-200mm lens.

Southpoint Park

On the southern tip of the island is Southpoint Park. As of early 2010, the 12-acre park was under heavy construction but is still accessible during the day until about an hour after sunset. You have plenty of time to observe the sunset and civil twilight from midtown all the way south to the Williamsburg Bridge and portions of

Brooklyn and Queens. This location is ideal for capturing a large panorama because you can get within a few feet of the very tip of the narrow point of the island (see Figure 13.2).

Moving north from the very tip, you can see the Queensboro Bridge and the beautiful cherry trees that run from south of the bridge into Southpoint Park. A wide-angle to normal zoom lens gives you a range of options when shooting panoramas or large sections of the city.

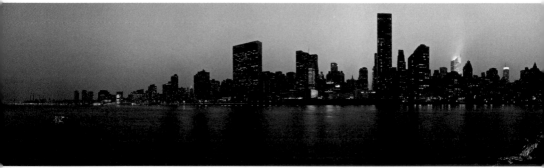

13.2 A nine-image panorama of midtown Manhattan south to the Willamsburg Bridge during a heavy winter snowstorm in late December twilight (see B on the map). Taken at ISO 200, f/11, 6 seconds with a 16-35mm lens. Panorama stitched together with Adobe Photoshop CS4.

The Roosevelt Island Tramway

The tram provides one of only two methods of directly accessing the island from Manhattan and is by far the most photogenic. However, if you don't like heights, you may want to consider taking the F train instead. Otherwise, the reasonable cost for a one-way or round trip provides stunning views from the north side of the Queensboro Bridge as the tram takes you from 60th Street and Second Avenue over the East River, climbing to 250 feet.

During the four-and-a-half minute ride, you will fly high over First Avenue, glimpse peeks of the Empire State Building, and have amazing views both north and south over the East River. A wide-angle to short telephoto zoom is ideal for this ride, and you want to keep your shutter speeds high to ensure sharp photos as the tram speeds you along to your destination (see Figure 13.3).

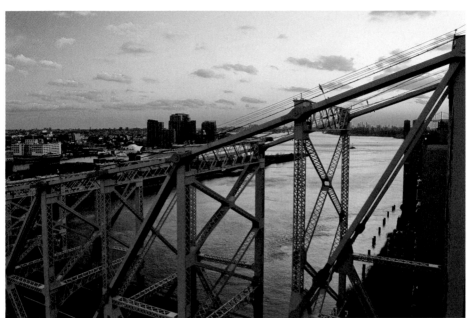

13.3 The Queensboro Bridge dominates the foreground of this image looking south during the tram ride to Roosevelt Island on a winter afternoon (see C on the map). Taken at ISO 500, f/5, 1/60 second with a 24-70mm lens.

How Can I Get the Best Shot?

Plan to arrive at Roosevelt Island about an hour before sunset and stay about an hour after. Doing so gives you time to explore and find a good location to shoot. You can also take a round-trip ride on the tram near sunset and take some fun pictures from high above the city. Bring a tripod for the promenade and Southpoint Park, so you can take long exposures during sunset and into civil twilight.

Equipment

Shooting in an open environment gives you freedom to bring more gear if you want to try creating different images. However, I suggest taking multiple trips instead, so you don't miss the sometimes fleeting moments of sunset magic as you are worrying about changing lenses.

Lenses

▶ **A standard zoom lens in the 24-105mm range.** This lens gives you a wide range of possibilities from sweeping wide angles to isolating just a few buildings directly across the river. From the tram, it allows you the same freedom on a very short ride.

- ▶ **An ultrawide-angle zoom lens in the 16-35mm range.** Such a wide-angle lens gives you the option of creating very wide panoramas in a smaller number of shots, or to create a panorama from a single shot by cropping during post-processing. You can also play with the distortion it provides by shooting into the water or up into the sky, causing either of these to appear exaggerated in the frame.

- ▶ **A wide-angle fisheye lens.** With a fisheye lens, you can really get a large part of the skyline in a single shot with the interesting distortion created by this lens.

- ▶ **A telephoto zoom lens in the 70-200mm range.** This lens allows you to really isolate individual buildings or features. From Southpoint Park, you can capture just the United Nations Headquarters or Trump World Tower and from the promenade you can zoom way in and capture the tram as it soars above your head into the setting sun. This lens would be difficult to use while riding the tram, however, due to the high shutter speed that would be required to get a sharp image while the car shakes and sways.

Filters

Neutral density filters allow you to lengthen your shutter speeds. Because your images will likely include the East River, longer shutter speeds of 5 to 30 seconds or more let you smooth out the surface of the river with a single image rather than combining multiple exposures later in the digital darkroom. The glass-flat look of the water with such an exposure looks magical (see Figure 13.4).

Extras

You want to bring a tripod to Roosevelt Island. You can carry it on the tram or on the subway without any problems, in a bag or over your shoulder. Long exposures absolutely require using a tripod, and it is a nice thing to have for panoramic shots.

Camera settings

Shooting at sunset and twilight can be very challenging for your camera's internal meter, especially if you are trying multiple compositions as the light is fading. If you have a newer camera with Live View, this is an excellent opportunity to utilize that feature. Live View can help you visualize the exposure by using the Exposure Simulation setting. By digitally zooming in to 10x, you can manually focus in low light when your camera may no longer be able to autofocus. Panoramas require a whole different set of rules.

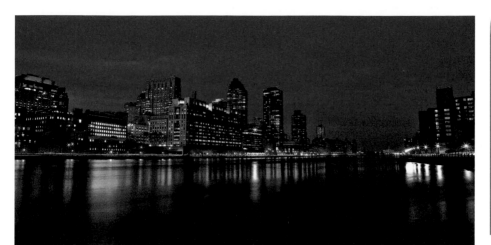

13.4 Looking north from the southern end of the Western Promenade during the blue hour on a cold winter evening. Taken at ISO 100, f/13, 30 seconds with a 24-70mm lens.

Exposure

When shooting into a sunset, capturing the full dynamic range of a scene is difficult. In order to capture the colors of the sky, you will likely end up with a silhouette of the skyline. Alternatives to this are to bracket your shots and create composite or HDR images in the digital darkroom. As the light fades, you can slowly increase the exposure time or decrease the f/stop to compensate for the decreasing light. Manual mode gives you the most control in rapidly changing light.

White balance

Set your white balance to Sunny or Cloudy and shoot in RAW mode to ensure that you can tweak the color temperature later if needed.

ISO

Shoot with the lowest ISO possible, especially for longer exposures. When riding the tram, increase your ISO to 400 or higher, if needed, to ensure a fast enough shutter speed.

Ideal time to shoot

Sunset is stunning from Roosevelt Island, as the sun fades behind the city. In spring, the path to Southpoint Park offers blooming cherry trees as a beautiful foreground element.

Shooting for Panoramas

Sometimes you just want to go wider. Instead of using an ultrawide-angle lens, you can capture multiple images and stitch them together in the digital darkroom. Programs such as Adobe Photoshop CS3 and CS4 are excellent at creating these multishot images with almost no user intervention. Some tips for shooting panoramas:

▶ Ensure your exposure mode is set to manual, your autofocus is disabled, and your white balance is set to a custom or preset, not Auto. You don't want any of these settings changing throughout the panorama.

▶ Use a tripod, if possible, and make sure that it is level. If shooting by hand, reset your feet every three to four shots.

▶ Shoot with the longest zoom possible to get the field of view you want vertically while leaving some padding.

▶ Shoot in portrait orientation and overlap each frame by at least 25 percent.

▶ If buildings are in the panorama and you are shooting wider then 50mm, make sure that any prominent ones get an exposure with the building near the middle of the frame to avoid distortion.

▶ To make it easier to isolate the panorama later, put your hand in a shot before the first frame and after the last frame. Like your power strip, use a vertical line to indicate the start and a circle or fist to indicate the end.

▶ Shoot in RAW and expose to the right, just like any other digital image.

▶ Before processing in Photoshop, do your RAW edits in your RAW editor and make sure that you do the same edits to all the files.

▶ After creating the panorama, work on this new file as though it is a fresh image. It isn't *done* until you are satisfied.

As long as you protect your gear, rain and snow can create beautiful effects when shooting a skyline (see Figure 13.5). Don't forget that you are on an island in the middle of a river. The temperature on Roosevelt Island is much colder than in the city and even colder at Southpoint Park. Bring extra clothes and be aware that your batteries may not last as long, especially in the colder months.

Low-light and night options

Civil twilight is an incredible time to shoot, morning or night. The city lights are still ablaze, but the sky is transitioning from night to day, or day to night. The blue hour gives a wholly different look to the city.

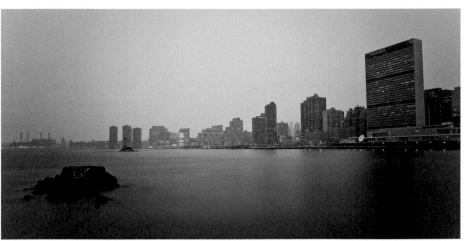

13.5 A view of the East River and the United Nations Headquarters at dusk during a heavy winter snowstorm. Taken at ISO 200, f/2.8, 240 seconds with a 16-35mm lens with a 10-stop neutral density filter and a cable release.

Getting creative

Watch for ships traversing the river and capture them in your images. If you use a one-or two-second shutter speed you can impart a sense of motion to the ship against the static background of the city (see Figure 13.6).

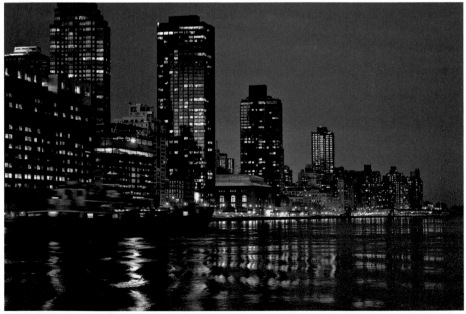

13.6 Manhattan and a passing ship during the blue hour on a chilly December evening. Taken at ISO 200, f/2.8, 0.8 seconds with a 24-70mm lens.

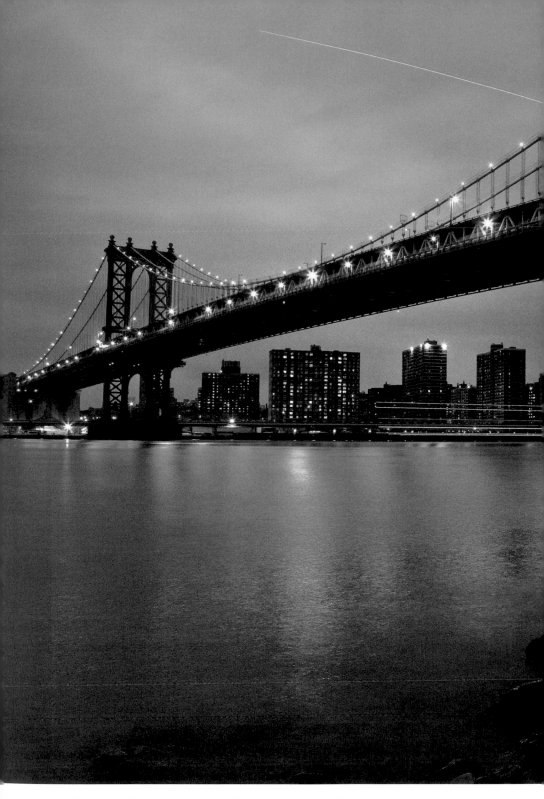

The Manhattan Bridge from the shoreline of the Brooklyn Bridge Park. A plane streaks across the sky after takeoff from Newark Airport while the lights of a slow barge head out into the Upper Bay on the East River. Taken at ISO 400, f/10, 30 seconds with a 24-105mm lens.

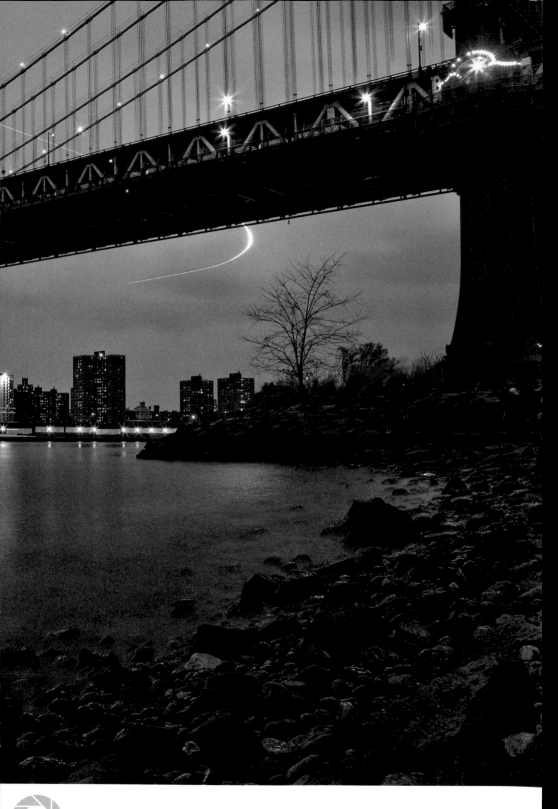

Why It's Worth a Photograph

The Manhattan and Williamsburg bridges connect lower Manhattan to Brooklyn. Built around the turn of the nineteenth century, both suspension bridges still carry both car and rail traffic in addition to offering pedestrian walkways. Although neither of these bridges carries the same cultural significance as the neighboring Brooklyn Bridge, they are still historically significant and famous in their own rights.

As the bridges straddle the East River, the boroughs of Manhattan and Brooklyn offer wonderful backdrops for sunset and twilight imagery. The austere metal construction of both the Manhattan and Williamsburg bridges contrasts with the neighboring Brooklyn Bridge's stone frame. Their design offers a simplified, architectural feel which stands out very well when backlit by a sunrise or sunset. These two magnificent bridges are an excellent place to start or end your photographic day.

The best vantage points from which to photograph the Manhattan and Williamsburg bridges: (A) Brooklyn Bridge Park and (B) underneath FDR Drive. Other photo ops: (2) Brooklyn Bridge and (6) Chinatown.

Where Can I Get the Best Shot?

The best places to photograph the Manhattan and Williamsburg bridges are from Brooklyn Bridge Park and from underneath FDR Drive.

Brooklyn Bridge Park

From its beginnings as the Empire-Fulton Ferry State Park, the Brooklyn Bridge Park now extends north and south and will continue to grow over the next decade. This new urban oasis offers excellent views of Manhattan and the three bridges. The Fulton-Ferry pier and Main Street Lot surrounding Empire-Fulton Ferry form the three best locations in Brooklyn Bridge Park to create images of the Manhattan and Williamsburg bridges.

As sunset fades to twilight and evening, the bridge and city alight with a rainbow of colors. Taking long exposures on a tripod transforms your images into magical photographs that leave those who view your photographs in awe. You can use wide and ultrawide-angle lenses to capture a broad view of the bridges against the city, and a telephoto zoom can isolate portions of your subjects while compressing the apparent distance to the urban backdrop (see Figures 14.1 and 14.2).

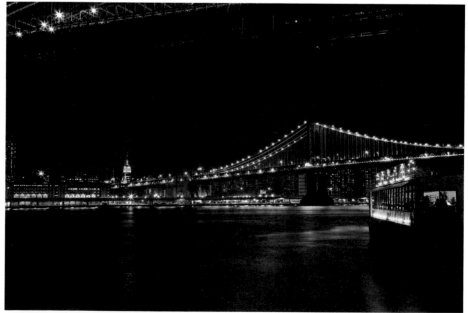

14.1 The Manhattan Bridge and the Empire State Building framed by the Brooklyn Bridge as seen from the Fulton Ferry docks in Brooklyn Bridge Park on a cold winter night (see A on the map). Taken at ISO 200, f/11, 30 seconds with a 24-105mm lens.

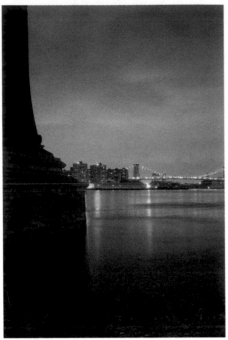

14.2 The Williamsburg Bridge from Brooklyn Bridge Park at twilight on a winter evening. Taken at ISO 400, f/13, 30 seconds with a 24-105mm lens.

Underneath FDR Drive

On the Manhattan side, the East River Bikeway under FDR Drive offers great views of these bridges. As you are facing east, position yourself to shoot images of the sun rising behind the bridge in the morning twilight. Consult a sunrise chart online and bring a compass to determine exactly what time and direction the sun will begin to rise behind Brooklyn and Queens (see Figure 14.3).

The bikeway is more than wide enough to bring a tripod and create long exposures, which will smooth out the East River's often turbulent waters. The smooth surface offers a beautiful look that increases the colors and brightness of the sun's reflected light (see Figure 14.4).

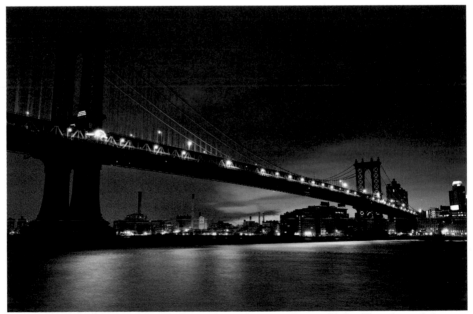

14.3 Manhattan Bridge over Brooklyn during the morning twilight. The glow of the sun is just beginning to light up the sky behind the bridge on a windy winter morning. Taken at ISO 100, f/7.1, 25 seconds with a 16-35mm lens.

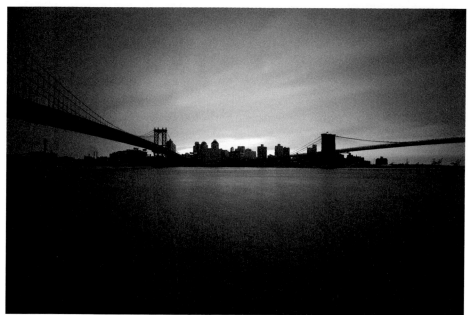

14.4 The Manhattan and Brooklyn Bridges shortly after the sun rises behind them on a cold winter morning. Taken at ISO 200, f/5.6, 30 seconds with a 16-35mm lens.

How Can I Get the Best Shot?

Time of day and location are especially important when creating sunrise and sunset images of the bridges. You need to be sure that you are in the right spot to get the shot you want and that you are there at the right time. Being confident in your equipment and camera settings is also important, because this time of day, the right light is fleeting.

Finally, persistence pays off. Every sunrise and every sunset will be different, with different colors and patterning of clouds in the sky. A tripod and a cable release or a self-timer is useful if you plan on doing long exposures. Wide and ultrawide-angle lenses are generally what you will be utilizing, although a telephoto zoom offers its own set of possibilities.

Equipment

Previsualization of your images can help minimize the amount of unnecessary equipment you will need to bring to your chosen photographic site. For long exposures, a tripod is a necessity, however, so find a good photo backpack in which to carry your gear — including a tripod. A variety of neutral density filters can also help in creating the magical long exposure images.

Lenses

▶ **A standard zoom in the 24-105mm range.** A standard zoom lens that goes from wide to short telephoto allows you to travel light and not worry about changing lenses or needing a backpack.

▶ **An ultrawide-angle zoom lens in the 16-35mm range.** Using ultrawide zoom lenses enables you to capture sweeping vistas of the river and bridges. Shoot low to the ground with this lens to include a large amount of the foreground in your image and create something that feels like you could step into the scene.

▶ **A telephoto zoom lens in the 70-200mm range.** A zoom lens allows you to isolate portions of the structures. It can also compress the apparent distance between the bridge and background buildings, such as the Empire State Building, which is visible behind the Manhattan Bridge from parts of Brooklyn Bridge Park.

Filters

Neutral density filters help to slow down your shutter speeds enough to create 5- to 30-second exposures, or even longer. A 10-stop neutral density filter can be used in the middle of the day and still give you 5- to 10-second exposure times, while 2- to 8-stop filters can be used before and after twilight to keep the shutter speeds up while maintaining ideal f/stops and ISO settings.

Extras

A sturdy, reliable tripod is critical when shooting long exposures. I also recommend a tripod strap if you intend to carry your tripod a long distance. Sling it over your shoulder opposite to your camera and walk hands-free to your various photo destinations. A good ball head for your tripod with quick release plates is also very useful. A tripod with a removable center column allows you to get extremely low to the ground or water.

A wired or wireless cable release is also important if your camera doesn't have a 2-second self-timer or if you want to take even longer exposures. The cable release helps your camera to remain still throughout the entire exposure, removing any vibration caused by depressing the shutter. A cable release also allows you to use bulb mode on your camera to exceed the 30-second maximum exposure time in Manual mode (see Figure 14.5).

Camera settings

Long exposures require a remote release of the shutter and repeatable settings. Use Manual mode or bulb mode and a cable release for exposures greater than 30 seconds. With today's digital cameras, you can immediately review your images and study the histograms, which is a huge advantage when shooting this type of imagery. This is especially true when using neutral density filters, which often block so much light that you can't see through the viewfinder at all.

Exposure

Obtaining a proper exposure can be challenging for long exposures during the fleeting minutes of twilight, sunrise, and sunset. Not only will the extremes of light confuse your exposure meter, but the light is constantly changing. Review your exposures often and make adjustments as necessary to adjust to the sun rising or setting. You may need some practice to learn how to create these images, but the final result is worth the effort. You can also try to create HDR images in the digital darkroom utilizing a bracketed set of images, both overexposed and underexposed.

14.5 The Manhattan Bridge from Brooklyn Bridge Park on a cold winter night. Taken at ISO 100, f/13, 120 seconds with a 24-105mm lens.

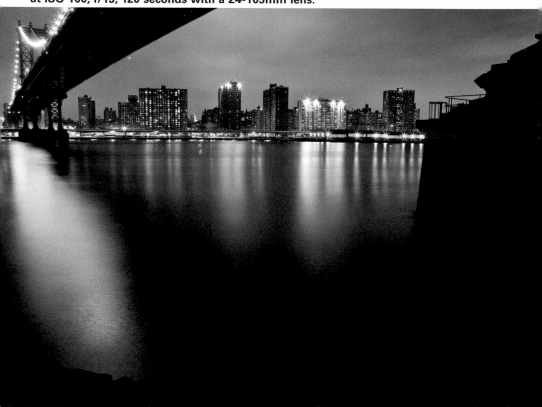

Using Manual mode is going to provide the most control of your exposures. You can still utilize the camera's meter by half-pressing the shutter button and watching if you are under/over exposed. However, the large dynamic range when shooting into the sun can trick your meter and you may want to bracket your images, or shoot exposures a stop or two over and under the reading from your meter. Doing so also gives you the option to create HDR images in the digital darkroom. If you don't want to bracket, review your images and histogram on the LCD screen to ensure that they are exposing the way you envisioned.

White balance

A Sunny or Cloudy white balance is a good place to start. Shoot in RAW mode to give yourself flexibility later. These images give you a great deal of creative latitude when you develop them into a final product, and RAW files provide you the greatest latitude to adjust them to meet your vision.

ISO

The lowest standard ISO available on your camera generates the least digital noise. Having a small amount of digital noise is even more important with a long exposure than with a short, handheld exposure. Long exposures have the propensity to generate more digital noise over the length of the exposure.

Noise reduction

In-camera noise reduction can be useful on certain models, but it generally requires a second exposure with a closed shutter to generate a profile, which is applied to that shot. Therefore, a 30-second exposure takes 60 seconds to complete, and that is a long time. Try one of the many excellent noise reduction software packages that you can use in the digital darkroom instead.

Ideal time to shoot

The sunrise is the best time to visit the Manhattan side, because the sun comes up over Brooklyn and Queens and behind the bridges. The colors in the sky combined with reflections of the both sun and artificial light off the water can make for a great image (see Figure 14.6). For the sunset, make your way to Brooklyn Bridge Park. Especially during the late spring through early fall, the sun sets off to your left but close to the Manhattan Bridge, and the afternoon light plays across the southern faces of the bridges.

It will be cold. You are shooting before and after sunrise and will be standing mostly still on the windy waterfront. Dress warmly and consider bringing hand

warmers to keep in your pockets or gloves.

Make sure that you have an outer shell to cut down the penetrating wind that can put a quick end to your day. Rain and snow can create interesting effects, but be sure that you and your gear are properly equipped to handle those conditions.

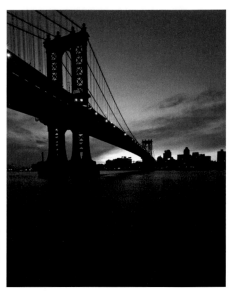

14.6 The Manhattan Bridge as the sun rises behind it and reflects off the East River on a chilly winter morning. Taken at ISO 50, f/20, 25 seconds with a 16-35mm lens.

Using Live View for Long Exposures

If your camera offers Live View, it can be an invaluable tool for long exposures. This feature has many benefits, including:

▶ **Previewing your exposure**. Instantly see what a change of aperture or shutter speed will do to the exposure.

▶ **Previewing your focal plane and depth of field.** Set your aperture and depress the Depth-of-Field Preview button. If the feature is available on your camera, digitally zoom 5x or 10x to manually fine-tune your focus.

▶ **Adjusting your composition without removing your neutral density filter**. With a neutral density filter, you often can't see through your viewfinder due to the very dark filter. However, Live View modes will still display the final exposure except in extreme cases.

▶ **Viewing your scene when your camera is set up at an odd angle**. When set up very low or very high on a tripod, it can be difficult to see through the viewfinder. Live View, however, allows you to see and adjust your composition without lying on the ground or needing something to stand on.

▶ **Setting your color temperature**. If your camera offers the ability to directly set color temperature, adjust it and get instant feedback as to how it will affect your image.

Low-light and night options

Watch the skies for planes, and keep an eye on the river for boats. You can have fun incorporating their movement into your images. If you use 10- to 30-second exposures, the crafts themselves will not show up, but their running lights will appear as streaks across your frame. Boats tend to make straight lines while aircraft usually carve large curves in the sky as they turn after taking off from one of the three international airports.

Getting creative

A self-portrait should be easy with your setup. Enable your built-in or accessory flash, ensure that you are within the focal plane, and get into the frame by using your self-timer. After the flash pops at the beginning of the exposure, just walk out of the frame.

The very bright flash should expose you close to the camera, and the shutter open for the remaining 30 seconds exposes the rest of the distant scene. Because the shutter is open for so long, your movements won't show up when you move out of the photo after the flash.

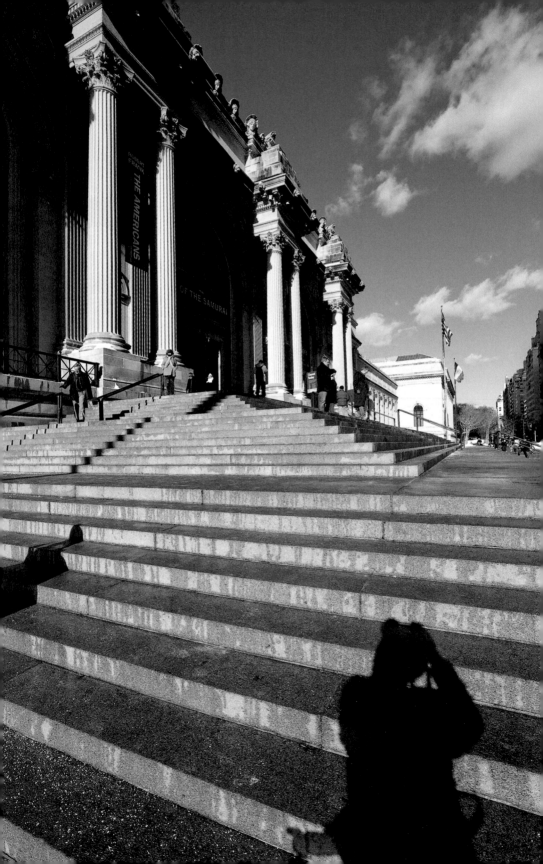

15 The Metropolitan Museum of Art

The outer coffin of Henettawy shot through glass. Taken at ISO 1000, f/2.2, 1/50 second with a 50mm lens.

Why It's Worth a Photograph

Anchoring the southern end of Manhattan's famous Museum Mile, the Metropolitan Museum of Art is located at 82nd Street on Fifth Avenue. The Met, as it is known colloquially, is one of the largest art galleries in the world. Stretching for a quarter-mile along Central Park, the building offers a multitude of photo opportunities before ever entering the world-class galleries. Once you step inside, the vastness of the museum becomes clear as the great entrance hall stretches before you.

The best advice for enjoying your visit is to pick two or three exhibits that really pique your interest. Then put your map away and get lost looking for the exit. The Beaux-Arts façade, the grand entrance hall, and the incredible collection of unique art and history make the Met a must-visit when in New York.

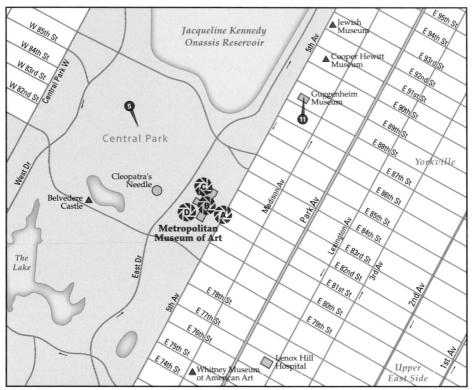

The best vantage points from which to photograph the Metropolitan Museum of Art: (A) Fifth Avenue, (B) the Great Hall, (C) the galleries, and (D) the grounds. Other photo ops: (5) Central Park and (11) Guggenheim Museum.

Where Can I Get the Best Shot?

The best places to photograph at the Metropolitan Museum of Art are from Fifth Avenue, the Great Hall, the galleries, and the grounds.

Fifth Avenue

The Met's beautiful façade, completed in 1902, is the first thing you see as you approach the museum. This amazing piece of architecture dominates multiple blocks of Fifth Avenue. At night, the building's lights offer contrast and completely different lighting than during the day. The stairs and railings offer a multitude of leading lines that can help you frame a shot that grabs your viewer.

By using a wide-angle lens you can get close to minimize pedestrians and distractions that might otherwise appear in your image. A standard zoom lens at the short telephoto end is sufficient to isolate details among the columns and decorative cornices along the top of the building (see Figure 15.1).

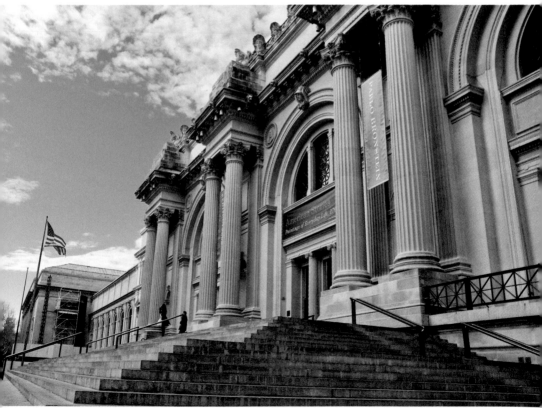

15.1 The Beaux-Arts facade of the Metropolitan Museum of Art on a cold winter afternoon (see A on the map). Taken at ISO 200, f/6.3, 1/250 second with a 16-35mm lens.

The Great Hall

This vast entrance hall is a wonder itself, deserving of some time to create some photographs. Looking up from the ground floor, the arches soar overhead. Moving to the second floor walkway allows you to look down upon the Great Hall and demonstrate the symmetry of the room.

With a tripod or using the railing as a brace, you can use a longer shutter speed to impart a sense of motion to the never-ending crowds of people below. A wide-angle lens is the best choice to capture the grandness of this room (see Figure 15.2).

The galleries

The permanent and special exhibitions that sprawl throughout the museum's 2 million square feet are the heart of the museum. Trying to view it all in one day with any sort of appreciation is impossible. Select a few target exhibitions for your visit and leave some time to wander until fatigue sets in. Consider not only what you would like to see but what would make a good photograph.

Although wonderful to view and study, for example, most paintings won't make very interesting photographs by themselves. Due to the often low light found in the museum, a fast prime lens is almost a necessity. Parts of the museum are well lit, however, and a standard or wide-angle zoom can be used (see Figure 15.3).

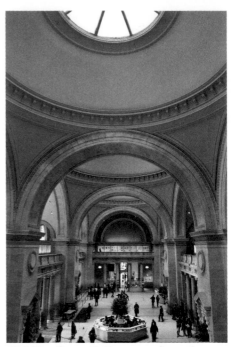

15.2 The Great Hall as seen from the second floor balcony on a winter morning (see B on the map). Taken at ISO 1250, f/4.5, 1/25 second with a 16-35mm lens.

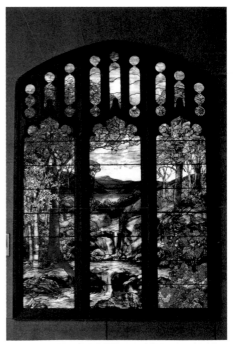

15.3 Built late in Louis Comfort Tiffany's career, this beautiful leaded glass piece entitled Autumn Landscape sits in the American Wing of the museum (see C on the map). Taken at ISO 100, f/2.2, 1/60 second with a 50mm lens.

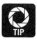 **TIP** After every photograph, look for the exhibit's information panel and snap a picture of it, too. This way, you can properly identify your images later.

The grounds

The beautiful gardens surrounding the museum are highlighted by the rooftop sculpture garden overlooking Central Park. The garden offers some of the most spectacular views of the park and Manhattan skyline especially at sunset.

Open from May until late fall as weather permits, you can get food, enjoy wine and cocktails, and view the rotating exhibits (see Figure 15.4). Bring a wide-angle lens to communicate a sense of the breadth of the view available from this urban oasis.

How Can I Get the Best Shot?

The Met is fairly photographer friendly, although there are some restrictions that impact what you can bring into the museum and what shots you plan on taking. Large bags must be checked, although a small shoulder bag or belt bag might be allowed.

Also, flash is expressly prohibited. However, tripods are allowed on certain days. Without a tripod, you need to be aware of your shutter speeds and camera stability in order to ensure sharp images indoors. A fast prime lens and higher ISO settings can help to alleviate these concerns as well. Many areas have large windows and skylights, which allow beautiful natural light to pour in.

© Terry Eagle 2008

15.4 Jeff Koons' Balloon Dog (Yellow) on display at the rooftop garden in the summer of 2008 (see D on the map). Taken at ISO 100, f/9, 1/125 second with a 75mm lens.

Equipment

Although having a range of lenses can help you achieve your vision, you may want to consider keeping it simple. Bringing a single fast prime lens lets you move around to build your compositions while providing a large aperture to deal with the low-light environments.

Lenses

▶ **A standard zoom lens in the 24-70mm range.** A multipurpose zoom lens allows you to shoot from wide-angle to short telephoto images. This lens usually offers a short minimum focusing distance, which is beneficial in the museum setting where you often want to get very close to your subject. This lens is also wide enough to take great architectural images of the front of the building and the Great Hall.

▶ **An ultrawide-angle zoom lens in the 16-35mm range.** When you really want to accentuate the size of the building or room, an ultrawide-angle lens is the tool you want. This lens allows you to capture a very large angle of view as well as get very close to your subject, which reduces clutter and distractions in your frame.

▶ **A fast prime lens.** In low-light environments like those found throughout the museum, a fast prime lens, such as a 50mm with a maximum f/stop of f/1.2 to f/1.8 is an excellent choice. Two to four stops faster than a traditional zoom lens, the prime lens allows you to keep your shutter speed high enough to get sharp images when handholding your camera. The museum has enough space between most exhibits to allow you to move around to create your composition.

Filters

A polarizing filter can be useful outside because it darkens the sky and reduces reflections on the windows. Using this filter will increase the contrast between the building and the sky, helping it to pop out of the image.

Extras

Wednesday through Friday, you can obtain a tripod pass at the main information desk in the Great Hall. You may find other events going on these days as well, such as painting students copying the masters (see Figure 15.5). With the preponderance of mixed-light environments, a pocket gray card is also an excellent tool to bring with you.

15.5 A painter copies a painting on a weekday afternoon at the Met. Taken at ISO 1250, f/3.5, 1/40 second with a 50mm lens.

Camera settings

Outdoors, your camera's meter provides an excellent exposure reading. Maximize your depth of field with a smaller aperture between f/8 to f/11. Indoors, your primary goal after creating enticing compositions will be to ensure that you have a sufficient shutter speed in order to capture a sharp photograph. Ensuring that you maintain a shutter speed of greater than 1/focal length and using proper techniques will let you create compelling images even in this challenging environment.

> When shooting an exhibit through glass, put your lens hood right up against the glass. This technique serves two purposes. First, it reduces the glare and reflection from the ambient lights bouncing off the glass. Second, it provides a modicum of stability, gaining you about a stop of shutter speed.

Exposure

Outdoors and in the parts of the museum filled with natural light, your exposure meter should have little trouble getting excellent, crisp images. In the rest of the museum, consider reviewing your images and histogram on your camera's LCD screen. Zoom in to check for sharpness and read the histogram to ensure a quality exposure. Use your exposure compensation to adjust and shoot again if necessary.

Using Aperture Priority mode gives you the most control over your depth of field. A smaller aperture outdoors gives you a greater depth of field for the architectural shots. Indoors, a large aperture helps to blur the background and isolate your subject. This can go a long way toward creating a composition that doesn't look like it is in a museum.

White balance

The Met can have wildly varying light conditions from one room to the next. Some rooms have lots of natural light, and some rooms have dim fluorescents, but most have a mixture of many different sources. Use a pocket gray card to get close in-camera and shoot in RAW mode to give yourself the most latitude in the digital darkroom.

ISO

Outdoors and in bright, naturally lit rooms, you want to use the lowest ISO available. Generally, 100-200 is sufficient in these situations. Elsewhere indoors, you need to start at 400 and may need to consider 800 or even 1600 to get a quality exposure with a reasonable shutter speed. If using a tripod, however, bring the ISO back down as low as it goes to create an image with the least amount of digital noise.

Drive mode

When shooting handheld in low-light environments, using burst mode can help you obtain a sharp image. Capture two to three images in a burst. Often the second or third photo is noticeably sharper than the first shots because you are not in the process of depressing the shutter during that time.

Ideal time to shoot

The middle of the week is always quieter than the weekends with the added bonus of being able to use a tripod from Wednesday through Friday if you desire. During the spring and summer months, be sure to visit the rooftop garden for photos at sunset.

A rainy day can be a great time to take a trip to the Met. Especially during the week, you might find yourself wandering the halls alone and not having to wait to create your compositions free of other people.

Low-light and night options

The museum is open late Friday and Saturday nights. Visit the rooftop garden with your tripod on a late Friday night to photograph the sunset and twilight as it settles over Central Park and the city. When you depart the museum, stop to capture some images of the nighttime lights across the facade.

Getting creative

Try to create images that don't look like they were made in a museum. You can try two methods. You can use a shallow depth of field to blur the background behind a sculpture or you can shoot an object tight enough to remove all other distractions. By using these methods, you can create a composition that seems as if it might have stepped off the pages of history (see Figure 15.6).

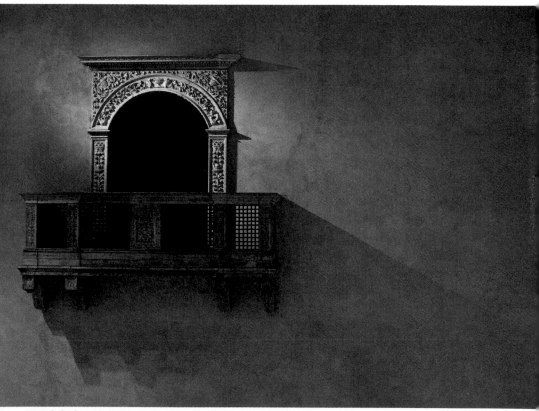

15.6 A balcony and window in the European Sculpture and Decorative Arts portion of the museum. Taken at ISO 1000, f/3.5, 1/50 second with a 50mm lens.

16 The Museum of Natural History

African elephants in the Akeley Hall of African Mammals. Taken at ISO 3200, f/1.4, 1/40 second with a 50mm lens.

PLEASE

EAST AFRICAN ELEPHANT
(LOXODONIA AFRICANI PEELI)

FOUR OF THE ELEPHANTS IN THIS GROUP, INCLUDING
THE LARGE BULL, WERE COLLECTED AND MOUNTED
BY CARL AKELEY IN THE 1920'S. THE ADDITIONAL
ELEPHANTS WERE COLLECTED IN 1933 BY MR. & MRS.
F. TRUBEE DAVISON AND LT. E. R. QUESADA, USA.

CONTRIBUTIONS TO THE MOUNTING OF THE GROUP
WERE MADE BY MR. ROBERT W. GIBSON,
MR. HENRY R. DAVISON AND BY MR. & MRS. PERCY R. PYNE
IN MEMORY OF THEIR SON MAURICE FOSTER PYNE.

Why It's Worth a Photograph

The Museum of Natural History is located on Central Park West in the heart of Manhattan. The museum was founded in 1869 and is one of the largest museums in the world, with over 46 permanent exhibition halls. The vast Theodore Roosevelt Rotunda looks out over Central Park and serves as the main entrance to the building that contains a huge cast skeleton of a Barosaurus.

The B and C subway lines bring you right to the museum's underground entrance, which may also offer a shorter queue and is even decorated with animal shapes built with subway tiles. The museum is very photography friendly; most exhibits allow flashes. There are rotating photography exhibits as well. Rare skeletons and explorations of Africa and Asia as well as the beauty of the building make the American Museum of Natural History a splendid place to spend a day exploring many unique photographic opportunities.

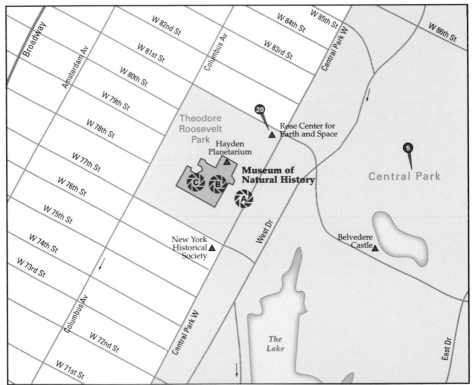

The best vantage points from which to photograph the Museum of Natural History: (A) the front of the building, (B) the Theodore Roosevelt Rotunda, and (C) the exhibit areas. Other photo ops: (5) Central Park, and (20) Rose Center for Earth and Space.

Where Can I Get the Best Shot?

The best locations from which to photograph the Museum of Natural History are from the front of the building, in the Theodore Roosevelt Rotunda, and in the exhibit areas.

Front of the building

Along Central Park West, the front facade of the Museum of Natural History offers a number of possible shots. These include some of the older sections of the museum at 77th Street and the New York State Memorial to Theodore Roosevelt at 79th Street.

Always bustling, this memorial to New York's former governor and President of the United States can be photographed from either side of the street and is an interesting subject to start your photo tour of the museum. Getting up close with a wide-angle lens allows you to avoid including many of the distractions from your image (see Figure 16.1).

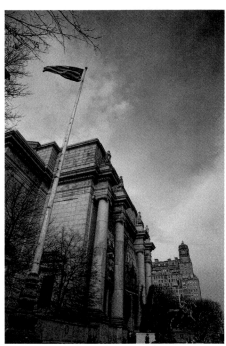

16.1 The front of the Museum of Natural History on Central Park West on a windy winter day (see A on the map). Taken at ISO 200, f/13, 1/250 second with a 24-105mm lens.

The Theodore Roosevelt Rotunda

Massive dinosaur skeletons greet you upon entering the Theodore Roosevelt Rotunda. This main lobby of the museum is a massive Roman basilica-style room over three stories tall. The walls and ceilings are covered in beautiful designs and textures.

Although numerous photo opportunities are inside the exhibits, don't rush through this beautiful lobby. Use a wide-angle lens to create large views of the room, and try a standard zoom lens to pick out the details. (see Figure 16.2).

The exhibit areas

The real beauty in the museum is its variety of exhibit areas. With so many permanent exhibitions, you are sure to find some that are of special interest. It is nearly impossible to enjoy and appreciate the entire museum in a single day, so you should

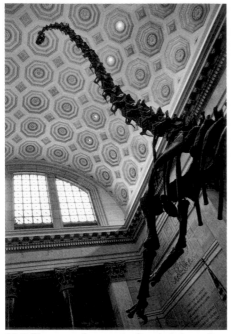

16.2 The massive cast of a skeleton of a Barosaurus looms overhead in the Theodore Roosevelt Rotunda (see B on the map). Taken at ISO 800, f/4, 1/40 second with a 24-105mm lens.

choose some locations to visit first. Visiting the museum's Web site lets you view an entire list of both permanent and special exhibitions as well as a downloadable floor plan.

Going into the museum with a rough plan of attack increases your likelihood of getting to everything that you find interesting.

When creating this plan, consider how photogenic a subject is likely to be as well as your interest. For example, while beautiful and fascinating to view, many of the minerals and gems do not make very dynamic images. Conversely, the dioramas in many of the halls can be photographed to feel very life-like (see Figure 16.3).

Due to the often low-light conditions in the halls, a fast prime lens is an excellent tool to have available.

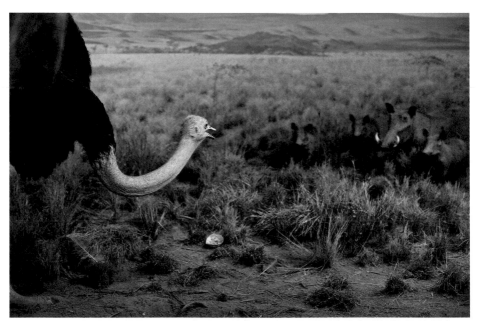

16.3 An ostrich defends its young from warthogs in this diorama in the Hall of African Mammals (see C on the map). Taken at ISO 640, f/2.2, 1/40 second with a 50mm lens.

How Can I Get the Best Shot?

Although the museum is more photography friendly than most, there are still some restrictions. Tripods, monopods, and very large backpacks are not allowed. All bags are searched on arrival. If at all possible, try to travel light.

For example, try carrying two camera bodies with different lenses rather than an extra lens in a bag. Doing this makes getting in and out much easier as well as offers you the flexibility of a full zoom range, or a zoom lens in addition to a fast prime. The low light indoors coupled with constantly changing lighting conditions can be difficult, but a fast prime lens or an accessory flash can help tremendously (see Figure 16.4).

GOLIATH FROG,
Conraua goliath

By far the largest species of frog, the Go
ath lives in mountain streams in Cam
roon and Equatorial Guinea, West Afri
It reaches a body length of at least
centimeters (12.5 inches) and a weigh
3.3 kilograms (7.3 pounds). The Bullfr
seen elsewhere in this case, is the lar
American species at a body length o
centimeters (8 inches).

16.4 A goliath frog is displayed in the Hall of Reptiles and Amphibians. Taken at ISO 320, f/2.2, 1/40 second with a 50mm lens.

Equipment

You can use a range of lenses to capture great images at the museum. However, a fast prime lens may be the only lens you need, offering speed for the low light and light weight when you are on your feet all day.

Lenses

▶ **A standard zoom lens in the 24-70mm range.** A multipurpose zoom lens allows you to zoom from wide-angle out to a short telephoto. These lenses usually offer a short minimum focusing distance, which is important in a museum environment, because you are often very close to your subject and unable to move farther away. Image stabilization, if available, is also helpful because most of your pictures will be taken in lower light environments (see Figure 16.5).

16.5 The skeleton of a giant aquatic turtle called Stupendemys hangs from the ceiling of the Hall of Vertebrate Origins. Taken at ISO 1600, f/2.8, 1/80 second with a 40-112mm zoom lens.

▶ **An ultrawide-angle zoom lens in the 16-35mm range.** When shooting large subjects in confined spaces, this lens allows you to capture the entire scene. The perspective in such scenes usually exaggerates the size of the large foreground object, making it appear even bigger.

▶ **A macro lens.** Museums are generally too dark to use a macro lens, which requires a lot of light or a tripod to obtain a good exposure. Because the Museum of Natural History allows the use of flashes, you can take some wonderful macro images. A ring flash or adapter is the perfect complement to this lens to get the light up close to the subject.

▶ **A fast prime lens.** When shooting in low-light environments a fast prime lens, such as a 50mm with an f/stop ranging from f/1.2 to f/1.8 is very useful. Offering an additional 2 to 4 stops over a traditional zoom lens, the increased shutter speed available lets you get sharp photos with a lot less light. Most manufacturers make relatively inexpensive 50mm lenses in this range — an excellent bargain.

Filters

For outdoor shots, a polarizing filter can help darken the sky and increase the contrast of the building against the background. This filter is very useful to cut glare off of glass on exhibit displays. However, keep in mind that a filter cuts between 1 and 1 1/2 stops of light. When shooting in the darker areas of the museum, this loss of light can easily mean the difference between getting the shot or not.

Using Flash through Glass

The challenge of using flash at the museum is the reflections from the glass in front of most exhibits. The very best solution to this problem is to find a way to make the image without shooting through the glass. Sometimes there are gaps in the glass big enough to fire your flash or camera through. In many cases, however, there is no other solution if you want to create the image.

The two best ways to ameliorate the effects are to get extremely close to the glass or to bring an off-camera flash cord. Getting close to the glass ensures that there is not enough space for the flash to reflect back into the lens. An off-camera flash cord allows you to move the flash to an angle where it won't bounce back into the frame. Neither of these solutions is perfect, but they can help you get the best picture possible under the circumstances.

Extras

Unlike most museums, the Natural History Museum allows you to use flash in most parts of the building. Some special exhibits do not allow flash, but these areas are clearly marked. Due to the ever-changing light mixtures, from halogen to natural to fluorescent, and everything in-between, a pocket gray card is an excellent tool to have available for setting a custom white balance.

Camera settings

When photographing outdoors, you want the large depth of field provided by a smaller aperture of f/8-f/11. The primary focus indoors is keeping your shutter speeds faster than 1/focal length and holding your camera steady. Color representation is important when shooting here, so adjusting your white balance as appropriate or being prepared to change it in post-processing is important.

Exposure

Obtaining quality exposures outdoors is not difficult when you use your camera's built-in metering system. Indoors, you can review your images and histogram on your camera's LCD screen when you are not sure about the exposure. Doing this allows you to compensate and adjust for exposure challenges as well as check for glare and reflection in any glass in your frame.

Indoors and out, Aperture Priority mode gives you the most control over your depth of field. When shooting indoors, you want to keep a close eye on your shutter speed and reduce the aperture as needed to ensure that it is sufficient to obtain a sharp image.

White balance

Due to the ever-changing light sources, the museum is a challenging environment in which to get a proper white balance. However, utilizing your gray card to take readings when in a new environment allows you to set a custom white balance in camera or adjust as needed in the digital darkroom. To have the full range of white balance adjustments available in post-processing you must shoot in your camera's RAW mode.

ISO

Although shooting with the lowest ISO available is important, having a fast enough shutter speed indoors may force you to raise this setting. Outside, 100 to 200 is generally good. Inside, you want to start at 400 and may need to try 800 or even 1600 in order to get a good exposure. If you are using a flash indoors, you can bring the ISO right back to 200 in many cases.

Drive mode

When shooting in low-light environments, you should consider shooting two-to three-shot bursts. Often, the second or middle shot is much sharper than the first shot because you are not actively depressing the shutter button.

Metering mode

Your camera's default metering mode is usually very good. However, there are times when a high-contrast scene will confuse it enough to prompt you to utilize a different setting. A Center-weighted or Spot metering mode greatly biases your camera's meter toward the light in the very middle of the frame. When creating an image of an exhibit in bright light bordered by much darker areas, this setting help your meter get the proper exposure for your subject while largely ignoring the surrounding areas.

Ideal time to shoot

The Museum of Natural History is open seven days a week year-round, closing only for certain holidays. Check the Web site to ensure that it will be open on the day you plan to visit and to see what special exhibits are available. The museum is less crowded midweek and in the winter and can be an excellent rainy-day activity as well.

Although you might be unable to create certain outdoor images, the weather doesn't otherwise affect your photography. If it is very cold and dry outside, be aware that you may need to wait to shoot if your camera and lens fog up when you arrive.

Low-light and night options

The museum closes at 5:45 p.m., which means if you leave at the end of the day, you can get twilight and nighttime images from October to March. If you are in the area at night during other times of the year, you can come back with a tripod and take street-level images with exposures of 1/4 second and longer to impart a sense of movement to traffic and pedestrians in the fading light.

Getting creative

Consider context and background when creating your compositions at the museum. If you can remove distractions in the frame, your images will look more realistic and believable. Get as close as possible to your subject and consider how the exhibit is displayed. Remember the importance of your subject's eyes. Even if you are shooting taxidermy, a sharp and engaging shot of the eyes will draw in your viewer every time.

17 New York Botanical Garden

An orchid hangs in the conservatory in front of a water feature on a winter afternoon. Taken at ISO 1250, f/4.5, 1/60 second with a 100mm macro lens.

Why It's Worth a Photograph

Located in the Bronx next to Fordham College, the 250-acre New York Botanical Garden is one of the most impressive in the country. The garden's curated collections are home to more than 1 million plants spread throughout a multitude of microclimates.

Where Can I Get the Best Shot?

Photographic opportunities abound in the gardens: The Haupt Conservatory offers rotating displays throughout the year. The grounds offer seasonal displays, such as Daffodil Hill and the rose garden. The natural and unlogged 50-acre native forest is bifurcated by the Bronx River. You will not be disappointed if you make the time to escape Manhattan to enjoy this garden oasis.

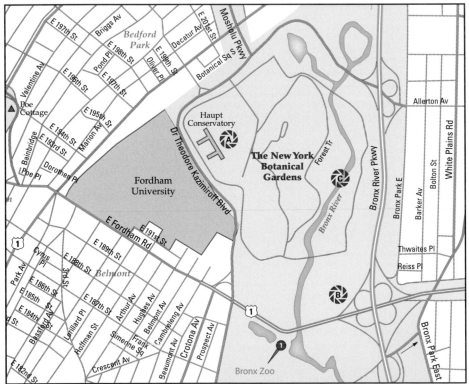

The best vantage points to photograph the New York Botanical Garden: (A) the Enid A. Haupt Conservatory, (B) the Benenson Ornamental Conifers, and (C) the waterfall on the Bronx River. Other photo ops: (1) Bronx Zoo.

The Enid A. Haupt Conservatory

Located on the southwest edge of the gardens, the European-styled greenhouse is one of the premier facilities in the United States. The conservatory is the home of many permanent collections but also provides space for many special displays throughout the year. The well-renowned spring orchid show sees thousands of orchids integrated into the existing collection, and the holiday train show brings a massive model train setup of New York City into the building as well. The opportunities for macro photography abound here, so bring a dedicated macro lens if you have one (see Figure 17.1). A standard zoom lens also offers a bounty of compositions from individual flowers to wide-angle views of entire show spaces.

Benenson ornamental conifers

Spread across 15 acres in the southernmost part of the garden, this recently restored collection of conifers offers year-round beauty. Welcomed by a pair of beautiful stone pavilions, a walk through over 400 trees provides you with many opportunities to make a picture.

17.1 An anthropomorphic orchid reaches down from its hanging basket (see A on the map). Taken at ISO 1000, f/2.8, 1/40 second with a 100mm macro lens.

Your Camera and Humidity

The conservatory contains a number of regulated microclimates, some of which are quite warm and humid. Entering these areas, especially in the colder months, can cause your camera and lens to fog up as condensation forms on the cold metal and glass. The best way to protect from this is to put your camera in a bag and wait for it to warm up before taking it out. A large, one-gallon resealable plastic bag works very well, although your camera bag also provides some protection. Do not change lenses during this transitional period because you risk getting condensation on your sensor, which can dry into water spots and require cleaning.

A standard zoom lens lets you capture entire groups of trees or zoom in to isolate one or some details. A macro lens offers the opportunity to explore the very small, such as the wildly differing cones and leaves. Bringing along a tripod can be useful for both macro photography and when composing a landscape scene (see Figure 17.2).

17.2 A beautiful red-barked conifer on a winter morning (see B on the map). Taken as an HDR image with three exposures of 1/4 second, 1 second, and 4 seconds at ISO 400, f/16 with a 24-105mm lens.

The waterfall on the Bronx River

The Bronx River runs south near the eastern edge of the native forest in the heart of the New York Botanical Garden. Just north of the Hester Bridge is a beautiful natural waterfall cascading through a narrow gorge. A path leads down right to the water's edge offering an excellent opportunity to create images of the waterfall. Using a tripod with a neutral density filter on your standard zoom lens, you can create a longer exposure, blurring the water's movement into a beautiful silky-smoothness (see Figure 17.3).

How Can I Get the Best Shot?

The New York Botanical Garden is a place to escape from the hustle and bustle of the surrounding city, slow down, and enjoy the natural beauty. Expand that mood to your photography and take your time in seeing the shot and waiting for the perfect frame. Perhaps more than elsewhere, the hunt for the ideal light is the most important step in creating a beautiful image (see Figure 17.4).

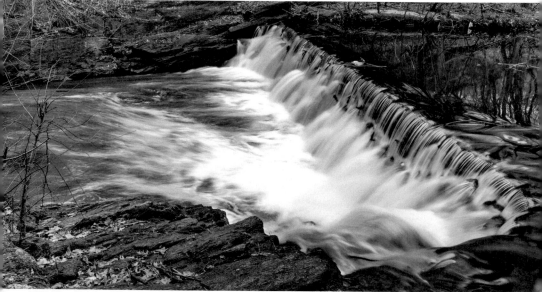

17.3 The Bronx River and waterfall in the native forest on a winter afternoon (see C on the map). Taken as an HDR image with three exposures of 1/4 second, 1 second, and 4 seconds at ISO 50, f/18 with a 24-70mm lens.

Equipment

There is little restriction in what you are allowed to bring to the botanical gardens. A variety of lenses, including wide-angle, telephoto, and macro can help in making a range of photographs.

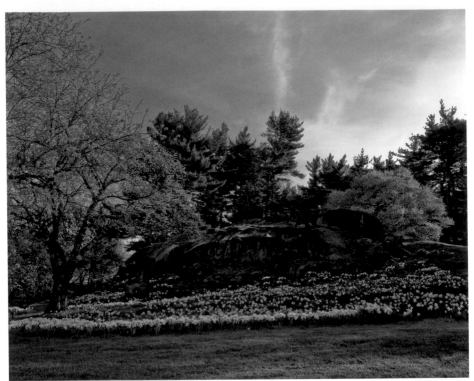

17.4 Daffodil Hill on a gorgeous spring afternoon. Taken at ISO 250, f/5.6, 1/80 second with a 24-105mm lens.

Lenses

▶ **A standard zoom lens in the 24-105mm range.** A standard zoom that goes from a wide-angle to short telephoto offers you a single tool to create most of your images. They often come with image stabilization and a basic macro capability as well. Their relatively small size and weight make it easier to concentrate on your photography than other, heavier equipment.

▶ **An ultrawide zoom lens in the 16-35mm range.** Often a great choice for a landscape, the ultrawide-angle lens allows you to capture a vast portion of the scene in a single frame. It will accentuate the distances between objects, causing them to appear farther apart than they may actually be.

▶ **A telephoto zoom in the 70-200mm range.** Using a telephoto zoom lens you can pick out details and compress the distances between foreground and background subjects. The reduced depth of field with a large aperture can also be appealing for artistic reasons (see Figure 17.5).

▶ **A macro lens.** Dedicated macro lenses are generally available in about 50mm, 100mm and 180mm. These lenses allow you to get close enough to achieve 1:1 magnification of your subject. This allows you to get close enough to isolate individual flowers or even petals on a single flower.

Filters

When shooting landscapes, a polarizing filter is often quite handy. By reducing reflections off of foliage and the sky, these filters allow the colors to be more deeply saturated. When shooting moving water or even foliage, a neutral density filter can be another good filter to have available. By reducing the amount of light reaching the sensor, a neutral density filter allows you to use a slower shutter speed even in the noonday sun.

Extras

A sturdy tripod is always a useful tool to have for landscapes and macro shots. However, be aware that they are not allowed inside the conservatory building. They are allowed elsewhere in the gardens. When shooting macros, a flash is very useful and sometimes necessary. A ring flash or ring-style adapter for an accessory flash is the ideal way to light for macro when on-the-go.

17.5 Cherry Tree petals in the spring. Taken at ISO 200, f/6.3, 1/100 second with a 300mm lens.

Camera settings

In the wide, sweeping landscape images you will generally want a sufficiently small aperture so the entire scene will be in focus. A small aperture of f/8 to f/16 is also helpful in macro photography, because your depth of field is so small at such close distances. Conversely, you may want to use a large aperture of f/1.2 to f/4 to create an artistic effect with a blurred background.

Exposure

Your exposures should be fairly straightforward in most circumstances at the gardens. Even using flash or a ring flash, if your camera supports a form of automatic flash metering it will set the flash output and camera settings. Watch for overexposures in the sky.

Aperture Priority mode gives you direct control over your aperture setting and uses the camera's internal meter to determine shutter speed and ISO. This mode will generally work very well and is the suggested setting here.

White balance

When you are outdoors, use the appropriate preset for the weather: Sunny, Shade, or Cloudy. Indoors, you can generally still use the same preset as outside because the greenhouse is mostly lit by sunlight streaming through the glass. Shoot in your camera's RAW mode to provide the most latitude in the digital darkroom.

ISO

Use the lowest ISO possible while still maintaining an acceptable shutter speed. This setting is uaually ISO 100-200 on a sunny day and ISO 400 when the clouds have rolled in.

Ideal time to shoot

Every season brings a new photographic opportunity to the gardens. Some of the more noteworthy times of year to watch for are:

- ▶ **March:** The Orchid Show is in full swing through the whole month.
- ▶ **April:** Daffodil Hill, magnolias, and cherry trees are in full bloom.
- ▶ **May:** Crabapple and dogwood trees as well as tulips are at their most beautiful.
- ▶ **September:** The rose garden, open all summer, peaks this month.
- ▶ **Fall:** The orange, reds, and yellows of fall transform the forest and rest of the park.

The gardens offer great shots all year long in all types of weather. Be sure that you and your camera are properly protected for whatever inclement weather may be headed your way, but don't let it stop you from venturing out to take photographs.

Low-light and night options

Because you can bring a tripod for use outside, you have much more flexibility for low-light dusk and twilight photographs. This magical time can provide some stunning images with the beautiful fading light of the day, but a tripod is required to keep the camera still during the longer exposures in such low light.

Getting creative

The often dense and colorful gardens can have deep shadows under and between plants contrasted by the sun and sky above. This very wide brightness range is a perfect opportunity for you to try creating an HDR image. Shoot a minimum of three images at least two stops under and two stops over the baseline exposure in order to provide a good range of data for your HDR application.

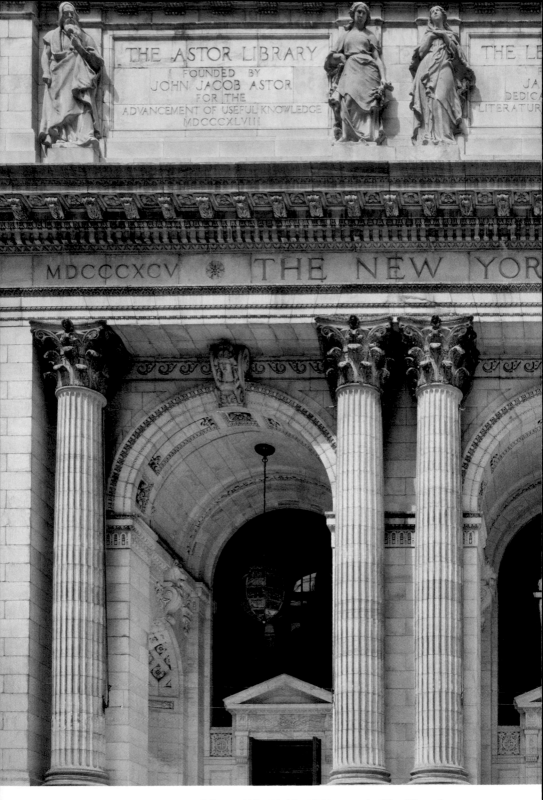

The New York Public Library. Taken at ISO 100, f/8, 1/320 second with a 35mm lens.

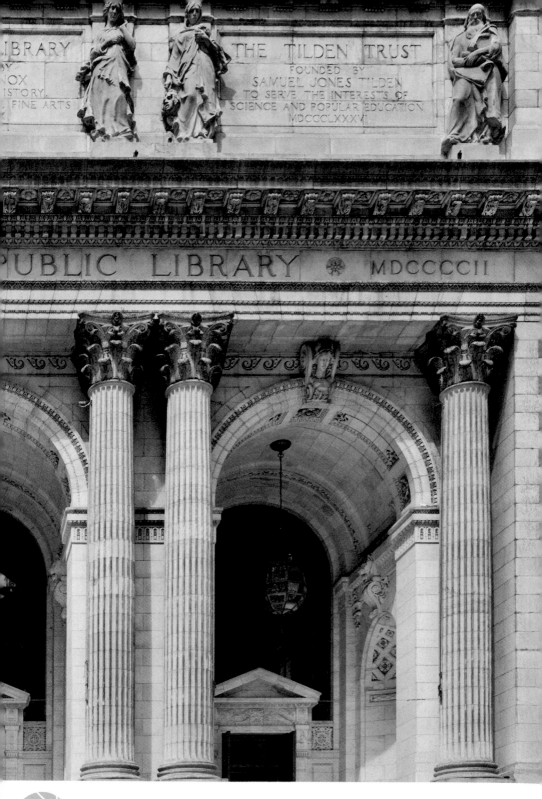

18 The New York Public Library

Why It's Worth a Photograph

The main branch of the New York Public Library in an imposing, Beaux-Arts style building opened in 1911. The building was constructed on the site of the former Croton Reservoir in the heart of Manhattan. The New York Public Library offers great architectural detail and abstract images. Plan on shooting this beautiful building both inside and out before enjoying lunch or a rest or people-watching in the nearby Bryant Park.

Where Can I Get the Best Shot?

You can make the most iconic photographs of the library at its entrance on Fifth Avenue, in its richly decorated lobby, and in the much-filmed and photographed Adam R. Rose Main Reading Room.

The best vantage points from which to photograph the New York Public Library: (A) Fifth Avenue, (B) the lobby, and (C) the Adam R. Rose Main Reading Room. Other photo ops: (10) Grand Central Terminal and (26) Times Square.

Fifth Avenue

There are many opportunities to create photos from Fifth Avenue. From the western side of the road, closer to the library, aim slightly up to capture the building and the famous lions, Patience and Fortitude (see Figure 18.1). You can also shoot from across the street to create a wide-angle shot including the building, street, pedestrians and zooming taxies. Use a wide-angle lens to capture a wide perspective of the building.

The lobby

After passing through security, stop in the vast lobby to create images. The room is topped with huge, vaulted ceilings and decorative details are everywhere (see Figure 18.2). The natural light entering from the eastern windows is great, especially in the morning. A standard zoom lens will offer you a great deal of flexibility in exploring the space. However, a prime lens with a large aperture will provide flexibility to continue shooting into the afternoon or into the darker corners.

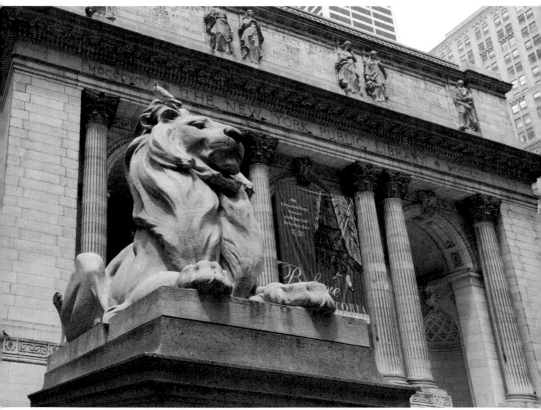

18.1 A lion at the New York Public Library on a summer afternoon (see A on the map). Taken at ISO 100, f/9, 1/100 second with a 16-35mm lens.

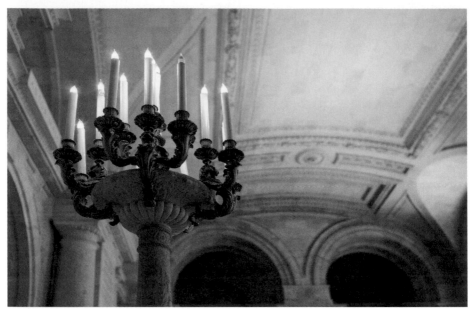

18.2 Architectural details of the lobby in late morning (see B on the map). Taken at ISO 100, f/2.5 at 1/125 second, with a 35mm lens.

The Adam R. Rose Main Reading Room

The Adam R. Rose Main Reading Room is 297 feet long with over 50-foot tall ceilings. Featured in many movies, television shows and commercials, it is one of the most recognizable aspects of the library (see Figure 18.3). Flanked by windows down its entire length, the room is well-lit with a diffuse light during the day. Wide shots showing the entire room with a standard zoom lens give a feeling of being there in the library.

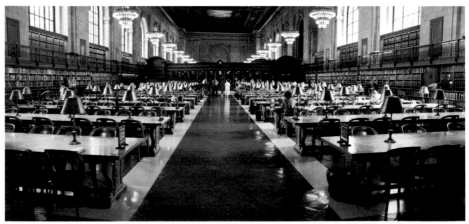

18.3 The Reading Room in late morning (see C on the map). Taken at ISO 400, f/4, 1/60 second with a 35mm lens.

How Can I Get the Best Shot?

The New York Public Library is a great chance to work on architectural as well as people photography. Be sure to spend time on all three levels of the library, and don't forget the stairwells, too. Outside, after you get the shots of the front of the building, stretch your limits and try some street photography.

Equipment

A range of equipment can be used to create compelling images at the library. However, in a place of study you don't want to stick out too much. Consider the types of images you wish to create and bring a minimal amount of gear in order to create those photos. By limiting what you bring you are freer to move about because you don't have as much to carry and will attract less attention. For street and people photography, consider a point-and-shoot or a small, electronic view-finder camera to remain unobtrusive.

Lenses

▶ **A standard zoom lens in the 24-105mm range (see Figure 18.4).** A standard zoom lens gives you a great deal of freedom with a single lens. This type of lens will often also offer image stabilization and some basic macro capability, granting you the ability to shoot in the darker locations in the library and even up-close detail shots.

▶ **A prime lens with a large aperture.** A prime lens with a large aperture of f/1.2 to f/1.8 offers two major benefits at the library. First, these lenses tend to be smaller and lighter than an equivalent zoom lens, making them easier and less obvious to carry. Secondly, their very large maximum apertures give you 2 to 4 more stops of light than most zoom lenses.

Filters

You may wish to consider a polarizing filter for the outdoor images of the library. By deepening the blue of the sky, a polarizer will help increase the contrast of the library against the sky. If you will be shooting in the middle of the day, a neutral density filter will allow you to still use slower shutter speeds on moving traffic and pedestrians to create a sense of motion by creating a little bit of blur.

Extras

Outdoors, a tripod can be very useful when creating architectural images of the building. A tripod will facilitate panning for panoramic images, taking longer exposures, or multiple shots for an HDR image. Tripods and flash are not allowed inside the library.

18.7 A stairway in the library. ISO 1250, f/4, 1/50 second using a 24-105mm lens at 100mm.

Camera settings

This venue lends itself to shooting in Aperture Priority mode. In this mode, you set the aperture, and the camera will meter the scene and set the appropriate shutter speed. This allows you to have direct control over the depth of field and use it to creative effect.

Exposure

The library can be a busy place, so you want to be fairly quick about your shooting. You'll be handholding, which means shutter speeds of 1/focal length and good shooting technique in order to capture sharp images.

ISO

Outside of the library, an ISO setting of 100 to 400 will be sufficient during the day. As you venture inside and farther from the large windows of the lobby, you may

need to increase your ISO to 800 or even 1600 in order to capture sharp images with a sufficient shutter speed.

White balance

When shooting outside, set your camera to a white balance preset of Sunny or Cloudy as appropriate for the day. Inside, many areas are actually lit by large windows so you can keep the same setting. If you wander into a darker area, use Incandescent or Fluorescent as appropriate.

Ideal time to shoot

Late morning to early afternoon is the best time to shoot so that you can take advantage of the light spilling into the New York Public Library's many huge windows.

You can shoot images at the NYC Public Library in any type of weather. Even on a rainy, cloudy day, enough light streams in from the numerous windows.

Getting creative

The library is full of leading lines, repeating patterns, and interesting colors. There is plenty here to help get the creative juices going. Try shooting the stairwells and the bookcases; even the books can create great images (see Figure 18.5).

18.5 Rows of books. ISO 1250, f/5.6, 1/40 second using a 24-105mm lens at 100mm.

19 Rockefeller Center

Looking south at midtown Manhattan and the Empire State Building from the Top of the Rock observation deck on a drizzly fall afternoon. An HDR image created with three exposures at 1/320, 1/1250, and 1/80 second at ISO 250, f/5 with a 24mm tilt-shift lens at full down shift and 6 degrees of tilt.

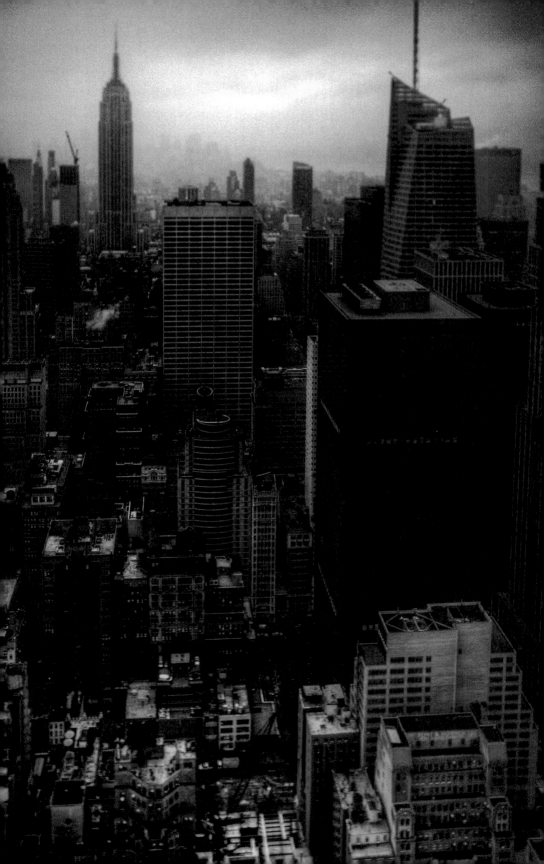

Why It's Worth a Photograph

Developed in 1930, Rockefeller Center is a 19-building complex full of shops, attractions and incredible sightseeing and photographic opportunities. This site offers towering skyscrapers, Art Deco designs, and architecture everywhere combined with some of the best people-watching in New York City. The ice rink and world famous Christmas tree over it are worth the visit themselves if you are here at the right time of year. The observation deck of the GE Building, also known as 30 Rock, opened in 2005 and offers panoramic views of the city including some of the best of Central Park.

Where Can I Get the Best Shot?

See Rockefeller Center at its most photogenic in the plaza (especially at Christmas), by the Atlas statue, and from the Top of the Rock.

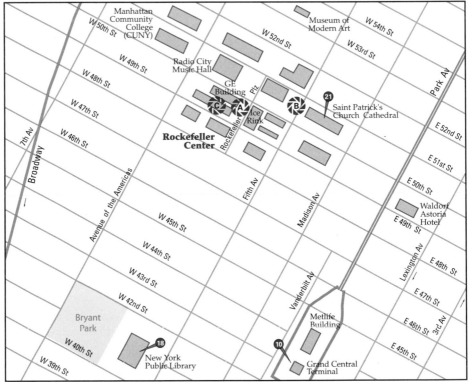

The best vantage points from which to photograph Rockefeller Center: (A) the plaza in front of the rink, (B) underneath Atlas, and (C) the Top of the Rock. Other photo ops: (10) Grand Central Terminal, (18) New York Public Library, (21) Saint Patrick's Church Cathedral.

The plaza in front of the rink

The iconic Christmas tree at Rockefeller Center is set up and unveiled here every year (see Figure 19.1). Located between the GE Building and the ice rink, the plaza is home to the tree and also offers a great vantage point of the ice rink and its skaters. A standard zoom lens will allow you to create a multitude of images. With the wide end, you can create shots with the tree set into the context of the plaza, with buildings and the ice rink all around. Using the telephoto end of the lens gives you the opportunity to isolate details and pick out smaller subjects to be the focus of your images.

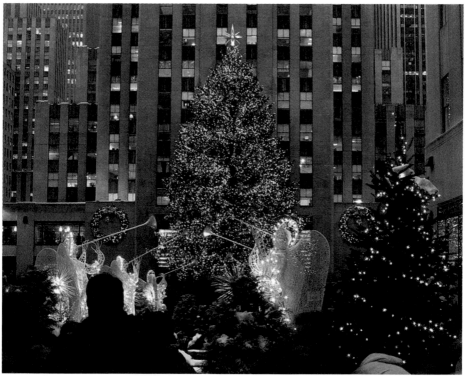

19.1 The Christmas tree at Rockefeller Center (see A on the map). Taken at ISO 100, f/4, 1/6 second with a 35mm lens.

Underneath Atlas

On Fifth Avenue, between West 50th and West 51st streets you will find a huge statue of Atlas holding up the world. This is just one of many architectural details available to shoot in the whole area of Rockefeller Center and it also demonstrates a very important concept to remember here: Always look up. You can capture so much amazing Art Deco art and architecture, and much of it is over your head.

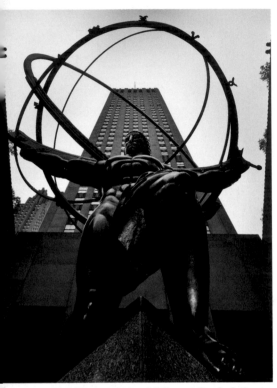

By getting low and shooting up you can also increase the drama of this art. The lower perspective with a wide-angle lens will cause the sculptures such as Atlas to appear to soar over you and they can be set against the open sky or rising skyscrapers of the complex (see Figure 19.2).

Top of the Rock

The Top of the Rock observation deck on the roof of the GE Building underwent a major renovation in 2005 and is now one of the best spots to visit for skyline views of New York City.

19.2 The statue of Atlas at Rockefeller Center (see B on the map). Taken at ISO 400, f/5, 1/250 second with a 24mm tilt/shift lens.

Equidistant from Central Park and the Empire State Building, both of these landmarks can be photographed from the wraparound viewing platforms. The lower three floors of the observation deck are enclosed in thick glass with narrow gaps between that you can sometimes shoot through.

However, for the best vantage point, head up the stairs to the 70th floor's 20-foot-wide viewing area for an unobstructed, 360-degree view of the city (see Figure 19.3).

Although tripods are not allowed on the observation deck, a beanbag or Gorillapod can offer some support in the oft-windy conditions. If your schedule allows, plan on arriving 30 minutes before sunset and budget time to stay through the sunset and twilight, watching and photographing the city's slow fade into incandescent-lit night.

Tickets for the Top of the Rock are available online or on-site. Visit www.topoftherocknyc.com to purchase in advance and skip the box office line.

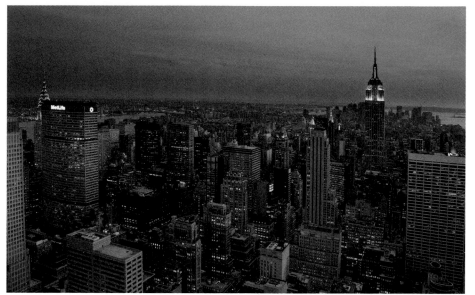

19.3 Midtown Manhattan from Top of the Rock at sunset (see C on the map). Taken at ISO 1250, f/5 at 1/30 second with a 24-105mm lens at 25mm.

How Can I Get the Best Shot?

Rockefeller Center is very large. Try to break up your shots into small chunks to avoid being overwhelmed by the sheer size of the buildings and grounds.

There's much to focus your photographic attention on: art and architecture, shoppers, diners, strollers, and skaters (see Figure 19.4).

19.4 News at Rockefeller Plaza on a summer afternoon. Taken at ISO 200, f/5.6, 1/60 second with a 50mm lens.

Equipment

A range of lenses and other equipment can be used to great effect at Rockefeller Center. From ultrawide-angle lenses to create an exaggerated perspective to a telephoto zoom for isolating people or architectural details, you have a lot of options to make great photographs.

Lenses

▶ **A standard zoom lens in the 24-105 range.** With a standard zoom lens you can create a wide variety of images without ever being forced to switch out your camera gear or carry a large amount of extra equipment. Many models are also reasonably small and discreet so you can create street photography without attracting the attention of your subjects.

▶ **An ultrawide-angle zoom lens in the 16-35mm range.** An ultrawide-angle lens is a great choice for art and architecture. Such a wide perspective allows you to exaggerate the height and grandiosity by shooting up on your subject. This lens is also so wide that you can capture very large areas in a single frame.

▶ **A telephoto zoom lens in the 70-200mm range.** A telephoto zoom lens serves to isolate details or more distant subjects. On the ground this lens will help you capture individual people at the skating rink or isolate the massive Christmas tree over the ice rink. From the Top of the Rock, the telephoto zoom allows you to compose shots with a smaller group of buildings or parts of nearby Central Park.

Filters

There are two filters that can be useful at Rockefeller Center. By blocking unpolarized light, a polarizing filter creates a number of effects that cannot be replicated in the digital darkroom. The blue of the sky will be darkened into a deeper blue, providing contrast for the foreground architectural subjects. This filter will also help cut through haze when shooting long distances from the Top of the Rock. The other filter to consider is a neutral density filter. If you are shooting in the middle of the day, it may be impossible to expose with a slow enough shutter speed to create motion blur of pedestrians or skaters without this filter.

Extras

No tripods are allowed at the Top of the Rock, so here's a good spot to try using a Gorillapod or a beanbag for stability. Outdoors at Rockefeller Center, tripods can be difficult to use due to the crowds and desire to constantly be moving. Unless you have a specific image you wish to create that will require the use of a tripod, plan on shooting handheld.

Camera settings

Creating images of people on the street requires a quick reaction when the moment arrives to create the frame. Ensuring you have proper settings on your camera ready to go when that time arrives is key so you do not miss the shot. Shooting a few shots while in continuous drive mode helps ensure you capture the exact moment you wish to see in the frame.

Exposure

Utilize Aperture Priority mode when shooting most subjects at Rockefeller Center. When your camera is set in this mode you will set the aperture and the camera's built-in meter will set the appropriate shutter speed for a perfect exposure. There are a few situations that might trick your camera's internal meter, however. When shooting tightly composed shots against the white of the skating rink, dial in at least +1 of exposure compensation. Creating images of the buildings against the bright sky, you may want to set +1/3 to +2/3 of exposure compensation as well.

White balance

When shooting outside, the camera's preset white balance modes of Sunny, Cloudy or Shade will be quite accurate for their equivalent conditions. Shoot in RAW mode to give yourself the most latitude with your white balance and more in the digital darkroom.

ISO

During the daytime you can use an ISO of 100 to 400 depending on the conditions and shutter speed. As day fades into night, you may need to bump up your ISO to 800 or sometimes higher if you wish to continue shooting into twilight and beyond.

For more tips on shooting New York City scapes from an observation deck, see Chapter 8.

Ideal time to shoot

Come to Rockefeller Center anytime during the day. But for a real treat, hit up Top of the Rock about 30 minutes prior to sunset and stay about an hour afterwards, capturing the blue hour of twilight after the sun goes down.

Rockefeller Center's outdoor plazas never close, so enjoy shooting at any time of day and in any weather. If you do come during inclement weather, be sure that you and your gear are prepared for and protected from the elements.

Getting creative

The Rockefeller Center skating rink is a chance to get creative with movement in a still image (see Figure 19.5). Shoot from the railing overlooking the ice rink, and use a slow shutter speed of between 1/2 second and 1/10 second (1/10, 1/5, 1/4 second). You can get some really cool shots of the ice skaters. Brace your camera on the railing itself, or if you have your tripod, and you can set up quickly, go for it!

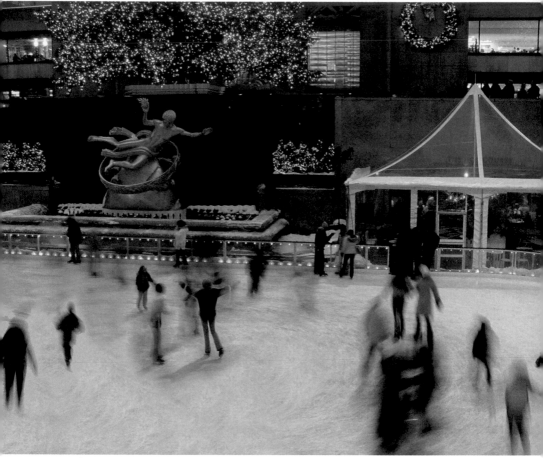

19.5 Skaters at Rockefeller Center on a late fall afternoon. Taken at ISO 100, f/5, 1/2 second with a 28mm-200mm lens.

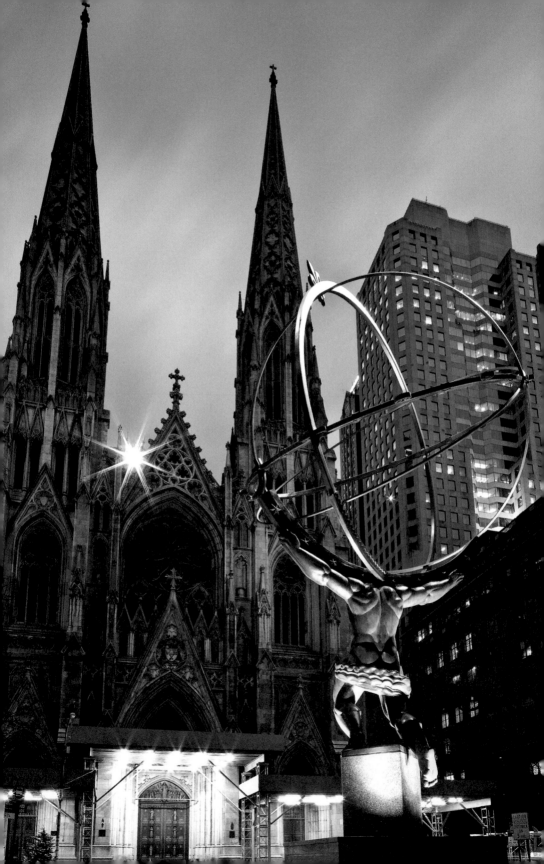

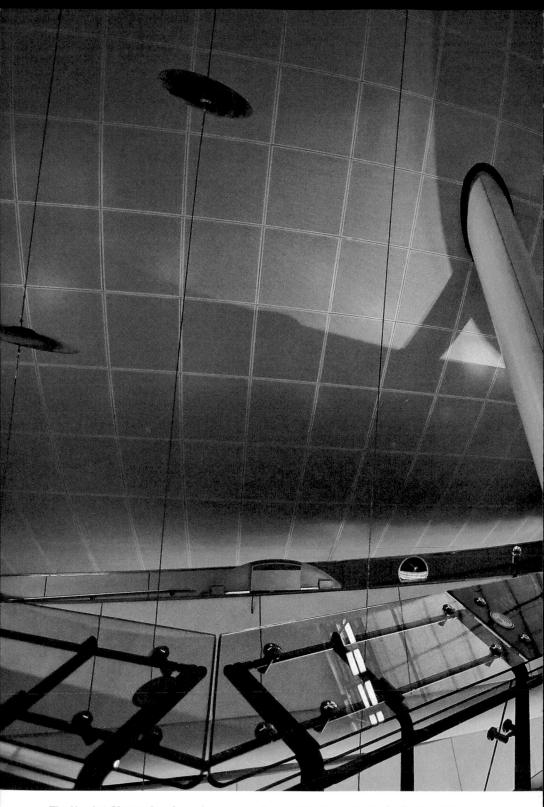

The Hayden Planetarium from the upper walkway of the Rose Center for Earth and Space. Taken at ISO 1600, f/2.8, 1/15 second with a 24-70mm lens braced against a support pillar.

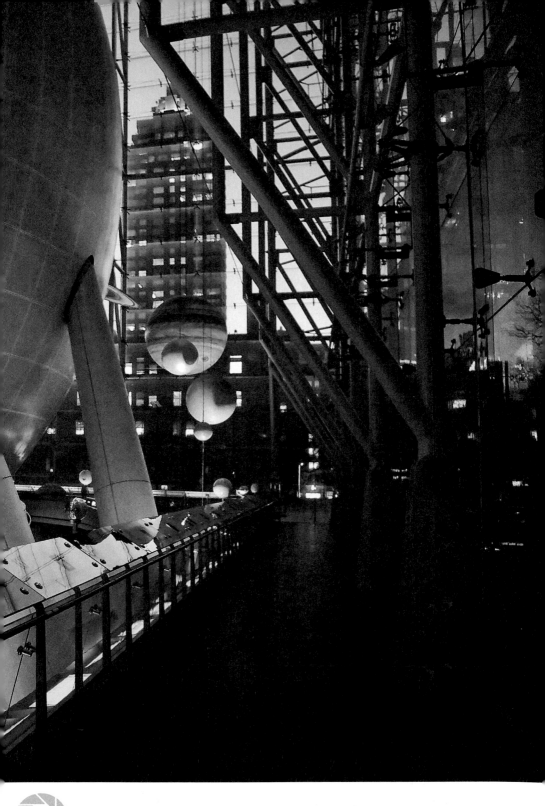

Why It's Worth a Photograph

One of the most popular parts of the American Museum of Natural History, the Rose Center for Earth and Space opened in 2000 on 81st Street near Central Park West. A new building surrounding the 1935-built Hayden Planetarium, this seven-story glass cube is an attractive piece of architecture and a great photographic subject.

The space lights up at night as seen from outside while inside there are enticing curves, shapes, and colors to explore around the interesting exhibits. The world-renowned planetarium is a visual feast as a break between creating photographs. The Rose Center is worth a trip by itself or in combination with a visit to the Natural History Museum.

Where Can I Get the Best Shot?

The best locations to photograph the Rose Center are from outside and from the Heilbrun Cosmic Pathway.

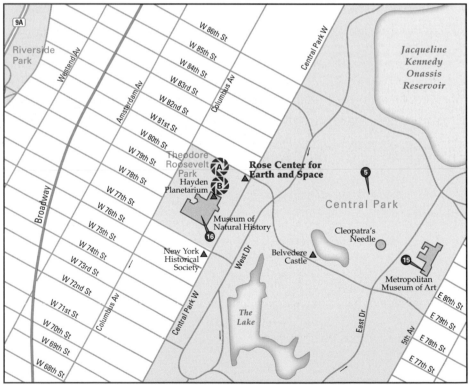

The best vantage points from which to photograph the Rose Center for Earth and Space: (A) outside the Hayden Planetarium and (B) on the Heilbrun Cosmic Pathway. Other photo ops: (5) Central Park, (15) Metropolitan Museum of Art, and (16) Museum of Natural History.

Outside the Hayden Planetarium

The 87-foot-diameter Hayden Planetarium is featured in the middle of the building, which slowly lights up after sunset. The internal lighting is surprisingly faint, so the balance between ambient sunlight and the artificial lights spotlighting the internal features doesn't come until near the end of twilight.

A standard zoom allows you to isolate sections of the spheres or use the wide end to capture the entire frontage (see Figure 20.1).

 Your ticket admits you to the entire Museum of Natural History, including the Rose Center.

On the Heilbrun Cosmic Pathway

A 360-degree spiral represents a 13 billion-year timetable of cosmic history (see Figure 20.2). Every step covers roughly 75 million years as you walk down the ramp.

20.1 The Rose Center for Earth and Space from the driveway outside on a cold winter night just after twilight (see A on the map). Taken at ISO 100, f/7.1, 20 seconds with a 24-70mm lens.

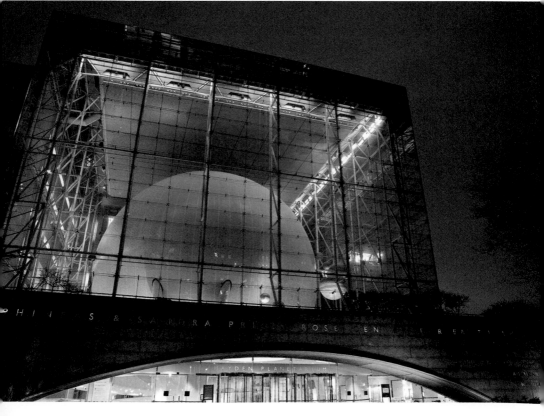

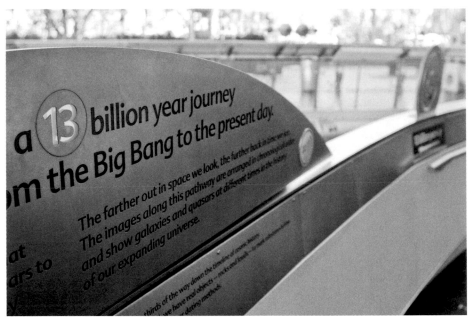

20.2 The start of your 13 billion-year journey down the Heilbrun Cosmic Pathway on a sunny winter afternoon (see B on the map). Taken at ISO 400, f/3.5, 1/125 second with a 40-112mm lens.

Aside from the interesting photographic exhibits, the pathway offers an excellent vantage point from which to photograph the Hayden Planetarium and other parts of the center.

Before entering the walkway, you can also circumnavigate the entire sphere on the top floor walkway.

The outer planets are featured on the northwest corner, their size relative to the planetarium as our sun (see Figure 20.3). A standard zoom or ultrawide-angle zoom lens offer the best ability to create interesting frames in this room.

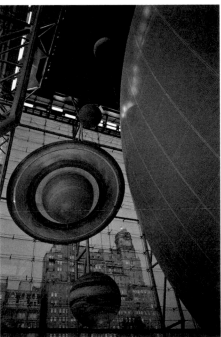

20.3 With the Hayden Planetarium representing the sun, Jupiter, Saturn, Uranus, and Neptune are shown to scale hanging next to one another (see B on the map). Shot on a chilly winter evening at ISO 1600, f/2.8, 1/30 second with a 24-70mm lens.

How Can I Get the Best Shot?

Although your outdoor images and those inside require different setups and equipment, they both have the same challenge to overcome of maintaining a sufficiently high shutter speed. Outdoors, you may need to use a tripod in order to keep the shot sharp. Inside, a fixed prime lens with a large aperture might be a good alternative to a zoom lens once the day begins to darken.

During the daytime, the sunlight filters through the all-white space and creates a great soft light once you move into the center's interior. Consider spending time inside the rest of the Natural History Museum during the day, and returning to photograph the Rose Center as the afternoon light begins to fade.

Equipment

Most of the museums will not allow you to bring large backpacks nor knowingly allow you to check camera gear in their coat room. You can get through with a belt pack if you have one, although prepare to be held up at security and have your bag searched. Your best bet is to bring a single lens or two camera bodies with two different lenses, if you have that available. Doing this lets you move more freely throughout the museum.

Lenses

▶ **A standard zoom in the 24-105mm range.** This all-purpose lens enables you to create many photographs without needing to bring multiple pieces of equipment. From a wide-angle shot at the 24mm range out to a medium telephoto at 105mm, you have a variety of options. These lenses often have image stabilization available, which helps as the lights begin to fade and your shutter speeds creep up. Standard zoom lenses also have a short minimum focusing distance giving you pseudo-macro capabilities for those interesting exhibits you want to highlight.

▶ **A prime lens with a large aperture of f/1.2 to f/1.8.** A *fast fifty* is usually the most accessible of these lenses, offering a 50mm normal lens on a full frame body. Although prime lenses do not zoom, the Rose Center is a fairly open and spacious place which means that you are free to zoom with your feet. The large aperture allows in lots of light, so you don't need to resort to flashes to capture your image.

▶ **An ultrawide-angle zoom in the 16-35mm range.** A very wide lens allows you to create some images with interesting perspectives. You can get extremely close to your subject yet still fit them in the frame.

Filters

A polarizing filter can help to reduce the glare on the glass outside and deepen the blue of the sky. This filter is only useful during the summer months, because the sun must be perpendicular to your lens in order to take effect, and the sun sets immediately in front of you all winter long.

Extras

Unlike many museums, the Museum of Natural History and the Rose Center allow flash photography. Bring an accessory flash if you want to shoot inside and are not able to maintain a high enough shutter speed with available light. When at all possible, use an off-camera cable or wireless flash to get the flash off the camera. Shooting outside will likely require a tripod to keep your images sharp. However, you cannot bring a tripod inside the museum, so you may need to consider your plans when deciding what to do here. A pocket gray card is also a useful tool to have in your pocket for challenging mixed-light compositions.

Camera settings

Most of your photography should be taken using Aperture Priority mode, even your twilight images outside where there is still enough light for your meter to work effectively. Due to the preponderance of light gray and white throughout the inside of the museum, your exposure compensation dial will probably need repeated adjustments. Even with these adjustments, using the back of your camera to review the exposure and the histogram is a good idea (see Figure 20.4).

Exposure

Although twilight exposures are often difficult, the fairly even lighting of the cube allows your meter to be fairly accurate when shooting outside. Indoors, the white of the building will be the biggest challenge. There are lots of places to prop up your camera inside if you need some extra stability for a slow shutter speed.

Using the Aperture Priority mode on your camera allows you to dial in the exact aperture you want, and your camera's meter will be used to set the shutter speed and ISO. This lets you adjust the depth of field for every shot. Using a small aperture in the f/8 to f/16 range produces a large depth of field while a very large aperture of f/1.2 to f/3.5 can create a razor thin focal plane. This can be useful to isolate an object or subject and blur a distracting background.

Drive mode

When shooting images in low light with borderline shutter speeds, using burst mode can be beneficial. Although it can be a challenge to hold the camera still at

shutter speeds near or below 1/focal length, it is not impossible. By shooting a two- to four-shot burst, you increase your chances that one of the shots will be acceptably sharp.

White balance

Outside, using the correct white balance is easy, setting it to Cloudy or Sunny as appropriate. Inside, however, is much more challenging. There will be some compositions where you will simply have to accept that the drastically mixed lights will never quite match. Shots like this, with sunlight streaming in the windows while darker interiors are well-lit by incandescent, fluorescent, and even tungsten bulbs can still create interesting photographs with a mix of color or can be converted to black-and-white. You can also come back later as the sun is setting, when the artificial light overpowers the sun.

ISO

Although using as low an ISO as possible is always recommended, you will likely need to bump it up a bit in order to get acceptable shutter speeds. Outdoors, a tripod may obviate this need, but inside, as the sun sets, there are places that are simply not well lit. During the daytime, an ISO of 100-200 outside and 400 inside should be sufficient. At sunset and in the evening, don't hesitate to move to ISO 800 or 1600, if necessary, if you are not using a flash (see Figure 20.4).

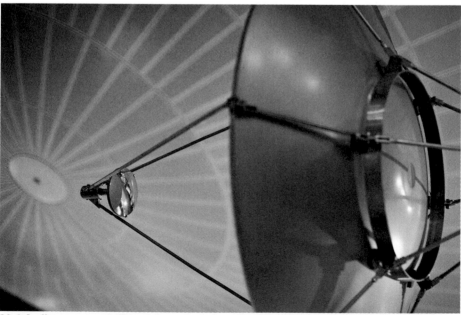

20.4 A silver-gray satellite dish against the off-white bottom of the Hayden Planetarium on an early winter day. Taken at ISO 1600, f/1.6, 1/100 second with a 50mm lens.

Ideal time to shoot

The Rose Center is open year-round, seven days a week, so you can always find something interesting to shoot. The winter months are the quietest, as are week-days, and you may even have the space to yourself (see Figure 20.5). Sunset and twilight are the best times of day to shoot.

The only significant weather considerations shooting inside will be the large tem-perature swings between outside and inside. When it is extremely cold outside and warm inside, you may end up with condensation on your camera and lens.

Keeping your camera in your bag or in a plastic bag can help alleviate this issue. If you arrive by subway, you can enter the museum from the 81st Street station and not deal with this at all. Shooting outside means being aware of the temperature and precipitation and ensuring you and your camera are prepared.

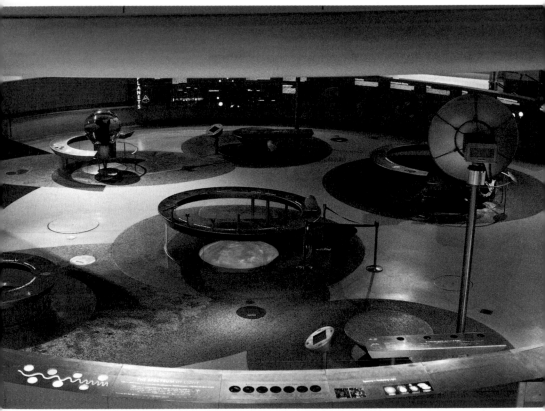

20.5 The ground floor of the Rose Center for Earth and Space is reminiscent of a sci-fi television show and features many interactive exhibits. Taken at ISO 1600, f/2.2, 1/50 second with a 50mm lens.

Low-light and night options

Because you are not allowed to use a tripod inside, consider alternatives to camera stabilization. The support structures or signs for the displays can either fully support or help you brace your camera, often allowing an additional 1 to 2 stops of shutter speed while maintaining a sharp image. An image-stabilized lens can also help in this regard.

Getting creative

The Rose Center contains many interactive exhibits. One way to express that photographically would be to interact with the exhibits and then photograph your actions (see Figure 20.6).

If you are there with children, watch them with your camera ready. You are guaranteed to have an opportunity to shoot them with a smile on their faces.

20.6 Various scales calculate your weight on different celestial bodies. Mars is an instant weight-loss regime. Taken at ISO 1600, f/1.6, 1/60 second with a 50mm lens.

A stained glass window at Saint Patrick's Church Cathedral. Taken at ISO 1600, f/2.8, 1/80th second with a Lensbaby.

21 Saint Patrick's Church Cathedral

Why It's Worth a Photograph

This gorgeous Neo-Gothic-style Catholic cathedral is smack in the middle of midtown Manhattan. Construction began on this seat of the archbishop of the Roman Catholic Archdiocese of New York with the laying of the cornerstone in 1858. After a delay during the Civil War, the building was dedicated in 1879 when it loomed over most of 19th century midtown. The cathedral, including the 330-foot tall spires, were built with brick then covered in New York and Massachusetts marble to complete the effect.

Where Can I Get the Best Shot?

You can best capture the architecture of the cathedral outside along Fifth Avenue, inside the Nave, in the cathedral's side chapels, and in the North Transept.

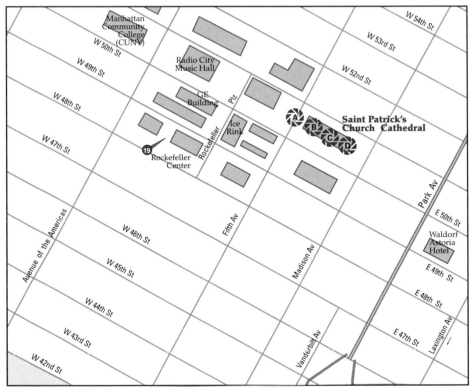

The best vantage points from which to photograph Saint Patrick's Cathedral: (A) outside on Fifth Avenue, (B) the Nave, (C) the side chapels, and (D) the North Transept. Other photo ops: (19) Rockefeller Center.

Outside on Fifth Avenue

The front of Saint Patrick's Cathedral along Fifth Avenue offers many compositions to capture this great subject. You can accentuate the size of the building with an ultrawide-angle lens on the sidewalk below the structure. Alternatively, use a zoom lens to isolate the details of the building such as the huge spires climbing into the sky (see Figure 21.1).

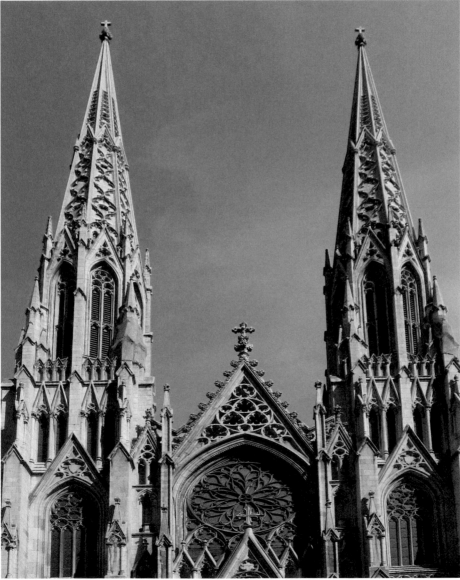

21.1 Detail shot of the massive spires fronting Saint Patrick's Cathedral on a summer afternoon (see A on the map). Taken at ISO 80, f/5.6, 1/320 second with a 28-100mm lens.

The Nave

The vast Nave of Saint Patrick's Cathedral will be your first photo opportunity after entering the building. Shoot right down the aisle with the pews framing the lower edges of your image with a wide-angle lens to accentuate the size of the room. The strong vertical lines of the pillars descending down to the front create a very strong composition (see Figure 21.2).

Keep your camera level to ensure all the lines remain parallel to the sides of the frame or get low and aim up to accentuate the height of the ceilings and size of the pillars.

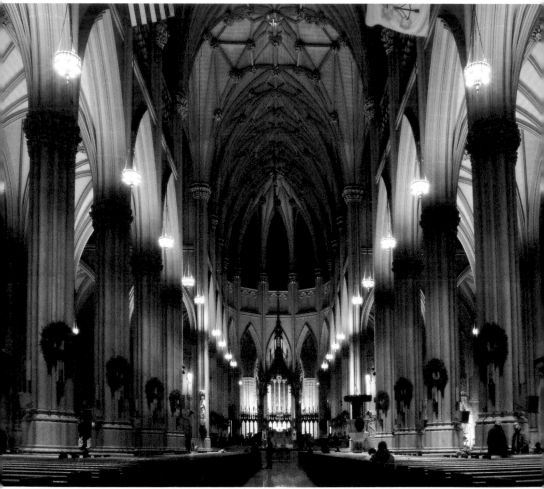

21.2 The Nave of Saint Patrick's Cathedral at Christmas in mid-afternoon (see B on the map). Taken at ISO 64, f/8, 4 seconds with a 28-200mm lens.

Side chapels

To the left of the aisle through the Nave is a gorgeous side chapel that is often lit primarily by candles. The light of these candles gives off a yellow/orange glow and creates flickering, ever-changing shadows in the surrounding spaces (see Figure 21.3). With a standard zoom lens, select some details to isolate and explore the shapes, lines, and decorations.

This is a situation to be sure you are shooting in RAW mode to give yourself the most flexibility later in the digital darkroom. With RAW mode, you can adjust the white balance losslessly and best tweak the final image to fit how you remember or wish to express your vision of this space.

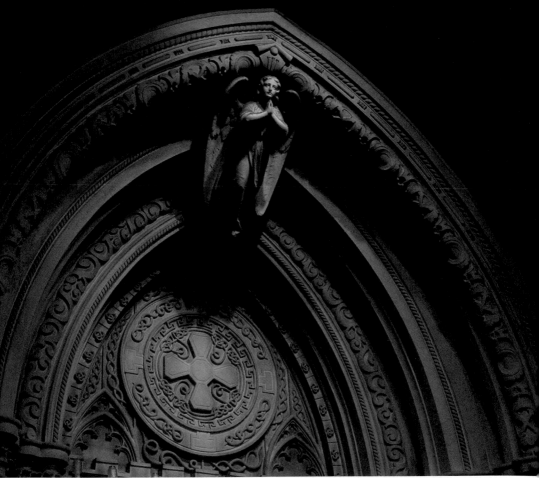

21.3 An angel in the side chapel of Saint Patrick's Cathedral on a winter midafternoon (see C on the map). Taken at ISO 100, f/2.2, 1/30 second with a 28-200mm lens.

The North Transept

Similar to the Nave, the North Transept offers a massive space in which to compose an image. You can really explore the beauty of the repeating parallelism present in the parish from this perspective. Use a standard zoom lens to create an image that keeps the straight lines mostly perpendicular to the edges of the frame and each other (see Figure 21.4).

Consider using a fisheye lens to accentuate the equilibrium of this vantage point by bringing in all the straight outer lines and curving them around the already nonlinear supports across the ceiling.

How Can I Get the Best Shot?

When you arrive at Saint Patrick's, take some time to explore the cathedral before pulling out your camera. There are so many photo opportunities here that it is beneficial to take that time to plan them out and let your creative juices bubble for a while. The architecture is fantastic here, with huge ceilings and extensive open spaces with both parallel and divergent lines to utilize in your compositions.

Don't forget to also explore the details of the space, though, with the many religious icons and artistic flourishes emanating from every corner and archway (see Figure 21.5). Exposure and white balance can be technical challenges, but if you are prepared for them you will come away with many great images.

21.4 The North Transept of Saint Patrick's Cathedral (see D on the map). Taken at ISO 1600, f/4, 1/20 second.

21.5 Saint Jude at Saint Patrick's Cathedral. Taken at ISO 64, f/8, 3 seconds with a 28-200mm lens.

Equipment

Saint Patrick's Cathedral can be photographed in nigh innumerable ways with a variety of lenses and techniques. However, because it is a working church, it is generally most respectful to visit during less crowded hours and with only a modicum of gear.

If you wish to try a number of different lenses or photographs that require different sets of equipment, budget some time to return on multiple trips. You won't run out of amazing images to create here.

Lenses

▶ **A standard zoom lens in the 24-105mm range.** A multipurpose zoom lens allows you to travel light and create many compositions and images without worrying about changing lenses. These lenses also often offer image stabilization to help with the low-light environment of the cathedral.

▶ **An ultrawide-angle zoom lens in the 16-35mm range.** An ultrawide zoom allows you to capture large swaths of the building, both inside and out, in a single frame. By tilting it up you can create a perspective that accentuates the soaring pillars inside or spires outside.

▶ **A prime lens with a large aperture in the f/1.2 to f/1.8 range.** A prime lens of 24mm, 35mm or 50mm with a large aperture will give you an additional 2 to 4 stops of light compared to an equivalent zoom lens. All of this extra light can allow you to handhold your camera at sufficient shutter speeds to capture a sharp image.

▶ **A tilt-shift or perspective correction lens.** A special type of lens that emulates the abilities of large format bellows cameras. This lens allows the shifting of the image up or down across the sensor while maintaining parallelism of the lines in the image.

▶ **A fisheye lens.** A wide-angle fisheye lens generally offers a 180-degree field of view from corner to corner. It will bend in straight lines around the outside to create a fisheye effect. The effect can be used to accentuate the left and right uniformity in a scene.

Filters

The only time to consider using a filter at Saint Patrick's Cathedral would be when outside during the day. Here, a polarizing filter can deepen the color and saturation of the sky, increasing the contrast of the cathedral in the foreground.

Extras

Tripods are not allowed in the cathedral and flash photography is discouraged, especially during services. If the light is low and your shutter speed is borderline for getting a sharp shot, try to use an existing object in the environment to help steady your camera. Leaning or bracing your camera against a wall can add one to two stops worth of stability. Bringing a pocket gray card can help you capture the proper color to set a custom white balance.

Camera settings

The biggest technical challenge inside Saint Patrick's Cathedral is the low amount of light available. Obtaining a good white balance follows as the second hurdle to overcome. Both of these, however, are easily overcome with a little planning and knowing which tools and settings to use.

Exposure

Utilizing Aperture Priority mode you can directly control the aperture and thus the amount of light entering through the camera lens. You will mostly want to shoot *wide open*, or with the lowest aperture available on your lens. While this may not be the sharpest setting, it does allow the most light to reach your camera's sensor.

White balance

With the mix of ambient sunlight, fluorescent, incandescent, and candlelight throughout this space, achieving a proper and consistent white balance requires a little bit of extra work. If you are shooting a wide scene with distinctly different light sources, there is nothing you can do to equalize them.

Consider your framing and whether there is a different composition you can create that minimizes the multitude of light sources. If this is not possible, then you will have to compromise and choose which light source to focus on getting right in camera. For these wide scenes and for detail shots with just a single light source, use a pocket gray card to create a custom white balance in the field and to assist in appropriately adjusting that color in the digital darkroom. Shoot in RAW mode to ensure you have all the original sensor data and give yourself the most latitude when editing in the computer.

ISO

Saint Patrick's is dark inside, so even with these wide-open apertures, you need to use high ISO settings. Outside you can use a setting of ISO 100 to 400 at all times through the day. Indoors, go as high as needed to create a sharp image. Many cameras can create decent images at ISO 800, 1600 or even higher.

Ideal time to shoot

Much of your shooting will be done inside the cathedral so try to shoot at late morning to late afternoon to have the most possible available light. The cathedral is open year-round and is obviously very crowded around major Christian holidays. Unless you specifically want to create images with parishioners, plan to visit at off hours. If you do wish to shoot during the more crowded times, just keep in mind that this is a working church and to be respectful of the worshippers.

Come to Saint Patrick's Cathedral in any kind of weather. Be sure that both you and your equipment are protected when visiting in inclement weather. If it's raining hard, the best shot of the outside of the cathedral is from under the portico of Rockefeller Center across Fifth Avenue.

Getting creative

Saint Patrick's Cathedral lends itself quite well to creative compositions and alternative processes. Using different cameras or lenses such as a Lensbaby or a Holga-like plastic lens can create dreamy effects that fit in quite well with the subject matter (see Figure 21.6).

21.6 Worshippers at Saint Patrick's Cathedral. Taken at ISO 1600, f/2.8, 1/25 second with a Lensbaby.

22 SoHo

A taxi picks up passengers on Prince Street on a clear fall afternoon. Taken at ISO 800, f/6.3, 1/100 second with a 16-35mm lens.

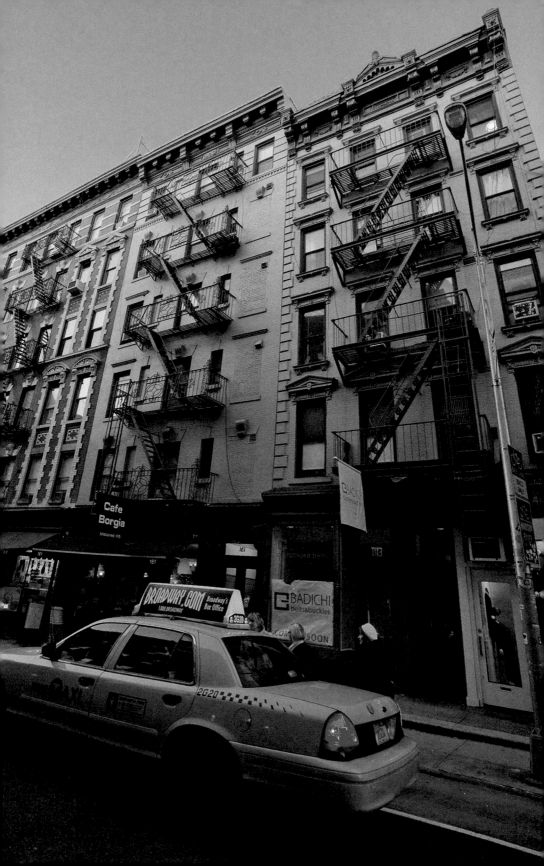

Why It's Worth a Photograph

The first Manhattan neighborhood with a geographical acronym, SoHo's name is derived from its location — south of Houston Street. Named in 1968 by a group of artists and activists, the neighborhood is also known as the SoHo Cast Iron Historic District. An innovation of American architects, cast-iron facades were less expensive than other materials. Almost 250 of these buildings still stand in this small area.

Today, SoHo contains the largest collection of these historic buildings in the world, built mostly from 1840 to 1880. The neighborhood also has a large number of boutiques for shopping as well as a handful of factories. The area's fantastic architecture offers a chance to capture striking photographs of these distinctive buildings.

Where Can I Get the Best Shot?

The best places to travel to get great photographs in SoHo are along Prince Street, West Broadway, and Grand Street.

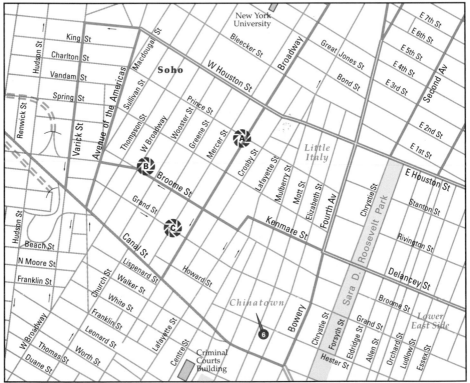

The best vantage points from which to photograph SoHo: (A) Prince Street, (B) West Broadway, and (C) Grand Street. Other photo ops: (6) Chinatown.

Prince Street

Cluttered with restaurants, boutiques, and cast-iron architecture, Prince Street from Broadway to West Broadway offers a range of photographic opportunities. On the corner of these two streets is the Little Singer Building, an exquisite building fronted with cast-iron and terra-cotta tiles (see Figure 22.1). A huge trompe l'oeil mural graces the side of 112 Prince Street, imitating the building's iron facade (see Figure 22.2).

On the corner of Prince and Greene streets, 109 Prince Street is a five-story white building with multiple bays of windows and a strong horizontal presence from a thick cornice on each level. You can use a wide-angle lens to capture the entire building or a telephoto zoom lens to isolate individual architectural elements on a structure.

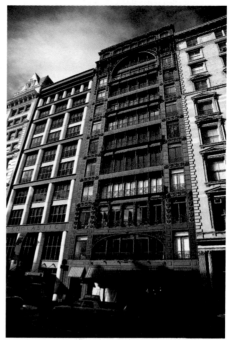

22.1 The famous Little Singer Building on Broadway at Prince Street on a cold winter morning (see A on the map). Taken at ISO 100, f/5, 1/80 second with a 24-105mm lens.

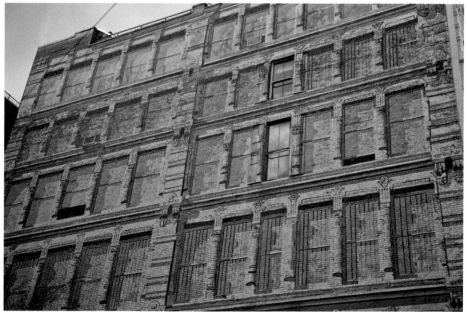

22.2 The eastern face of 112 Prince Street with a huge mural imitating its cast iron facade. Taken at ISO 100, f/4, 1/40 with a 24-105mm lens.

West Broadway

West Broadway is the western border of SoHo and the end of the cast-iron architecture. Walking south along West Broadway from Prince Street to Grand Street, the boutiques and shops slowly fade toward the grittier feel of SoHo's earlier days. A few factories remain when you get as far south as Canal Street.

Intersections, such as the one at Broome Street and Broadway, offer a visual contrast between the historic style of SoHo and the much newer buildings to the west in the South Village. Looking east continues to offer views of beautiful vintage buildings (see Figure 22.3).

Grand Street

Heading east on Grand Street back toward Broadway is a distinct contrast from the commercial and packed northern end of SoHo. With narrower streets and fewer commercial establishments, the buildings still retain a similar architecture, albeit more raw. Create some images along this street to show the differences from just a few blocks north (see Figure 22.4).

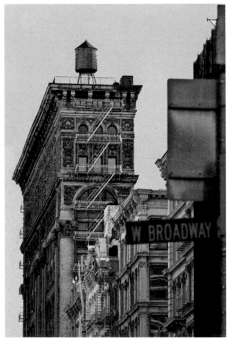

22.3 The corner of West Broadway and Broome Street on a chilly winter afternoon. Taken at ISO 200, f/4.5, 1/500 second with a 70-200mm lens.

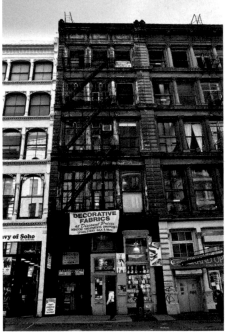

22.4 Near the corner of Broadway and Grand Street, the older buildings show their age more than the buildings farther north and closer to Houston Street. Taken at ISO 125, f/7.1, 1/25 second with a 24-105mm lens.

Once you reach Broadway, a block north at the corner of Broome Street and Broadway is the Haughwout Building. Yet another distinctive structure, this building housed the first passenger elevator in the world. The keystone arches across the entire facade make a wonderful repeating pattern to photograph (see Figure 22.5).

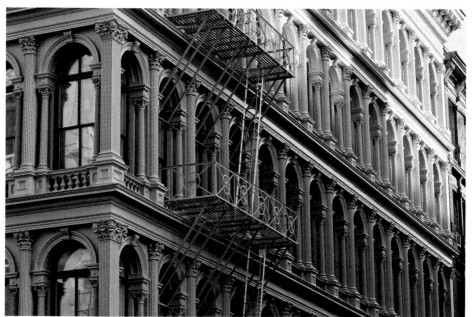

22.5 Keystone arches line each of the five floors of the Haughwout Building at the corner of Broadway and Broome Street. Taken at ISO 200, f/4.5, 1/200 second with a 70-200mm lens.

How Can I Get the Best Shot?

Planning a leisurely walk through the neighborhood is your best chance to get some great architectural shots in SoHo. With the crowded streets and busy roads, you may have to be patient to get the images you want. Using wide-angle or ultra-wide-angle lenses gives you the ability to capture entire buildings in a frame from fairly close. Getting closer increases the liklihood that your frame will be free of vehicles, pedestrians, and signs.

Depending on your goals, do not be afraid to include some features to place your images, be they street signs, yellow cabs, or recognizable buildings in the background.

Equipment

You have a few good choices for lenses, and carrying a small backpack or belt bag is not too difficult in much of the neighborhood. If you are going to be walking

around Spring and Prince streets a lot on a beautiful weekend, however, be aware that it is likely going to be difficult to move around due to the crowds, so you may want to travel with less equipment.

Lenses

▶ **A standard zoom lens in the 24-105mm range.** A multipurpose zoom lens lets you travel light and focus on your images and not your gear. Often these lenses include image stabilization, so you can shoot into twilight without a tripod. And their pseudo-macro capability lets you take close-up shots of street-level architectural decorations found on many buildings.

▶ **An ultrawide-angle zoom lens in the 16-35mm range.** An ultrawide-angle lens allows you to get extremely close to the buildings, offering a clean perspective against the sky. When creating such an image, however, you are sacrificing a rectilinearly correct perspective for a cleaner image.

▶ **A telephoto zoom lens in the 70-200mm range.** A telephoto zoom lens is a great option for a long line of sight when capturing entire buildings. Standing far enough away to utilize this lens to capture an entire building, the perspective will look correct and square the building in the frame. However, it can be difficult to get this shot free of vehicles, signs, and pedestrians. This lens is also excellent to zoom in and pick out details, such as a single archway or a small cast-iron decoration on a building.

Filters

A polarizing filter can help deepen a blue sky and remove reflections from windows. Offering increased contrast against the sky helps the buildings pop in your photos.

Extras

Using a good backpack or belt bag to carry a range of lenses makes it much easier to try a variety of shots. Alternatively, if you have an older camera body, consider bringing two cameras with two different lenses and nothing else. You can bring a tripod if you are going to be doing longer exposures or shooting at night, but it might be cumbersome to move around the streets with it.

Camera settings

When shooting architecture shots, you want to use a small f/stop in the f/8 to f/11 range to maximize your image quality and sharpness. Doing so also gives you a large depth of field. Using your camera's built-in meter is very effective when coupled with use of your exposure compensation for shooting all-white buildings.

Exposure

When you are in the heart of the city, daytime shadows from buildings can pose a challenge to your exposure. Create your compositions to keep the entire frame in the sun or shadow as much as possible. When including the sky in your images, be aware that your camera's dynamic range may be exceeded and consider bracketing your exposures to ensure a quality exposure or to enable creating an HDR image in the digital darkroom.

Using Aperture Priority mode gives you control over your depth of field and use the camera's meter to set the shutter speed. You will want to use +2/3 to +1 exposure compensation on some of the bright buildings.

White balance

Because you will be exclusively outside during your walk, use Sunny or Cloudy white balance as appropriate and shoot in RAW mode to offer the most flexibility in the digital darkroom.

ISO

Use the lowest ISO you can to get acceptable shutter speeds — generally, ISO 100-200 on a sunny day and ISO 400 on a cloudy day.

Ideal time to shoot

You can shoot the architecture of SoHo during the entire year. You will want to focus on capturing quality light on the faces of the buildings. The golden hours after sunrise and before sunset give you the best opportunity to see this light splash across the building facades.

Be sure to check the local forecasts for wind, rain, and snow because these are challenging conditions in which to capture photographs. Keeping warm by going in and out of buildings can cause condensation on your camera which can delay your shooting or create water spots on your sensor. Dress appropriately if it will be cold.

Low-light and night options

As night falls, the artificial lights replace the sunlight. The twilight period where both exist can be a superb time to create images of this transient stage of the day with the buildings lit in a way that few will ever see or stop to appreciate.

Getting creative

When shooting architecture, your perspective is critical. If you are serious about creating quality architecture shots, consider renting a tilt-shift/perspective correction lens for your trip to SoHo. These lenses let you use your SLR camera like a bellows camera and shift the image up or down while maintaining a proper perspective. Although it is possible to approximate this effect in the digital darkroom, there is no substitution for the proper perspective offered by one of these lenses.

The South Street Seaport and Brooklyn Bridge from the Fulton Ferry Pier on a winter evening. Taken at ISO 200, f/11, 30 seconds with a 24-105mm lens.

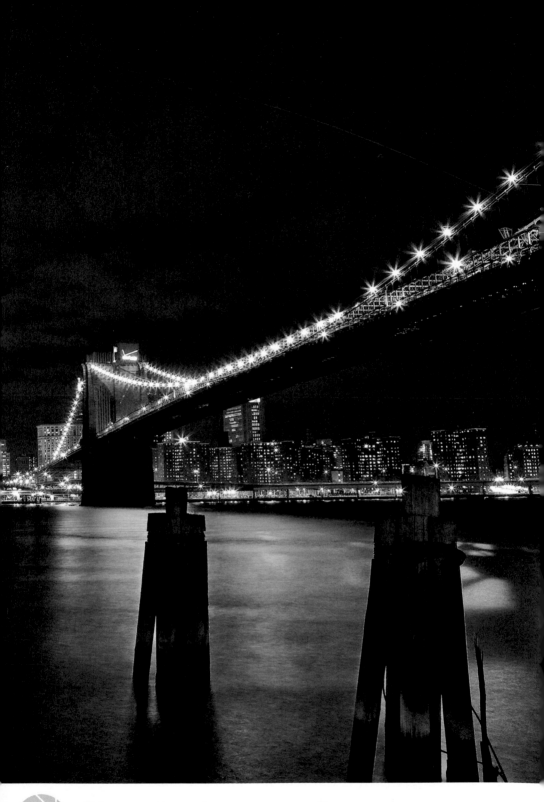

23 South Street Seaport

Why It's Worth a Photograph

The South Street Seaport at Fulton and South streets in lower Manhattan features some of the city's oldest architecture, historical ships, shopping, and vibrant street life. This photogenic neighborhood is just south of the Brooklyn Bridge and adjacent to the Financial District on the southern tip of the island. The streets are filled with people eating, shopping, and enjoying performances day and night throughout most of the year.

The indoor mall on Pier 17 contains both shops and galleries. Restaurants overlook the docks where you can visit a number of historic vessels, such as the 377-foot-long barque, the *Peking*. This location offers fantastic views of the Brooklyn Bridge from numerous locations around the seaport. You can also hop on a water taxi and take a quick ride over to the Fulton Ferry Landing near the Brooklyn Heights Promenade. The South Street Seaport is a dense photographic landscape for you to explore with your lens.

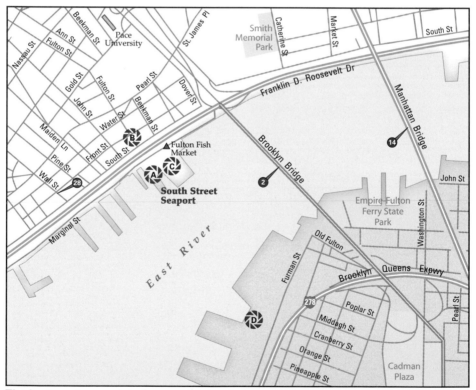

The best vantage points from which to photograph the South Street Seaport: (A) Pier 16, (B) Fulton Street, (C) the Seaport at Pier 17, and (D) the Brooklyn Heights Promenade. Other photo ops: (2) Brooklyn Bridge, (14) Manhattan Bridge, and (28) Wall Street.

Where Can I Get the Best Shot?

The best photographs at the South Street Seaport are from Pier 16, Fulton Street, the Seaport at Pier 17, and the Brooklyn Heights Promenade.

Pier 16

Pier 16 is home to many of the South Street Seaport Museum's fleet of historic vessels and offers great views of the river and the Brooklyn Bridge's eastern terminus. The *Peking*, a huge barque, and the *Ambrose* lightship are interesting historically and photographically. You can create an image of these museum ships against the backdrop of the modern buildings of the Financial District (see Figure 23.1).

It is also possible through creative angles to create a frame without any modern accoutrements, especially when exploring the interiors of the ships. For example, the deck of the *Peking* offers a great elevated platform to shoot down onto other parts of the seaport. A standard zoom lens gives you the most freedom to move around while a telephoto lens offers you the ability to zoom in to isolate details in a larger scene.

Fulton Street

Cobblestoned Fulton Street is a pedestrian-only roadway lined with restaurants, shops, and historical buildings, such as Schermerhorn Row. Filled day and night during the warmer months, this location is great for street photography. Steet performers, known as buskers, are omnipresent from spring through fall, performing acrobatics, juggling, or swallowing fire. A standard zoom lens or a fixed prime lens allows you to shoot unobtrusively (see Figure 23.2).

23.1 The Peking at its Pier 16 home in front of the modern buildings of the Financial District on a winter morning (see A on the map). Taken at ISO 250, f/9, 1/320 second with a 16-35mm lens.

The Seaport at Pier 17

The Seaport building on Pier 17 has been converted into a mall and tourism center. You can find shopping inside, and the outside decks offer elevated views of the other piers and Seaport neighborhood, the East River, and the Brooklyn Bridge.

For most of the year, you can see the sun rising behind the Brooklyn Bridge when viewed from this location.

Looking down on the piers instead of over the water, you can find an ever-changing sea of people and colors (see Figure 23.3). There is also a range of boat traffic moving in and out of the area to include in your shots (see Figure 23.4).

Use a wide-angle or standard zoom lens to see a large portion of the scene and keep a feeling of anonymity in your people images. A telephoto zoom lets you pick out a single subject for your images.

Brooklyn Heights Promenade

Across the East River, the Brooklyn Heights Promenade offers great views of the seaport. To get there, take a leisurely stroll over the Brooklyn Bridge, ride the water taxi to the Fulton Ferry Pier, or pick up a taxi if you are tired or

23.2 A busker plays with fire at the corner of Fulton and Front streets on a warm summer night (see B on the map). Taken at ISO 640, f/1.2, 1/40 second with a 50mm lens.

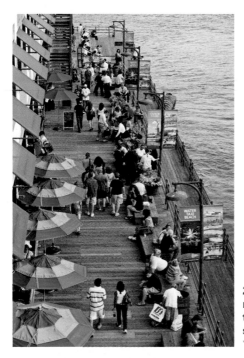

23.3 Pier 17 wraps around the Seaport now housing shops and tourist information (see C on the map). Taken on a summer afternoon at ISO 200, f/2.2, 1/1250 second with an 85mm lens.

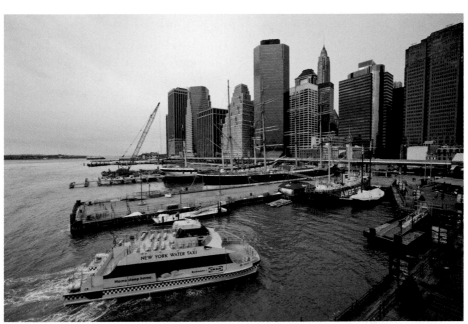

23.4 A water taxi pulls in to Pier 17. Pier 16 and the Financial District are visible in the background. Taken on an overcast winter morning at ISO 250, f/8, 1/250 second with a 16-35mm lens.

pressed for time. Along Columbia Heights, you can most easily access the promenade at Orange Street.

Shooting there at sunset is ideal because you will have a colorful sky for your images. As twilight darkens into night, the artificial lights slowly take over and reflect in the waters of the East River. You want a lens with some reach if you are going to isolate specific features (see Figure 23.5). A wide-angle lens shows a large swath of the Manhattan coastline.

NOTE Immediately below the promenade, the Pier 1 section of Brooklyn Bridge Park opens in 2010. This new park will offer similar views as the promenade plus an unobstructed view of the Brooklyn Bridge.

23.5 The tall ships of Pier 16 as seen during twilight from the Brooklyn Heights Promenade on a windy winter afternoon (see D on the map). Taken at ISO 50, f/8, 30 seconds with a 300mm lens.

How Can I Get the Best Shot?

Your photographic goals affect how much and what kind of equipment you will want to bring with you. A backpack or belt pack to hold excess equipment is generally not a problem. Because most of your images will be outdoors, the weather and skies may dictate what and when you shoot.

Get up early to watch the sunrise and create uncluttered images focusing on the seaport and its historical attractions. Later in the day and into the evening, the streets come alive with throngs of people. Consider the contrast of the wealth of history mixed with the modern details strewn about.

Equipment

A photographic microcosm, you can easily spend days photographing this small area. Although there is a lot of equipment that you can use, generally targeting a smaller number of shots for a day and focusing on their execution is preferable to trying to do one of everything. You can always come back to try something new.

Lenses

▶ **A standard zoom in the 24-105mm range.** This all-purpose zoom lens goes from wide-angle to medium telephoto. Although these lenses may not be as fast, wide, or long as other specific lenses, they tend to be lighter and can cover the majority of shots you want to create. With this tool, you carry just one lens and focus on your photographs.

▶ **An ultrawide-angle zoom lens in the 16-35mm range.** An ultrawide-angle zoom lens allows you to get close to a subject yet still fit it into the frame. This perspective offers the benefit of reducing the likely clutter in the frame because you are so close. It will also cause close-up objects to appear larger than they are in respect to the background.

▶ **A telephoto lens in the 70-200mm or longer range.** When you visit the Brooklyn Heights Promenade, you want to use a lens that is long enough to reach across the East River so that you can isolate portions of the waterfront.

▶ **A prime lens with a large aperture of f/1.2-f/1.8.** A *fast fifty,* referring to a lens of 50mm, is the most likely lens to be available with such a large aperture at a reasonable price point. These lenses tend to be much smaller than zoom lenses, and because they are 2 to 4 stops faster than many zoom lenses, you can shoot in the evening without a flash. These two features are ideal for street photography when you want to remain inconspicuous.

Filters

A polarizing filter can help darken the blue of the sky and cut glare off of the river's surface. Both of these effects help to increase the contrast in your shot. When shooting across the river, a neutral density filter allows you to use longer shutter speeds and smooth out the river's surface.

Extras

A good photo backpack or belt pack lets you carry a few lenses and other accoutrements easily. If you plan to use a tripod for longer exposures, you can usually carry them attached to the outside of the backpack.

Camera settings

Using a small aperture of f/8 to f/11 gives you a large depth of field and keeps your lens sharp. Your camera's built-in meter will do an excellent job, in most cases, shooting around the seaport, freeing you to focus on creating your composition, and waiting for the shot.

Exposure

Exposing outdoors during the day should be straightforward. Your camera's meter is very good at these types of situations. Be aware of specular highlights off the glass or water in your shots. At night, you may need to use your exposure compensation dial to adjust the camera's settings if there is a drastic difference in lighting across the frame.

Aperture Priority mode gives you direct control over your depth of field and has the camera set your shutter speed automatically. This will work great except when shooting long exposures on a tripod when you will want to use Manual or bulb.

White balance

Setting your camera on Sunny or Cloudy white balance presets as appropriate yields good results. At night, you need to adjust your settings to reflect the artificial lighting you happen to be using. A pocket gray card can be useful in this changing light.

ISO

The lowest ISO possible for your exposure yields the cleanest image. Use ISO 100-200 during a clear day or 400 if it is cloudy. At night, don't hesitate to go to 800 or even 1600, if necessary. Better to have a sharp image with digital noise than a uselessly blurry shot.

 See Chapter 14 for more detailed information about long exposures at sunset.

Ideal time to shoot

The South Street Seaport offers wonderful photos at almost any time of day or night. Early in the morning the sun rises over the bridge, and the streets and piers are nearly empty. As the day progresses, people will flock to the museums, restaurants, and shops while the buskers perform all day and well into the night. The warmer months offer more opportunities to photograph people because there are fewer visitors during the winter.

Watch the local weather to keep abreast of the city's ever-changing conditions. Not only do you want to be aware of the wind, rain, or snow, but the forecast for clouds can affect your shots. A clear sky can be beautiful for many shots, increasing the contrast against ships or buildings. However, a partly to mostly cloudy day will generally offer a much more pleasing vista for wide shots as well as a more colorful sunset. Overcast skies are excellent for people photography, providing a flattering, flat light.

Low-light and night options

If anything, the streets just get more interesting as the sun falls. After photographing the sunset and twilight's descent from the Brooklyn Heights Promenade, head back to Fulton Street to enjoy some people photography or to the docks to see the tall ships in an entirely new light.

Getting creative

The Brooklyn Bridge is an ever-present form over the South Street Seaport, but it is often partially or fully occluded by other buildings. After spending some time on the streets, see if you can create some images that capture this feeling of presence without being overwhelming (see Figure 23.6).

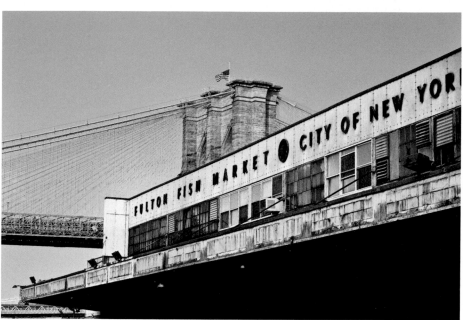

23.6 The former Fulton Fish Market building from South Street with the Brooklyn Bridge in the background on a clear summer afternoon. Taken at ISO 200, f/7.1, 1/500 second with an 85mm lens.

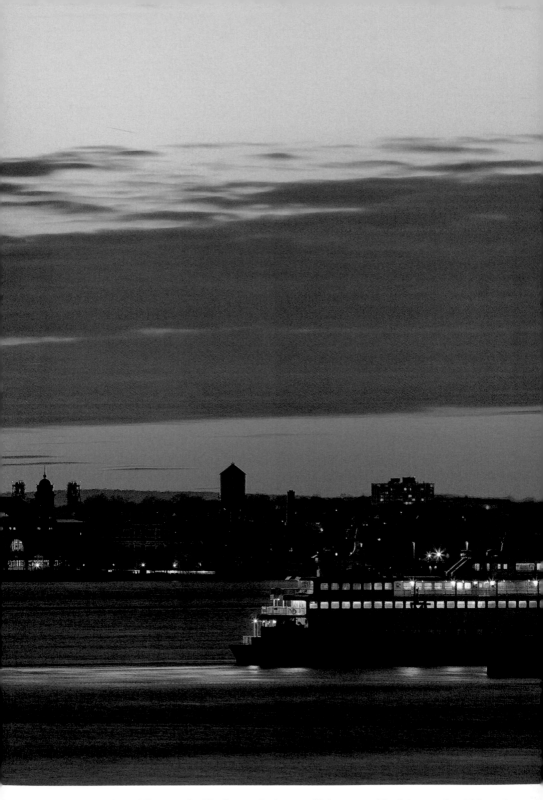

The Staten Island Ferry at the Manhattan docks at twilight on a cold winter evening. Taken at ISO 50, f/8, 10 seconds with a 300mm lens.

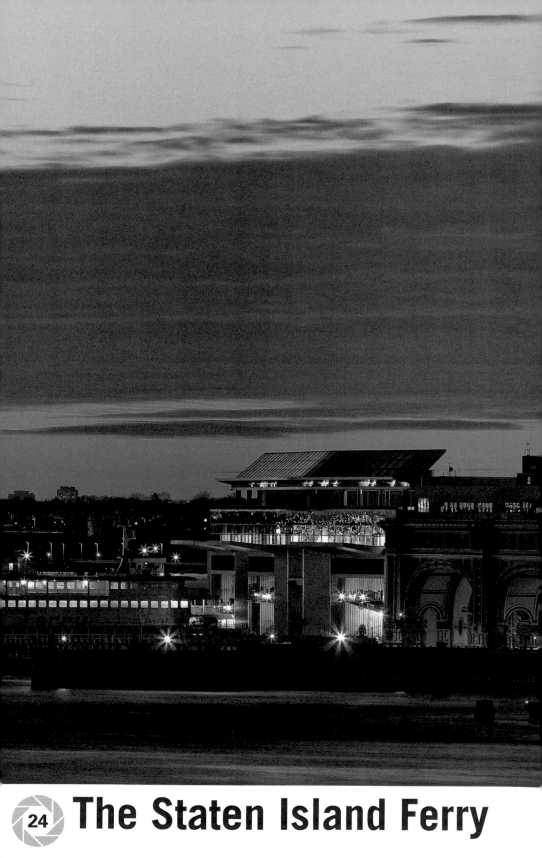

24 **The Staten Island Ferry**

Why It's Worth a Photograph

The Staten Island Ferry is one of the best deals in New York City. This free ferry service between Manhattan and Staten Island offers views of the Statue of Liberty, Governors Island, and the Lower Manhattan skyline as it carries its 60,000 passengers every day. In service since 1817, the fleet of boats runs 24 hours a day.

You can take the 25-minute ride out of Manhattan and then get right back on for a return from Staten Island at most times of day. During the late-night hours, you will have to wait roughly 30 minutes for the next trip.

Riding on the bow or stern observation decks can be a cold and windy proposition, but the fantastic points of view you can obtain are well worth the discomfort. Be sure to make a round trip on the Staten Island Ferry part of your photo tour of New York.

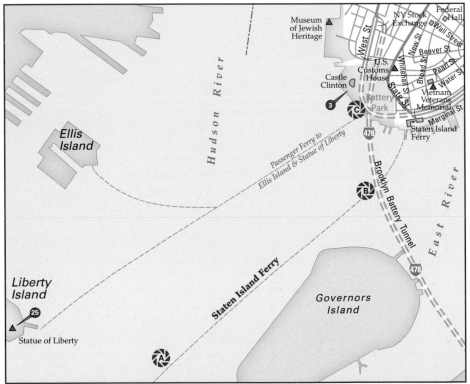

The best vantage points from which to photograph around the **Staten Island Ferry:** **(A) the ferry passing the Statue of Liberty, (B) the ferry leaving Manhattan,** and **(C) Battery Park.** Other photo ops: **(3) Castle Clinton.**

Where Can I Get the Best Shot?

The best locations from which to photograph on and around the Staten Island Ferry are from the ferry passing the Statue of Liberty, from the ferry while leaving Manhattan, and from Battery Park.

The ferry passing the Statue of Liberty

This location is about as close as you can get to the Statue of Liberty without actually travelling to Liberty Island. The ferry passes within about 500 yards of Lady Liberty and offers fantastic opportunities to shoot her from the front and sides. To get an image from a similar angle would otherwise require being much farther away on the Brooklyn or Queens shore with a significantly larger lens.

And as you move by, you have the option to capture a multitude of angles and compositions while the ferry steams on. Riding the ferry early in the morning will offer beautiful light illuminating the easterly facing statue. Even though you are relatively close, you still want a telephoto zoom lens to fill the frame as much as possible with the statue (see Figure 24.1).

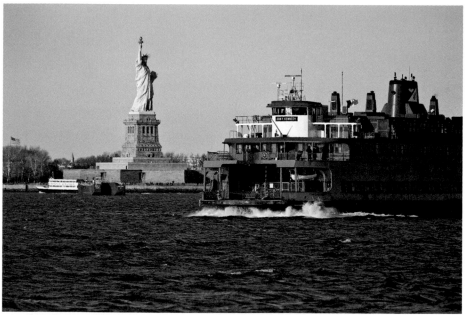

24.1 The Staten Island Ferry leaving Manhattan passes in front of the Statue of Liberty on a cold winter afternoon. Shot from the front, lower deck of another ferry returning from Staten Island (see A on the map). Taken at ISO 500, f/5, 1/3200 second with a 70-200mm lens + 1.4x teleconverter.

The ferry leaving Manhattan

Pulling out of New York harbor on the ferry can be a stunning experience. Although you may have been walking through the urban canyons all day, seeing these build-ings grow in front of you as the boat heads away from port emphasizes the sense of vast scale that is New York City. After boarding the ferry, head directly down the steps to the observation deck and watch the city first expand to fill your field of view and then fade into the distance as you head out into the bay (see Figure 24.2).

24.2 Lower Manhattan as seen from the lower deck of a Staten Island Ferry leaving Manhattan on a blustery winter afternoon (see B on the map). Taken at ISO 500, f/6.3, 1/3200 second with a 70-200mm lens + 1.4x teleconverter.

Before long, Governors Island will begin to slide by on the eastern side, beautifully lit by the afternoon sun (see Figure 24.3). Consider creating a panoramic image of the harbor after you are far enough out to capture the whole thing. However, be sure to work fast when creating the panorama.

As the ship moves, your perspective will change, which makes it very difficult to stitch together the images into a realistic-looking panorama (see Figure 24.4). When creating a panorama, overlap each individual photograph more than necessary

to compensate for the movement of the boat. After docking at Staten Island, you must get off the boat and get back in line to get on. This time, head to the opposite end of the boat from where you boarded on to enjoy the same views of Manhattan as you return.

24.3 Castle Williams sits on the northwest corner of Governors Island overlooking the Upper Bay while the Brooklyn and Manhattan bridges are visible in the background on a windy winter afternoon. Taken at ISO 500, f/5.6, 1/3200 second with a 70-200mm lens + 1.4x teleconverter.

24.4 A panorama of lower Manhattan and the East River created from 30 images. Taken at ISO 500, f/5.6, 1/3200 second with a 70-200mm lens + 1.4x teleconverter.

Battery Park

After enjoying the beautiful views offered from the ferry, Battery Park gives you a chance to create images of the iconic boats themselves. Immediately southwest of the ferry terminal, the park's promenade lets you watch the boats pass in front of Brooklyn and then move out into the bay and past the Statue of Liberty.

For most of the year, the sun sets between the Statue of Liberty and Ellis Island, offering a brightly colored sky to capture images against. Bringing a telephoto zoom lens will help you fill the frame with the boats even as they move far out into the bay (see Figure 24.5).

24.5 Two Staten Island ferries pass each other under the hint of a rainbow near sunset on a chilly winter afternoon (see C on the map). Taken at ISO 100, f/11, 1/200 second with a 70-200mm lens + 1.4x teleconverter.

How Can I Get the Best Shot?

The observation decks of the ferry offer a bumpy, windy ride and even sometimes some spray. Ensuring that you have a high shutter speed and shooting in Burst mode are paramount to avoiding blurry shots. The ferry moves past some of the great photo opportunities quickly, so be prepared before ever getting on the boat.

Know what you plan on shooting, ensure your camera settings are in place, and use the appropriate lenses. If, for some reason, you must change lenses, cards, or anything else, go inside of the ferry. The possibility of getting spray inside the camera's body or dropping something over the edge is not worth the few moments you would save. Also, the lower observation decks can be much less crowded but may also get some sea spray, especially in front of the boat.

Having confidence in your ability to capture a good shot is also very important. Check your first few exposures to ensure that they are correct and make any adjustments to your exposure compensation as necessary. For the rest of the ride, focus on standing steady and shooting. Don't check every image on the camera's LCD, because you will miss many great photographic opportunities.

The ferry is a challenging environment in which to take photographs, but it offers great practice. You can enjoy a huge confidence boost when you disembark, review, and find you have nailed the shots.

Equipment

The best choice for the majority of your images will be a telephoto zoom lens. The ferry passes far enough away from most things that you want to be certain you have enough reach to fill the frame with an obvious subject of your photos.

Lenses

▶ **A telephoto zoom lens in the 70-200mm range.** This lens, ranging from short to medium telephoto, is a great choice to pull distant objects close and isolate subjects when you are nearby. Although they often have a minimum focus distance of 3 to 5 feet, you will generally not be focusing on anything closer than 100 feet.

▶ **An ultrawide-angle zoom in the 16-35mm range.** This lens allows you to capture a panoramic view of the harbor from the ferry or the bay from Battery Park in a single exposure. It won't offer the same resolution as a panorama stitched together from multiple photographs but is a much simpler proposition.

Filters

Any time you are shooting images with water or sky, a polarizing filter can be beneficial. This filter helps to cut down the glare on the water and deepens the blue of the sky. However, it also cuts the light reaching the sensor by between one and two stops. Keeping shutter speeds high is very important when riding the boat, so you may not be able to use this filter and attain those shutter speeds.

At the opposite end of the spectrum, you may want to bring a neutral density filter to Battery Park to slow down your shutter speeds enough to impart a sense of motion. A graduated neutral density filter darkens just the sky in your image.

Extras

When shooting from Battery Park, you can use a tripod in order to take longer exposures. However, using a tripod on the boat is not recommended. The tripod transfers the movements and vibrations of the ship into the camera more so than if you are handholding the camera. When you shoot in Burst mode, you want to be sure that you have plenty of memory card space or multiple cards. Bring a lens cloth to wipe off any spray that may splash onto your lens.

Camera settings

When shooting from the boat, you are dealing with vibrations from the motors, the rolling from the waves, and sometimes heavy winds in the front boat buffeting you and your camera about. To combat all of this motion, you will want to use a Shutter Priority mode, so you can control your minimum shutter speeds. Burst mode is also very helpful because it allows you to take three to five exposures of every shot. By shooting a burst, one of the exposures should be at a peak or valley of your vibrations, yielding the sharpest shot of the group.

Exposure

When checking your initial exposures, ensure that your image is properly exposed without blowing out the highlights. If you are drastically changing shooting angles — for example, into the sun instead of with the sun at your back — you want to recheck the histogram to ensure that you are still getting a good exposure and adjust your exposure compensation as needed.

Shutter or Time Priority mode lets you set an exact shutter speed, and then the internal meter calculates the settings for the aperture. I recommend keeping your shutter speed between 1/1000 and 1/8000 second depending on how rough the seas and winds are that day. Having a higher shutter speed is good as long as your aperture and ISO are still within usable limits. And remember that such high shutter speeds will freeze all motion, so you might get some interesting effects, including freezing the blades of passing helicopters (see Figure 24.6).

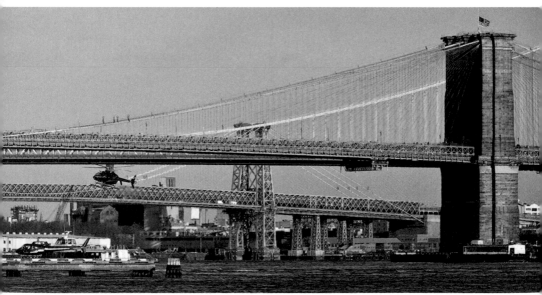

24.6 A helicopter's rotors are frozen mid-flight as it lands at the South Street Heliport on Manhattan's south shore on a cold winter day. Taken at ISO 500, f/5.6, 1/3200 second with a 70-200mm lens + 1.4x teleconverter.

White balance

When shooting outside, you can set your camera to Sunny or Shade white balance presets as appropriate.

ISO

If your camera offers Auto ISO, this is a great time to use it. Otherwise, set your ISO as low as possible while still being able to use your high shutter speeds. On a clear day, start with ISO 200 and ISO 400 on a cloudy day.

Image stabilization

An image stabilized lens can help with some of the conditions on this ride; however, be sure that it is in the proper mode for the shots that you are taking. When shooting off the side of the boat at quickly moving objects, such as other nearby boats or the Statue of Liberty, make sure that your image stabilizer is in the mode that recognizes panning. Otherwise, you may have blur caused by the image stabilizer fighting your lateral movements. If you are unsure, you can simply disable your image stabilization and just keep those shutter speeds up and not worry.

Ideal time to shoot

The morning light provides the best view of the Statue of Liberty, and the eastern side of Manhattan will have the sun rising behind it. The sun's afternoon light illuminates Battery Park and the rest of southern Manhattan. When shooting the ship from shore, this light will make the sky a multicolored backdrop (see Figure 24.7).

Be sure to check the wind, rain, and snow forecasts when heading out to shoot from the Staten Island Ferry. Wind can exacerbate the cold and quickly turn a journey unpleasant. (You can move inside if you get too cold.) If you shoot from the lower decks on the back of the ship, you will be fairly well shielded from rain and snow.

Low-light and night options

Focus on shooting the ferry itself from shore as the day moves into twilight. Bring a tripod to Battery Park or one of the other great spots that overlook the Upper Bay and shoot through sunset and into twilight and the evening. The best time to photograph the ferry terminal with its bright neon sign is after dark (see Figure 24.8).

24.7 The Staten Island Ferry sails away from its Manhattan terminal into a bright orange sky just after sunset on a cold winter evening. Taken at ISO 100, f/16, 1/2 second with a 300mm lens.

24.8 The Staten Island Ferry terminal in Manhattan lit up on a winter evening. Taken at ISO 800, f/5, 1/20 second with a 24-105mm lens.

Getting creative

Like much of Manhattan, birds are all around the Staten Island Ferry. If you have ever wanted to try photographing them in flight, though, this is an excellent opportunity. On the rear deck, seagulls will fly with the boat, appearing to hover 10 feet away.

Use the same settings as discussed earlier in this chapter and change your autofocus to your camera's Continuous/servo mode. This keeps the focus sharp even with variations of distance to your avian subjects (see Figure 24.9).

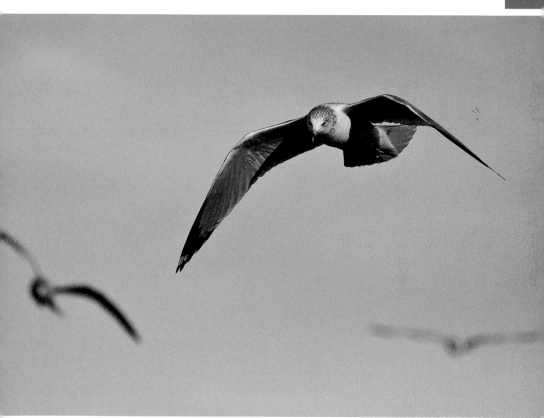

24.9 A seagull flies abreast the lower rear observation deck on a windy winter day. Taken at ISO 500, f/5.6, 1/5000 second with a 70-200mm lens + 1.4x teleconverter.

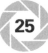

25 The Statue of Liberty

The Statue of Liberty on a winter morning from the ferry. Taken at ISO 400, f/6.3, 1/2000 second with a 70-200mm lens.

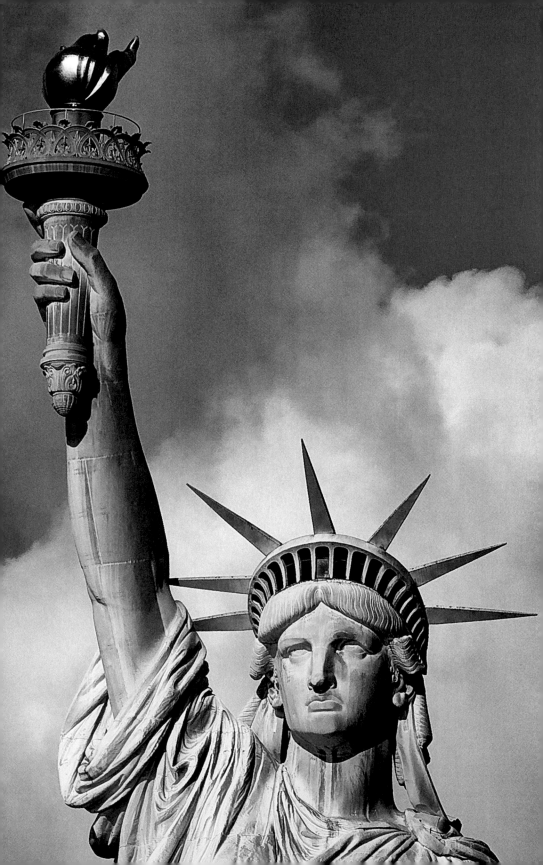

Why It's Worth a Photograph

The Statue of Liberty is one of the most recognizable icons of the United States. Located on Liberty Island in New York Harbor, the statue was dedicated in 1886. The statue was given to America by France as a symbol commemorating the centennial of the signing of the Declaration of Independence. Today, over 15,000 people visit the island each day while 3,000 passes are available to enter the statue's pedestal and crown. As one of the most well-known symbols of New York, the statue offers an instantly recognizable photo subject.

Great shots can be made all over the island, from the ferry, and from the Manhattan and New Jersey shores. When you are on the pedestal or in the crown, you can see awesome views of the harbor and a panoramic view of the surrounding metropolis. A visit to the Statue of Liberty is a full day's commitment, but you are committing to a unique photo opportunity. Once the first sight of millions of immigrants, the statue offers you the opportunity to express your own vision of one of the most well-known monuments in the world.

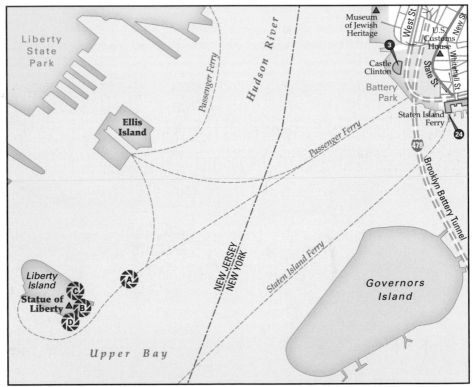

The best vantage points from which to photograph the Statue of Liberty: (A) the approach on the ferry, (B) the pedestal base, (C) up the stairs, and (D) the observation areas on the pedestal and in the crown. Other photo ops: (3) Castle Clinton and (24) Staten Island Ferry.

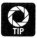 Buy pedestal or crown tickets online before your trip. They sometimes sell out months in advance.

Where Can I Get the Best Shot?

There are many places to capture great images of the Statue of Liberty. The best spots are from the approach on the ferry, from the pedestal base, up the stairs, and from the observation areas on the pedestal and in the crown.

The approach on the ferry

Riding the ferry from Battery Park in Manhattan or Liberty State Park in New Jersey is the only way to get to Liberty Island. If possible, consider taking the Liberty State Park ferry. This entrance is significantly less crowded with shorter lines at the airport-style security checkpoint you must pass through to board the ferry. The short ride to Liberty Island offers views from three sides of the statue as you pull in to the docks.

Be prepared with different lenses on different cameras or plan on a different lens for the ride in and the ride out. Wide-angle shots set the statue in the harbor and show her in context, often with the pedestal and island crawling with people (see Figure 25.1).

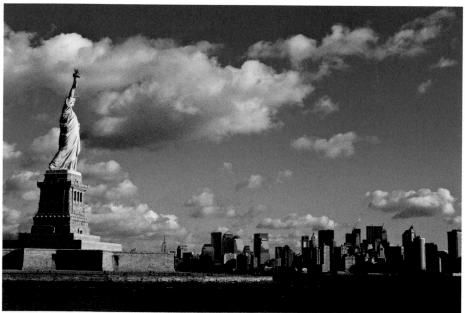

25.1 Manhattan Island is visible behind the Statue of Liberty as the ferry pulls into the docks on a winter day (see A on the map). Taken at ISO 400, f/6.3, 1/1250 second with a 25-60mm lens.

The pedestal's base

Even if you aren't able to get one of the limited tickets to enter the Statue of Liberty, Liberty Island offers beautiful views and photographic opportunities. Walking around the statue and the irregular 11-pointed star base, you can explore different angles to view the statue. Turn around, and you have panoramic views of the Manhattan skyline and New York Harbor.

A partially cloudy day gives you great contrast against the sky, allowing you to create an image that will pop off of the page. Including something in the foreground of a wide-angle shot increases the sense of depth in your photo (see Figure 25.2).

25.2 A ubiquitous set of New York City binoculars is turned around to look upon the Statue of Liberty (see B on the map). Taken on a chilly winter afternoon at ISO 250, f/18, 1/80 second with a 25-60mm lens.

Up the stairs

The stairs from the top of the pedestal to the crown are an impressive sight. A glass window at the top of the pedestal allows you to capture a view of them even if you

are not ascending to the crown (see Figure 25.3). If you are climbing the remaining 186 steps to the top, shoot up or down the stairs to communicate the tight, steep passage you navigated (see Figure 25.4). During your trip up and down, be aware of the location of your equipment to avoid bumping your camera against the railings.

The observation area

Planning ahead and purchasing tickets to the pedestal or the crown is well worth your time. You don't want to miss this unique photo opportunity. As of 2010, the crown is open to the public after being closed for nearly a decade. You need to climb 354 steps to get there, but the effort is worth the visual rewards at the top.

After your ascent, enjoy the view through the windows in the crown; the smaller ones at the edges of the row can be opened. You can take interesting photos of the statue with a wide-angle lens through the windows. A wide-angle or telephoto zoom lens offers a range of views of Manhattan and New York Harbor (see Figure 25.5). After descending from the crown, you travel through four levels of observation decks around the outside of the pedestal.

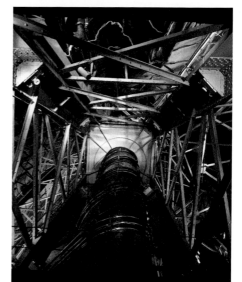

25.3 The final 186 steps are a narrow, winding staircase from the top of the pedestal to the statue's crown (see C on the map). Taken at ISO 1600, f/2.8, 1/50 second with a 16-35mm lens.

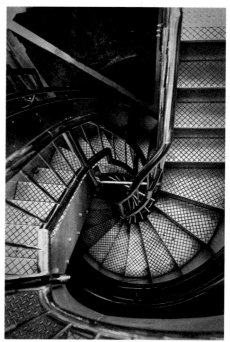

25.4 The staircase spirals away when viewed from the crown's observation deck. Taken at ISO 1600, f/2.8, 1/15 second with a 16-35mm lens propped against the railing for stability.

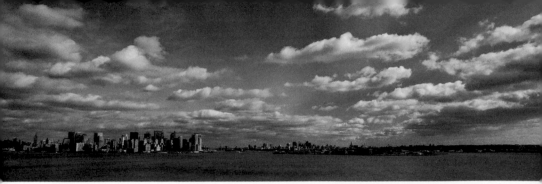

25.5 A panoramic crop of New York Harbor from a single image taken in the Statue of Liberty's crown through an open window on a cold winter morning (see D on the map). Shot at ISO 200, f/9, 1/250 second with a 16-35mm lens.

A wide-angle lens lets you capture images of the statue towering above as you descend and move farther away from the center with each successive level (see Figure 25.6).

How Can I Get the Best Shot?

Before you visit Liberty Island and the statue, go online and look at other photographs to get inspiration and a feel for the site. By previsualizing some images, you can better select the right gear to bring.

Like many of the other museums and historical sites in the city, you cannot bring a backpack or belt pack into the statue.

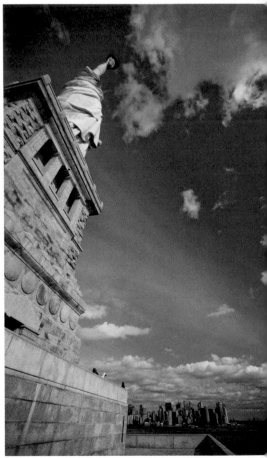

25.6 The Statue of Liberty towers overhead while Manhattan and the Brooklyn Bridge are visible in the background on a brisk winter day. Taken at ISO 200, f/2.8, 1/2000 second with a 16-35mm lens.

Lockers are available to store a small bag and only the smallest travel tripod. Remember that you have to carry them up 354 narrow and windy steps, though. The light indoors is tricky and dim, but there are plenty of railings and struts to use as a camera brace. When shooting outside, you generally want to use a wide lens to capture the entire statue in your frame.

Equipment

A range of lenses can help you to create memorable photos of this famous landmark while a standard zoom helps you travel light. Consider carrying two camera bodies to have the most flexibility rather than carrying a backpack or belt pack that you will need to check in a locker. Be prepared and remember that you cannot bring bags of any size into the statue. Cameras are the only stated items allowed into the pedestal and the crown, although you may also be allowed to bring filters or other camera accessories as long as they fit in your pockets.

Lenses

▶ **A standard zoom lens in the 24-105mm range.** The standard zoom lens allows you to capture a full range of images in a single package. Offering a moderately wide-angle option at 24mm, you can capture soaring images and sprawling landscapes. Traveling all the way to a medium telephoto length of 105mm offers isolation of details or brings the statue close when on the ferry. These lenses often offer both image stabilization for the dark interior and close minimum focusing distance for close-up shots.

▶ **An ultrawide-angle lens in the 16-35mm range.** There is nothing quite like standing at the base of a 300-foot statue and being able to fit the entire thing in your frame. An ultrawide-angle lens lets you do just that, and the exaggerated perspective causes it to look even larger.

▶ **A telephoto zoom lens in the 70-200mm range.** A telephoto zoom lens is useful on the ferry ride out to the island. This lens allows you to zoom in from quite a distance away from the island and still capture photographs with the statue filling the frame. When on the island, you can use its reach to isolate details in Manhattan or out in the harbor.

Filters

When you use a wide-angle lens, you will most likely capture lots of sky. A polarizing filter can help darken the sky and increase the contrast against clouds and your subjects. Be careful, however, on very wide-angle shots not to get too much of a change in the sky in your frame because it may look unnatural. Turn the polarizing filter to its fullest effect and then back it off about halfway.

Extras

Indoors, built-in or accessory flash is allowed if you want to carry it up the stairs. If you take photos of other people, such as traveling companions, this flash may be helpful. If you do not plan on entering the pedestal or crown, you can bring a tripod for photos of the statue from the shore and island, or to assist in creating panoramas of the city and harbor (see Figure 25.7).

 See the sidebar in Chapter 13 for tips on shooting a panorama.

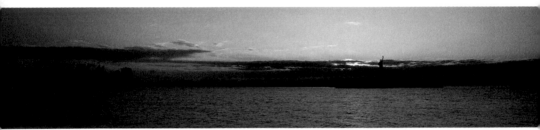

25.7 Panorama of New York Harbor from Liberty State Park including southern Manhattan and the Statue of Liberty. Taken on a chilly winter day at ISO 100, f/5, 1/250 second with a 26-50mm lens.

Camera settings

When creating landscape photos, you generally want a large depth of field to keep everything in focus. Using Aperture Priority mode gives you the most control over the depth of field while utilizing your camera's meter to set the proper shutter speed. Through most of your trip, except possibly when at the crown, you have as much time as you want to compose and create your images. Take your time and ensure that you have it *just right* before moving on to the next image.

 See Chapter 24 for more detailed suggestions about shooting photos from a moving boat.

Exposure

Most of your exposures should be straightforward by utilizing your camera's built-in meter. Indoors you may need to use your flash in order to get enough light, while outdoors this will not pose much of a challenge. Utilize your camera's LCD screen to review your histograms occasionally to make sure you are obtaining a good exposure without clipping the highlights.

Aperture Priority mode lets you dial in the exact aperture and depth of field you want for the scene. When inside, watch the shutter speed to ensure that it stays within a reasonable speed to handhold or be prepared to brace your camera on a railing or edge. Outside, watch for highlight clipping if shooting against a bright sky and be prepared to use some negative exposure compensation if needed.

White balance

When shooting photos outside, use your camera's Cloudy or Sunny white balance as appropriate. Indoors, try Tungsten or Fluorescent and check your image review to see if you are close. The mixed light indoors makes it difficult to get consistent lighting across the frame, but you can use that to your advantage to create interesting colors of background light. Make sure that you shoot in RAW mode in order to give yourself the greatest latitude with white balance in the digital darkroom.

ISO

When selecting your ISO, you will want to set it as low as possible to minimize the digital noise. However, you also need to ensure the ISO is high enough to allow you to use the shutter speed and aperture combination that you wish to employ for a specific composition. For the outdoor shots on the island, ISO 100-200 is good for most days and up to ISO 400 if it is overcast. Inside, you may need to go to ISO 800 or possibly ISO 1600 to ensure you can obtain a sharp exposure.

Ideal time to shoot

Spring is a beautiful time on the island, when all the trees are in bloom. However, there is no bad time to visit the Statue of Liberty. Visiting during the week can help ensure shorter lines at every step of the way, as does leaving on the earliest available ferry and traveling from Liberty State Park instead of Battery Park.

Inclement weather can be challenging at any outdoor location. If you plan on visiting the pedestal or crown, though, you may have purchased your tickets a month in advance and certainly don't want to reschedule. Ensure that both you and your camera are properly outfitted for rain, snow, or cold if you are travelling in inclement weather.

Low-light and night options

Although the hours adjust throughout the years, the first ferries leave after sunrise and the last ferries usually leave before sunset. This doesn't mean you can't get some wonderful photos of the sun, though. Arrive early or stay after the ferry rides and you can view the sun at its most spectacular.

Sunrises are best viewed from Liberty State Park in New Jersey from the 1.3 mile Liberty Walk promenade (see Figure 25.8). Sunsets are best viewed from Battery Park on the southern tip of Manhattan (see Figure 25.9).

 See Chapter 14 for more detailed suggestions for shooting long exposures on a tripod.

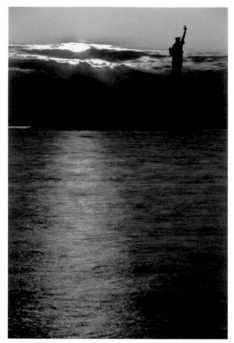

25.8 The sun rises over Liberty Island and the Statue of Liberty on a brisk winter morning. Taken at ISO 100, f/9, 5 seconds with a 70-200mm lens.

Getting creative

After climbing all the steps to the crown, don't forget that the windows open for fantastic views of the harbor and the statue. Ensure that your camera strap is safely around your neck and try holding your camera out of the window for a truly breathtaking view as well as a bit of a surprise.

Prefocus before going out the window and use drive mode to make a number of exposures while moving your camera around to get slightly different images (see Figure 25.10).

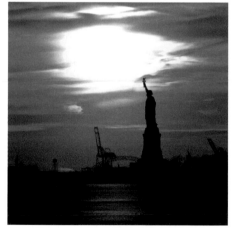

25.9 The sun sets behind the Statue of Liberty in New York Harbor on a cold winter evening. Taken at ISO 50, f/40, 30 seconds with a 70-200mm lens + 1.4x teleconverter.

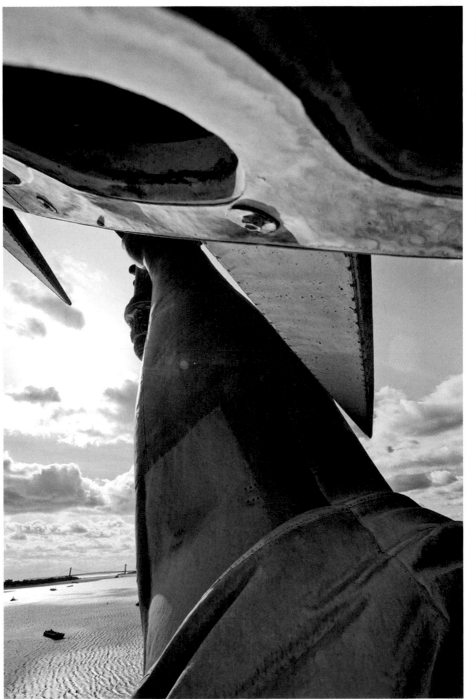

25.10 An image captured by holding the camera out an open window in the statue's crown. Taken on a breezy winter morning at ISO 200, f/10, 1/500 second with a 16-35mm lens.

A small piece of the sea of neon and billboards that is Times Square. Taken at ISO 400, f/2.5, 1/320 second with a 50mm lens.

Why It's Worth a Photograph

New York City's most famous intersection, Times Square, is located at the junction of Broadway and Seventh Avenue. This section of Manhattan, from 42nd to 47th streets, is filled with lights, sounds, and people 24 hours a day. A sea of cameras and languages washes over the crowds, and the constantly changing lights offer many opportunities to capture great photographs.

Everything in Times Square is bright and loud — even the police station is lit up with neon lights. The huge billboards and signs mean that this is a great place to come after dark as night never really settles into these streets. A constantly moving stream of lights, cars, and people flow past your frame and create compelling, instantly recognizable images.

Where Can I Get the Best Shot?

The best places to photograph Times Square are from 43rd Street looking north, from the TKTS stairs at 47th Street, and from 50th Street looking south.

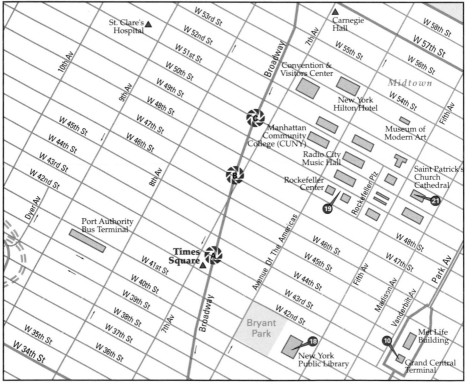

The best vantage points from which to photograph Times Square: (A) 43rd Street looking north, (B) Duffy Square at 47th Street, and (C) 50th Street looking south. Other photo ops: (10) Grand Central Terminal, (18) New York Public Library, (19) Rockefeller Center, and (21) Saint Patrick's Church Cathedral.

43rd Street looking north

Standing near the base of the One Times Square building and looking north, an ocean of neon lights seems to swell before you. The world-famous ball drops every New Year's Eve from the top of this building, and the crowds stretch to 50th Street and beyond. Here in the heart of Times Square, named after the building you are standing next to, everything is designed to be seen.

The subway stations are lit by flashing lights, and the signs stretch 30 stories over your head (see Figure 26.1). Using a standard zoom lens gives you the most freedom to explore different compositions and capture the scene while freely moving through the crowds. Besides wider shots to show the bright lights in all directions, focus on the details that make Times Square unique.

26.1 Even the subway entrances look like they belong here (see A on the map). Taken at ISO 1600, f/2.8, 1/400 second with a 50mm lens.

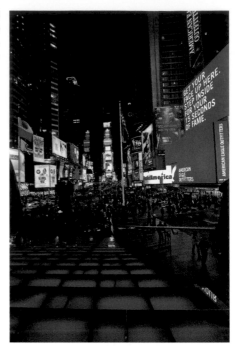

26.2 Looking south from atop the TKTS booth steps in the heart of Times Square (see B on the map). Taken at ISO 800, f/3.5, 1/80 second with a 16-35mm lens.

Duffy Square

Duffy Square is at 47th Street between Broadway and 7th Avenue. Located on top of the newly rebuilt TKTS booth, a free-standing set of red-lit stairs reaches 17 feet into the air, providing a vantage point above the crowds. Looking south, much of the heart of Times Square is revealed including a perspective of One Time Square and the ball. The always-full stairs are also a great place to people-watch and shoot portraits.

Bringing a standard telephoto lens gives you the most flexibility without needing to change lenses in a crowd (See Figure 26.2).

50th Street looking south

Continuing north to the northern fringes of Times Square gives you the opportunity to capture a large swath of the streets in one frame. Around 50th Street on the Broadway side is as far as you can go before the landmarks start to disappear around neighboring buildings.

Using the telephoto end of your standard zoom allows you to compress the distances and fit around eight blocks in a single frame, including the famous One Times Square and its distinctive ball (see Figure 26.3).

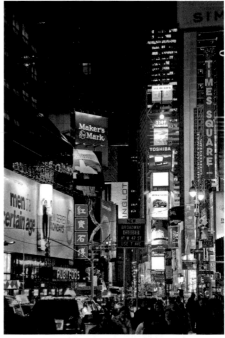

26.3 Looking south down Times Square from Broadway and West 50th Street (see C on the map). Taken at ISO 1600, f/4.5, 1/40 second with a 24-105mm lens.

New Year's Eve

New Year's Eve in Times Square is a world-famous party. If you take photographs here on that crowded night be sure to dress warmly, get there early, and be prepared to move around a bit to find the best shots. However, be aware that the police sometimes set up barricades around the blocks, and once an area fills up and you leave, you cannot return.

How Can I Get the Best Shot?

Although interesting during daylight hours, Times Square really shines at night. As the sunlight fades, the artificial lights take over. Within this ten-block area, twilight lasts from sunset to sunrise because of the omnipresent signs. You will face challenges from the dynamic range and mixed colors between the lights and signs above and the darker streets below.

Being careful not to clip the highlights is the key aspect you need to watch for on your camera's LCD. Review your histogram whenever your compositions change, so you can ensure that you are capturing as much data as possible. When you are moving through crowds, a minimal amount of gear works best, so you are not changing lenses or bumping into people with a large backpack.

Equipment

Focus on bringing a small amount of equipment when you visit Times Square. Because it is one of the most accessible spots in the city and one of the few locations to shoot in the evening, you can always come back another night of your trip if you decide you need another image with a different lens that was left in your hotel room.

Lenses

There are a few lenses to consider bringing with you to Times Square. A standard zoom lens offer you a lot of flexibility while a fast prime lens lets you get artistic with low light and shallow depth of field.

▶ **A standard zoom lens in the 24-105mm range.** A standard zoom lens offers you a lot of options when you are composing your shot. You can create wide-angle images to accentuate size and distance or use a medium telephoto to compress the scene into a single frame. Often these lenses contain image stabilization, which is very helpful when shooting in low-light environments.

▶ **A fast prime lens.** A prime lens with a large maximum aperture of f/1.2 to f/1.8 provides an advantage over most zooms with 2 to 4 stops more light. This allows you to obtain faster shutter speeds and keep your images sharp without using a flash for even the shadows of what passes for night in Times Square.

Filters

If you do bring a tripod, a neutral density filter can help you create very long exposures of ten seconds or more. By creating such a long exposure, most moving objects simply disappear in your frame, and any moving light sources turn into streaks across the frame.

Extras

In such a varied lighting environment, using a pocket gray card can be helpful to try to get close with your white balance. Also, you can consider bringing a tripod if you want to create HDR images or long exposures. Be aware, however, that using a tripod in portions of Time Square will attract the attention of police or auxiliary officers. For example, the TKTS booth steps are a sure place to be asked to move. However, as of late 2009 the New York City police have distributed multiple internal memos about allowing tripods for personal use. You will generally only be asked to move if you are impeding the flow of pedestrian or vehicle traffic.

Camera settings

In such a high-contrast environment, your camera's light meter is frequently fooled. The dynamic range of the scene can also very easily exceed that of your camera's sensor. For these reasons, you may need to pay closer attention to your settings and your results while still in the field.

Exposure

Your goal should be to create a digital negative with the greatest amount of latitude in the digital darkroom. Although you should always try to achieve this goal, it is even more important in a high contrast, mixed-light situation like Times Square. Shoot in RAW mode and watch your histogram to ensure you are protecting your highlights. These ideals help you to create the high quality digital negative you want in order to develop a beautiful digital photo.

In this area, consider using Manual mode. By finding a reliable exposure and setting it in manual settings, you can be sure that your exposure won't drift. Using

Aperture Priority mode can work, but be aware that drastic differences in the brightness from frame to frame can cause big swings in your exposure meter. Using exposure compensation after reviewing your image can help when using Aperture Priority mode. Otherwise, set the camera on Manual, find a setting that doesn't clip too many highlights, and then stick with it.

Metering mode

Change your camera to Center-weighted or Spot metering to bias the built-in meter towards the center of the frame. Compose your shot with your subject in the center, enable the Exposure Lock feature on your camera, and recompose. Doing this ensures that your subject is perfectly exposed in the scene.

White balance

White balance is also going to be a bit more difficult in this environment. Because there are various colors of lights from every direction, different parts of your scene will end up with different color tints. Using a pocket gray card to set a custom white balance lets you choose what color to correct for. Use it on your subject to ensure that the focus of your image, at least, is the correct white balance. Also be sure to shoot in RAW mode to ensure the most latitude in the digital darkroom.

ISO

You don't need to raise your ISO as high as you might normally expect when shooting at night. Generally, ISO 800 is sufficient, although in some bright places you can use ISO 400.

Ideal time to shoot

Although Times Square is fairly bustling during the day, it becomes so much more interesting and photogenic at night. And because most of the landmarks and museums close in the later afternoon, this is a perfect place to come to capture some nighttime images. Busy all year round, the holidays and New Year's Eve are, of course, highlights of the year.

You do not have many options when it comes to avoiding the weather in Times Square. Although you can take refuge in a store for a short storm, you are out in the open before too long. If you will be here during rain, snow, or cold, make sure that you and your gear are properly protected.

Low-light and night options

There are so many bright, flashing buildings and towers of neon. Try focusing on a single building and capture its neon facade in a single frame (see Figure 26.4).

Getting creative

Where the crossroads cut through the well-lit streets of Times Square is a perfect place to practice panning. A New York City taxi is a perfect subject, because its yellow color is instantly recognizable and it stands out nicely from the background.

Find a place with a lot of lights in the background and cars in the foreground. Set your camera to Shutter Priority mode and set your shutter speed to around 1/6 second. Then as taxis drive past, pan your camera along with them

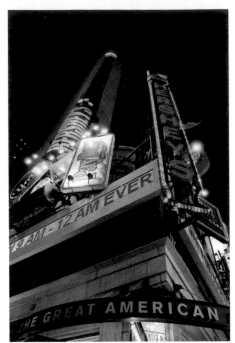

26.4 The Hershey's store in Times Square at Broadway and West 48th Street. Taken at ISO 1600, f/4, 1/40 second with a 24-105mm lens.

while depressing the shutter. Practice a number of times until you get one with a clear taxi moving across a light-streaked background (see Figure 26.5).

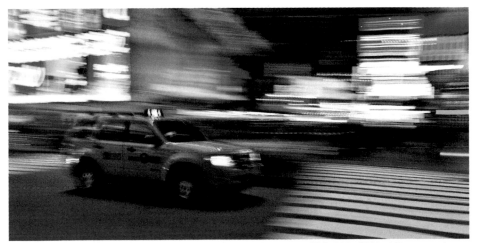

26.5 NYC Taxi driving east along 42nd Street. Taken at ISO 800, f/11, 1/6 second with a 16-35mm lens.

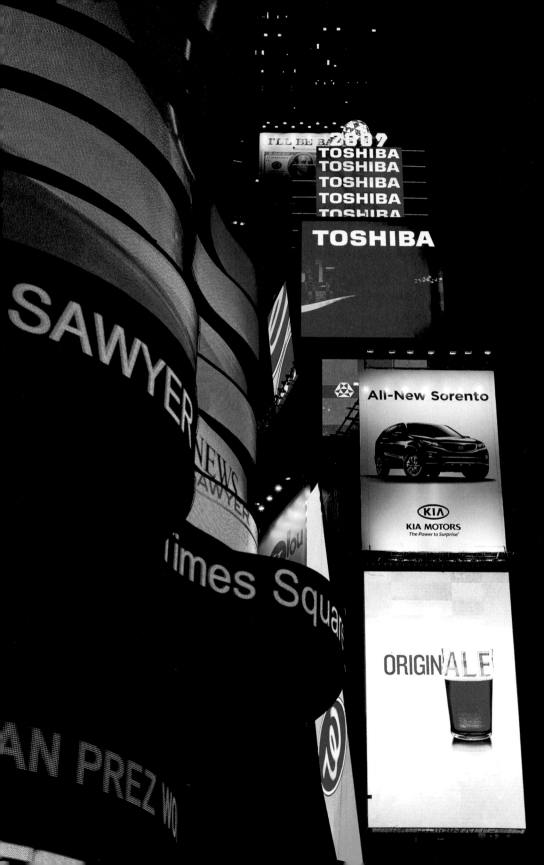

27 The United Nations

The United Nations Headquarters and the East River from Southpoint Park on Roosevelt Island during a winter sunset. Shot at ISO 800, f/7.1, 1/80 second with a 24-70mm lens.

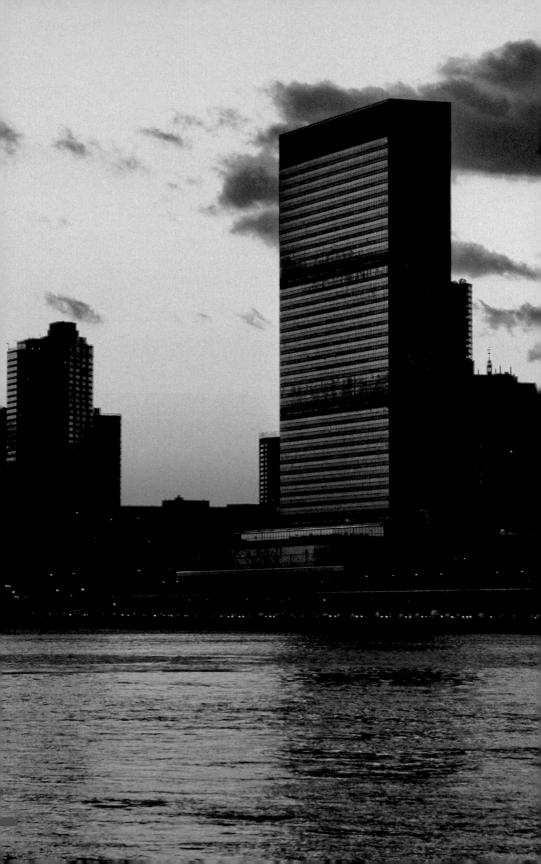

Why It's Worth A Photograph

The headquarters for the United Nations is located on First Avenue between 42nd and 48th streets on 17 acres of international territory. The impressive glass and steel Secretariat Building soars 39 stories overlooking the East River while the street side is lined by flags from every member country. The complex offers modern architecture with great foreground elements while the grounds have a number of interesting, internationally flavored sculptures. The interior of the General Assembly building has a multitude of artwork to enjoy both on the tour and in the public areas when you are not taking photos.

Where Can I Get the Best Shot?

The best locations to photograph the United Nations Headquarters are from First Avenue, from the grounds and from the General Assembly.

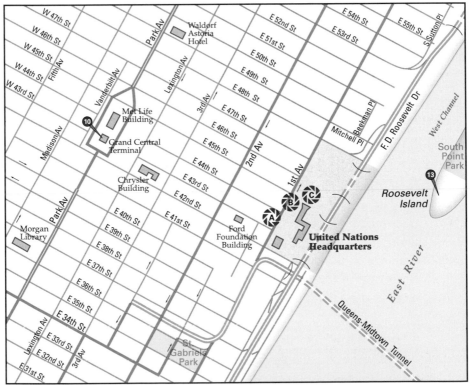

The best vantage points from which to photograph the United Nations: (A) First Avenue, (B) the grounds, and (C) the General Assembly. Other photo ops: (10) Grand Central Station and (13) Roosevelt Island.

First Avenue

Along First Avenue are some great photo opportunities. On a windy day, the 193 flags that line the front of the complex flutter in the breeze giving you the opportunity to create an iconic image of the Secretariat Building with a wide-angle lens. You can try different compositions, from nearly straight on at 44th Street to shooting from as far north as 53rd Street with a large zoom lens.

However, you don't need to stray that far in order to create an instantly recognizable photograph (see Figure 27.1). The morning sun rises behind the building while the afternoon sun reflects on the westward-facing glass facade, creating interesting colors and reflections of surrounding buildings.

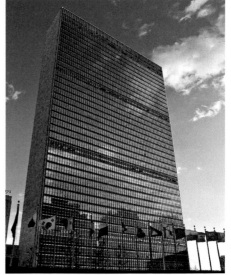

27.1 The United Nations Headquarters in New York on a windy winter afternoon on First Avenue at 44th Street (see A on the map). Taken at ISO 400, f/9, 1/30 second with a 24-70mm lens.

The grounds

The grounds surrounding the United Nations Headquarters complex offers more views of the building and a number of sculptures. The various artworks — gifts from member countries — are interesting by themselves and make relevant foreground elements for wide-angle shots of the grounds or the buildings. A standard zoom lens gives you a range of options from isolating details to capturing a wide scene with multiple features (see Figure 27.2).

27.2 A large bronze globe near the visitor's entrance of the United Nations Headquarters near sunset on a winter afternoon (see B on the map). Trump World Plaza looms in the background. Shot at ISO 400, f/5.6, 1/100 second with a 24-70mm lens.

The General Assembly

After passing through the security tent's highly sensitive metal detectors and surrendering all your bags to the bag check, you can purchase tickets for a guided tour through the General Assembly. By far, the most photogenic spot along the tour is the General Assembly chamber. This impressive room slopes down toward the front of the room, although you are not allowed past the top tier. Shooting down one of the aisles creates leading lines to bring your eye to the front and pulls the viewer into the scene (see Figure 27.3).

Your tour guide explains the history of the General Assembly and then gives you a few minutes to take photographs. Don't hesitate to move around the available area to try different angles from the back of the room.

NOTE Although tours take place when the General Assembly is in session, you may not take photographs. Call the Guided Tours desk (212-963-8687) the morning of your planned tour for an update.

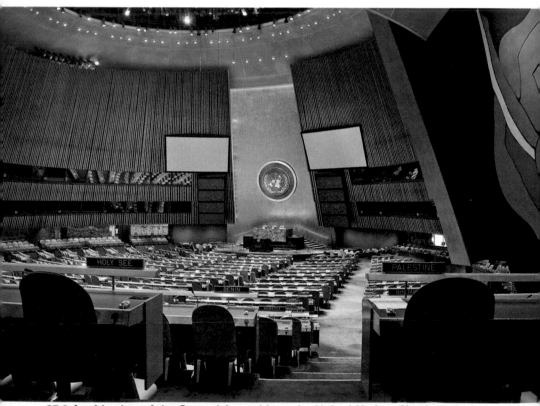

27.3 A wide shot of the General Assembly at the United Nations Headquarters on a midday tour (see C on the map). The camera is braced on the railing in the back of the room to help keep the image sharp in the low light of the room. Taken at ISO 800, f/4, 1/25 second with a 24-105 lens.

How Can I Get the Best Shot?

Although the outside of the United Nations Headquarters offers all the freedoms of shooting on the street, the inside tours and any other access to the grounds are all past a strict security checkpoint. You may not bring any sort of bags into the building, although a secure baggage check is provided.

When shooting outside, combine multiple elements to give your images a sense of depth, for example, combining the sculptures on the grounds with background elements, such as the main office buildings or the East River. Inside, your biggest concern will be low light, so make sure that your lens has a large aperture or raise your ISO enough to get a sufficiently fast shutter speed.

 Even at a strict spot such as the UN, wearing spacious cargo pants to carry a little extra gear is allowed. Use all your pocket space to hold the equipment you would normally have in a smaller camera bag.

Lenses

▶ **A multipurpose zoom lens in the 24-105 range.** You can use a multipurpose zoom lens for most of the shots you want to create. It will also help reduce the need to bring a photo bag and be forced to check it. Many of these lenses include image stabilization, which is beneficial when shooting in the low light found inside. They also offer a small minimum focusing distance so you can capture some close-up images of the beautiful art on the tour.

▶ **A fast prime lens.** An alternative to needing to use image stabilization, a fast prime lens with a large f-stop in the f/1.2-f/1.8 range allows you to shoot indoors with a faster shutter speed than most zoom lenses. Most manufacturers make relatively inexpensive 50mm f/1.8 and f/1.4 lenses that can be used for a wide variety of purposes. Consider bringing one along to shoot inside the General Assembly.

Filters

When shooting outdoors against the sky, a polarizing filter can be useful to reduce glare off buildings and deepen the blue of the sky. A darker sky increases the contrast of the building against the background.

Extras

Travel light to the United Nations Headquarters to avoid headaches at security. Most locations indoors are too large to bother using a flash. Increase your ISO and lower your f/stop to shoot with the ambient light instead.

Camera settings

When working outside, you will want the large depth of field from a smaller aperture around f/8-f/11. When you are shooting indoors, be sure to keep your shutter speeds up to 1/focal length and be sure you are holding your camera steady. If you are shooting some of the artwork around the building, be sure to disable your pop-up flash, and put your lens right up against the glass to reduce reflections and glare (see Figure 27.4).

Exposure

The outside exposures are not too difficult using Aperture Priority mode and your camera's internal meter. You might need to increase your exposure compensation +1/3 to +2/3 if shooting into the sun or a reflection of the sun. Indoors, the exposure can be challenging as some of the spaces are poorly lit.

Aperture Priority mode gives you the most control over your depth of field both inside and out.

27.4 A piece donated by Thailand to the United Nations Headquarters. Taken at ISO 800, f/5.6, 1/15 second with a 24-105mm lens flush against the glass display case to reduce the glare from shooting through glass.

White balance

For outside shots, use Sunny or Cloudy white balance as appropriate. In the General Assembly, Tungsten white balance will get you very close. In both cases, shoot in RAW mode to have the most control in the digital darkroom.

ISO

When shooting outside, use the lowest ISO possible to get the shutter speed you need—generally, ISO 100-200 on a sunny day and up to 400 in the early morning or during sunset. Indoors, you may need to go as high as 800 or even 1600 to maintain an acceptable shutter speed while handholding.

Ideal time to shoot

Guided tours are weekdays from 9 a.m. to 5 p.m. However, the information desk states that there are often tours on weekends, as well. If you get there for one of the first or one of the last tours, not only are you likely to wait for less time, you may have a sunrise or sunset outside as well.

The indoor tours are not affected by the weather, although do be aware that the pickup for bag check is outside with no nearby cover to get everything resituated. The outdoor shots are best against a blue sky or sunrise/sunset colors. On an overcast or rainy day, look for more detailed shots that won't include a boring, flat sky.

Low-light and night options

In poorly-lit indoor spaces, use a railing or chair to help brace your camera to hold it steady when shooting at a slow shutter speed. You can also enable continuous mode and shoot in a three-shot burst. Often, the middle shot is going to be clearer than the first or last because you are not actively pushing on or releasing the shutter button. Most of the spaces are too large for a single flash to be of much help, so focus on using the ambient light and increase your ISO as needed.

Getting creative

The large bronze globe by the visitor's entrance makes a wonderful mirror. Zoom in tight and take an interesting, if distorted, self-portrait.

The Charging Bull at Broadway and Bowling Green in an early winter snowstorm. Taken at ISO 500, f/3.5, 1/640 second with a 16-35mm lens.

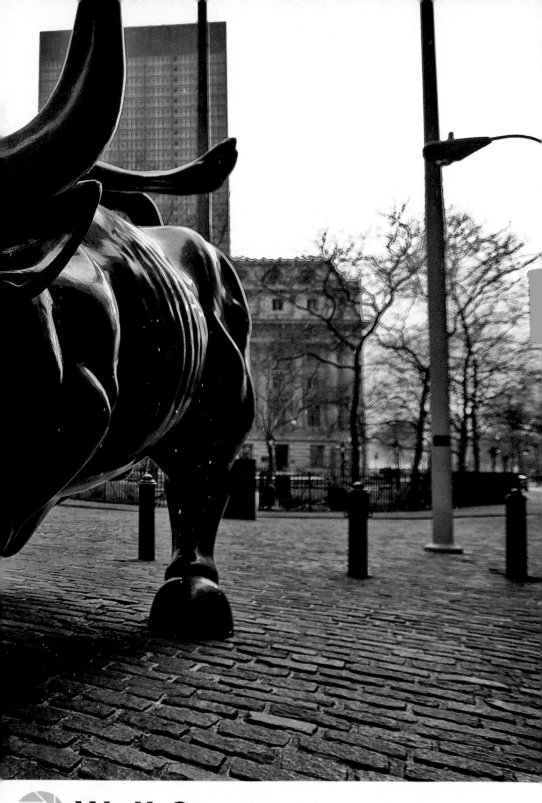

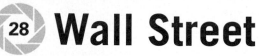
28 Wall Street

Why It's Worth a Photograph

Wall Street is the home to the New York Stock Exchange, Federal Hall, and other historic buildings on the southern tip of Manhattan. The historical center of the Financial District, the street's name also refers to the neighborhood and the entire American financial sector. Most of the historic buildings are of Gilded Age construction with influences of the Art Deco era. With three different subway terminals and the Staten Island Ferry, this is a busy part of town.

You can make photographs of people as well as the architecture and history. An instantly recognizable street corner no matter where you point your camera, Wall and Broad streets puts you in front of the NYSE, where the afternoon sun plays against its columns and decorative sculptures. Just across the way is Federal Hall, a national memorial built in 1700 with a rich history. Exploring the Wall Street area is a pleasure for architectural and historic photographs.

The best vantage points from which to photograph Wall Street: (A) Broadway and Wall Street, (B) in front of the NYSE, (C) Federal Hall, and (D) Broadway and Bowling Green. Other photo ops: (3) Castle Clinton, (23) South Street Seaport, and (24) Staten Island Ferry.

Where Can I Get the Best Shot?

The recommended locations to get the best shots of Wall Street are from Broadway and Wall Street, in front of the NYSE, from Federal Hall, and from Broadway and Bowling Green.

Broadway and Wall Street

The famous Trinity Church serves as an excellent backdrop for photographs of the Broadway and Wall Street signs. The afternoon lights create soft shadows on the bricks providing a great backdrop. The signs on this corner are symbols that you are entering the Financial District. Unless you want to take photos of the increased security surrounding the New York Stock Exchange, wait until you move down toward Broad Street to create images of the NYSE and other buildings on this block (see Figure 28.1).

In front of the New York Stock Exchange

Located at the corner of Broad and Wall streets, the New York Stock Exchange is a beautiful building with columns and engravings across its Broad Street facade. In front of the building, you can isolate some of these details, which will glow in the morning or afternoon light (see Figure 28.2). You can also turn and capture images of Federal Hall on the opposite street corner (see Figure 28.3). A standard zoom lens offers you the most flexibility when moving around these often crowded streets.

Federal Hall

Climbing the steps of Federal Hall gives you an elevated view of the street and NYSE building. Using a medium tele-photo zoom lens lets you fill the frame with the building, and a wide-angle or standard zoom lens sets the building into its surrounding streets and neighboring

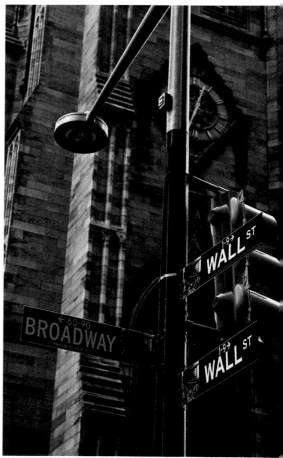

28.1 The street signs at Broadway and Wall Street in front of Trinity Church on a cold winter morning (see A on the map). Taken at ISO 400, f/4.5, 1/50 second with a 40-170mm lens.

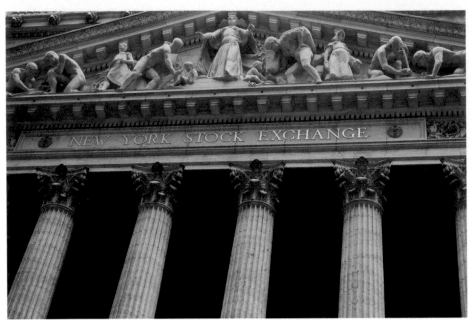

28.2 The Broad Street facade of the New York Stock Exchange on a windy winter morning (see B on the map). Taken at ISO 400, f/4, 1/200 second with a 40-170mm lens.

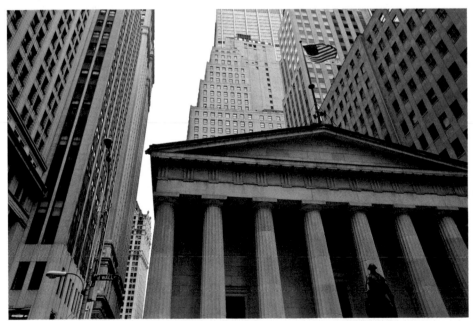

28.3 Federal Hall as seen from in front of the New York Stock Exchange building on a windy winter afternoon. Taken at ISO 250, f/5.6, 1/160 with a 16-35mm lens.

buildings. The morning sun filters down to light the building without overexposing the sky behind (see Figure 28.4).

Broadway and Bowling Green

At the intersection of Broadway and Bowling Green is the famous *Charging Bull* sculpture, created by Arturo Di Modica. Originally installed in the middle of the night on December 15, 1989, the 7,000 pound bronze sculpture was eventually installed permanently at this intersection.

Behind the famous bull is Bowling Green Park and the Alexander Hamilton U.S. Custom House, both opportunities to create images. Combine them to contrast the flora of the park with the Beaux Arts styling of the Custom House (see Figure 28.5).

28.4 The New York Stock Exchange viewed from atop the steps of Federal Hall, beside the statue of George Washington (see C on the map). Taken at ISO 100, f/7.1, 1/50 second with a 24-105mm lens.

28.5 The Alexander Hamilton U.S. Custom House and Bowling Green station elevator beside Bowling Green park on a quiet winter morning (see D on the map). Taken at ISO 200, f/8, 1/80 second with a 16-35mm lens.

How Can I Get the Best Shot?

Composing images of the Wall Street area can be an exercise in patience if you want to create compositions free from pedestrians. Otherwise, embrace the scene and include the normal crowds in your shots. If possible, a blue sky adds a good contrast to the architectural images of the buildings on the street. Be aware of the dynamic range of the shadowed buildings and watch for specular highlights on the windows as well as those reflected off neighboring buildings' windows. Photographing when the sun is mostly at your back helps keep the sky and the buildings within your camera sensor's dynamic range.

Equipment

Different compositions call for different lenses. A common theme in selecting the appropriate lens for your shot will be choosing something that helps isolate your subject from the throngs of people usually found in and around them.

Lenses

▶ **A standard telephoto lens in the 24-105mm range.** This all-purpose lens, ranging from moderately wide-angle to normal to short telephoto, offers you a tool to do everything in a single package, saving you from changing lenses for different shots. Generally having the ability to do some basic macro work, you can isolate close-up details at street level or use the short telephoto to pick out some details on the buildings.

▶ **An ultrawide-angle zoom lens in the 16-35mm range.** This lens allows you to get close yet still capture an entire subject. This perspective causes some apparent distortion at the corners of the image but allows you to isolate your subject with a minimum of other distractions in the frame.

Filters

When shooting building windows or against the sky, a polarizing filter can be useful. This filter darkens the blue of the sky to increase the contrast against the gray and tan buildings. It can also reduce the reflections from windows, so they fade into the structure of the building rather than being bright points of distraction to the eye.

Extras

Unless you plan to shoot HDR images or long exposures to blur pedestrian motion, a tripod isn't really necessary here. A good backpack or belt pack is useful if you plan to utilize multiple lenses.

Camera settings

Camera settings for your shots on Wall Street should be straightforward. Your camera's internal meter should be quite reliable for the majority of the images you will be creating here. Using Aperture Priority mode and an f/stop of f/8 to f/11 helps to ensure sharp images with a large depth of field.

Exposure

Obtaining a good exposure is important. Expose to the right to avoid losing details in the shadows and ensure you don't overexpose the highlights or the sky if possible. Shooting into the sun or on an overcast day, you may have to sacrifice the sky in order to obtain a good exposure of your subject because the dynamic range between the two will exceed your camera's capabilities.

Use Aperture Priority mode to control your depth of field and let your meter set the shutter speed and ISO as necessary. A smaller aperture helps to keep everything sharp, but you may have an artistic reason to blur the background in a shot.

White balance

Generally outdoors using the presets for Cloudy or Sunny as appropriate will result in being very close. Shoot in RAW mode to give yourself the ability to tweak this in the digital darkroom.

ISO

Keeping as low an ISO as possible yields the cleanest digital negative. ISO 100-200 for a sunny day and 400 for a cloudy day or in the shadow is a good rule of thumb.

Ideal time to shoot

Early in the morning or the afternoon is a great time to shoot. Be aware that the streets get quite busy before the opening and after the close of the markets, around 9 a.m. and 5 p.m. On weekends, you won't see as many business people, but you will see more tourists than on weekdays. The spring means beautiful blooms at Bowling Green Park and on the other trees around the streets but otherwise the buildings themselves take great images all year round.

Because you will be outside with little shelter, be sure to check the local weather forecasts and dress yourself and your gear appropriately for any inclement weather. Snow and rain can bring their own unique photographic opportunities, so if you are equipped for those conditions, don't let them put a damper on your day.

Low-light and night options

After the sun goes down, the artificial lights add a new set of accent lights to the buildings, especially the larger more well-known addresses, such as the NYSE. If you shoot during sunset and twilight, balance the ambient sunlight with this artificial light to create interesting images of this transient phase of the day.

Getting creative

The busy streets are crowded with people and security checkpoints. You have to be creative to shoot around these and not include them as distractions in your frame. Getting low and shooting upward lets you cut them out of the bottom of the frame but gives a distinctive perspective that is sometimes unwanted. Ascending a neighboring building's steps can get you over these unwanted elements without cutting off too much of the bottom of the scene.

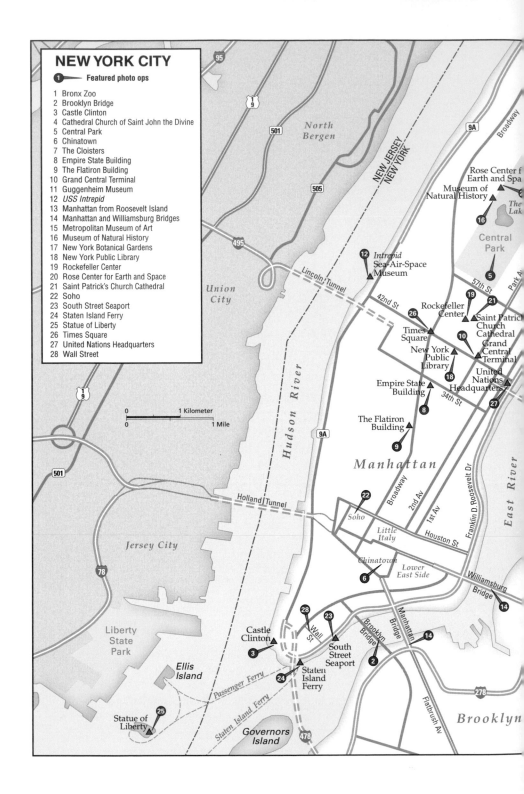

NEW YORK CITY

🔵 **Featured photo ops**

1 Bronx Zoo
2 Brooklyn Bridge
3 Castle Clinton
4 Cathedral Church of Saint John the Divine
5 Central Park
6 Chinatown
7 The Cloisters
8 Empire State Building
9 The Flatiron Building
10 Grand Central Terminal
11 Guggenheim Museum
12 *USS Intrepid*
13 Manhattan from Roosevelt Island
14 Manhattan and Williamsburg Bridges
15 Metropolitan Museum of Art
16 Museum of Natural History
17 New York Botanical Gardens
18 New York Public Library
19 Rockefeller Center
20 Rose Center for Earth and Space
21 Saint Patrick's Church Cathedral
22 Soho
23 South Street Seaport
24 Staten Island Ferry
25 Statue of Liberty
26 Times Square
27 United Nations Headquarters
28 Wall Street

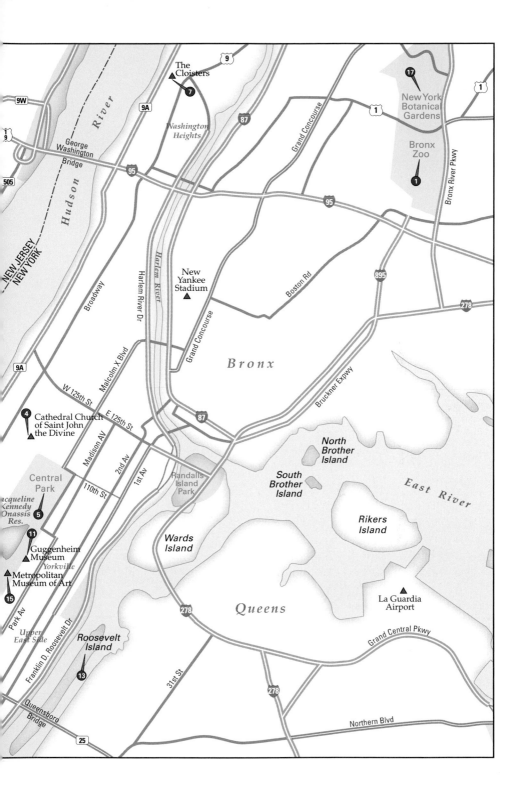

Index

Postcard-perfect pictures

Just what you need to capture breathtaking shots of today's most photographed destinations! Colorful, portable *Digital Field Guides* are loaded with tips to improve your photography skills— pack one with your compact camera or digital SLR.

978-0-470-58684-6

978-0-470-58687-7

978-0-470-58685-3

978-0-470-58686-0

Available wherever books are sold.

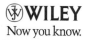

Get the iPhone app for postcard-perfect pictures!

Destination Digital Field Guide iPhone apps help you and your digital camera get top-quality travel photos! Now available for San Francisco, Washington D.C., and Yosemite, these cool apps help you choose popular attractions to photograph, identify the ideal vantage point and time of day for the shot, and more. Interactive maps tell you where attractions are and how far you are from them.

You can even:

- Make a list of sites to photograph by location, vantage point, or time of day

- Get maps and directions using the built-in GPS functionality

- Learn how experts captured certain photos and follow their recipe

- Use advanced tools to help set up your digital camera

Get your apps today!
Go to **http://lp.wileypub.com/DestinationDFGiPhoneApp** and follow the link to the iTunes Store.